LUCY +JORGE ORTA

--- FOOD WATER LIFE

Princeton Architectural Press · New York

Published by
Princeton Architectural Press
37 East 7th Street, New York, NY 10003

For a free catalog of books, call 1-800-722-6657
Visit our website at www.papress.com

© 2011 Princeton Architectural Press
All rights reserved
Printed and bound in China
14 13 12 11 4 3 2 1 First edition

Editors: Becca Casbon and Megan Carey
Designer: Paul Wagner

Special thanks to: Bree Anne Apperley, Sara Bader,
Nicola Bednarek Brower, Janet Behning, Fannie Bushin,
Carina Cha, Tom Cho, Penny (Yuen Pik) Chu, Russell Fernandez,
Jan Haux, Linda Lee, John Myers, Katharine Myers,
Margaret Rogalski, Dan Simon, Andrew Stepanian,
Jennifer Thompson, Joseph Weston, and Deb Wood of
Princeton Architectural Press
—Kevin C. Lippert, publisher

Library of Congress
Cataloging-in-Publication Data

Lucy + Jorge Orta : food, water, life. — 1st ed.
 p. cm.
ISBN 978-1-56898-991-4 (alk. paper)
1. Orta, Lucy—Criticism and interpretation. 2. Orta, Jorge,
1953—Criticism and interpretation. 3. Artistic collaboration—
France. I. Orta, Lucy. II. Orta, Jorge, 1953– III. Title: Lucy plus
Jorge Orta. IV. Title: Lucy and Jorge Orta.

N6797.O78L83 2011
709.2'2—dc22

 2010041651

Front cover image:
70 × 7 The Meal, act XXIX La Venaria Reale, Turin, 2008
Curated by Maria Perosino and Bartolomeo Pietromarchi
Photography: Thierry Bal

Back cover image:
OrtaWater—Purification Station, 2005
Installation in the Museum Boijmans Van Beuningen, Rotterdam,
The Netherlands
Private Collection, Bologna, Italy
Photography: Bob Goedewaagen

Contents

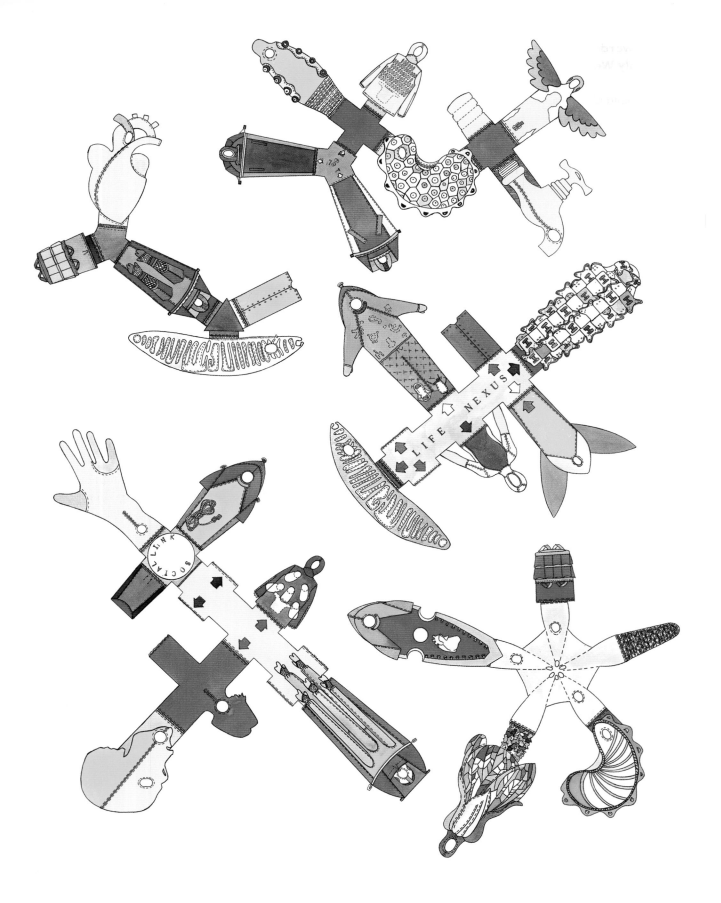

Foreword:
If Only We Wanted To!

Simonetta Carbonaro

Let us imagine, just for a second, that we will somehow manage to fix the current state of emergency and find a way to avoid collapsing into a greater economic depression before climate change becomes irreversible—before we run out of drinkable water and fossil fuels; before the unrest that arises because more than half of our world's population is living in hunger, with no shelter or homeland, becomes stronger; and before we irrevocably lose our natural capital and the knowledge (and wisdom) necessary to come up with a balanced and fair way to produce and distribute our food, clothing, shelter, and wealth to each spot of our planet. Let us envision a true world of tomorrow, in which the distributed affordability of any commodity, of endless energy flows, of unlimited resources, will allow us to avoid making new feedstock-based materials and "birth-to-birth," mass-market industrial products. I think that even if these things were to happen, we would still end up hitting a wall, simply because the infinite growth of material "stuff" is a dystopia! It would be an unsustainable development, not only because that kind of hyper-productive perpetual machine will end up impinging on our physical space (like Leonia, one of Italo Calvino's "invisible cities," destroyed under an avalanche of its own garbage), but because it will also invade our mental space. The fact is that our living spaces and our lifetimes are also finite and limited—nonrenewable resources.

Let's get one thing straight: if there is a way out of our global emergency, it will come from cultural activists—like Lucy + Jorge Orta—who are willing, through their artwork, to wake people up from their coma-like acceptance of their current (and deeply damaged) ways of living. What we urgently need today is not only the design of new economic, political, and environmental policies, but above all cultural models that can profoundly and quickly change people's habits and lifestyles. Studio Orta's work is evidence of how art can change our way of looking at reality. Their work—centered on today's scarcity of water, food, shelter, homelands, peace, and freedom—activates our critical thinking and sparks our imagination. It wakes us to the state of things by embracing us with conviviality. It shows us that the "sustainable thing" is not just about frugality, but a happy frugality. It goes beyond the repetitive compulsion of the unbearable lightness of *having* and shifts our scope to the significance of *being*.

The Ortas' language goes beyond the self-referential language used in many contemporary artworks. It speaks another language: the language of aesthetics/ethics. When the language is other, so is the message, as Marshall McLuhan teaches us. The Ortas' artworks emit, without making any audible sounds, messages so strong and loud that they seem to be attempting to crush our eardrums: "Peace Is Not the Absence of Armed Violence," "I Destroy My Enemies When I Make Them My Friends," "Are You Ready for the Worst?" and so on.

Studio Orta's audience and commissioners are not from the business side of the art world. Lucy + Jorge Orta belong to the part

of the art world that is dedicated to social transformation and speaks to civil society, to human beings. They open people's eyes to the mythology that supports material growth based on the subjugation of nature and the marginalization of "others." They speak to those in the younger generations who are trying to liberate themselves from the straitjacket of packaged "free time," who join the Ortas' art expeditions to those parts of our world where producing art means witnessing what in reality is actually reality (and not the fiction of the mass media).

With their works, the Ortas present a perspective of the civil courage of a vast community of artists who are prepared to work in the field, hands-on, among the people—mixing it up in "marginal" communities, sharing experiences with the subcultures of those who live cheek-to-cheek with the affluent yet are in a state of ongoing emergency and/or discrimination. Furthermore, the Ortas' projects not only explore the "otherness" of those who are living through war, diaspora, destitution, or homelessness, but are also about those who live in a state of existential exile, of permanent terror, and the sense of anthropological alienation that is so common in our so-called advanced societies. This is art that makes us think about what remains of our Western civilizations, based on a "excesscivilization."

Take Lucy + Jorge Orta's *Antarctica*, for example. This art venture is not just an intelligent and forceful provocation, it also creates an exciting new utopia in a forgotten landmass: the Antarctic. In 1959, countries representing two-thirds of humanity signed the Antarctic Treaty, which turned Earth's sixth continent into the only ideal place in the world. A nonplace that, perhaps due to its temperatures as low as -60° C, is so unfit for human life that it has become the only place on the planet that can be used only for peaceful purposes. It is a place where any degree of military involvement is prohibited, where there is freedom of scientific investigation and cooperation, where all nuclear energy production, all explosions, and all disposal of radioactive waste material is ruled out. This is where Studio Orta founded the Antarctic Village, the first symbolic settlement of the "nation of humanity." Here, a new generation of women and men will have the right to citizenship and a passport, which will allow them to travel freely. Each citizen of this nation of humanity will be requested in return to "dedicate him or herself to fight all acts of barbarity, to fight intimidation and poverty, to support social progress, to protect the environment and endangered species, to safeguard human dignity, and defend the inalienable rights to liberty, justice, and peace."

The Ortas' work urges us to reflect on our model for human progress and development, looking well beyond the standard parameters that prevail in these times of global economic and environmental crisis. It embodies and heralds a true cultural transformation, where our objects of desire, and even our everyday gestures, become symbolic and cultural stepping-stones toward awareness. The Ortas point to deep cultural and social transformation, from the

current "culture of economy," which is driven by the mythology of quantity, to a new "economy of culture" compelled by the reality of quality.

In order to achieve this transformation, all our actions need to be questioned and reviewed, as does the balance between our Western lifestyles and our intracultural thought patterns, between our affluent, unsustainable way of life and a good, fair, and clean distribution of prosperity in the world. The Ortas call for a new economy of culture in which "culture" is no longer an abstract term, but a network of cultural actors who—like the many people that Studio Orta catalyzes—generate and disseminate the kind of communication and education that reveals the aesthetic side of ethics, finally allowing us to grasp how it really feels to be a citizen of a human nation and a fellow inhabitant of our blue planet.

Those who claim that such a transformation is impossible should first ask themselves if the current dogma of senseless, unlimited material growth still carries within it the prospect of well-being and the seed of a healthy future. If the answer is negative, a new course of action is needed. History has already witnessed some cultural (and artistic) movements that have dramatically changed the unfolding of time, such as Christianity, the Renaissance, and the Enlightenment. All these transformations have stemmed from what distinguishes our species from all others: our human mind and spirit.

There are no more excuses. If we were ready to trust the "invisible hand" of culture and the arts instead of the Ponzi-scheming hand of the financial markets, we could change our direction overnight. If we decided to use all the regenerative powers of our minds and spirits, we could set this new transformation in motion. It will clearly take time, but we have to start somewhere.

I have already forwarded my citizenship request to the Antarctic Village and obtained my World Passport, number 1004. Armed with fiery patience, I await the day when, together with many, many others, I will finally be entitled to show this same and shared document at every national border of this new world of ours.

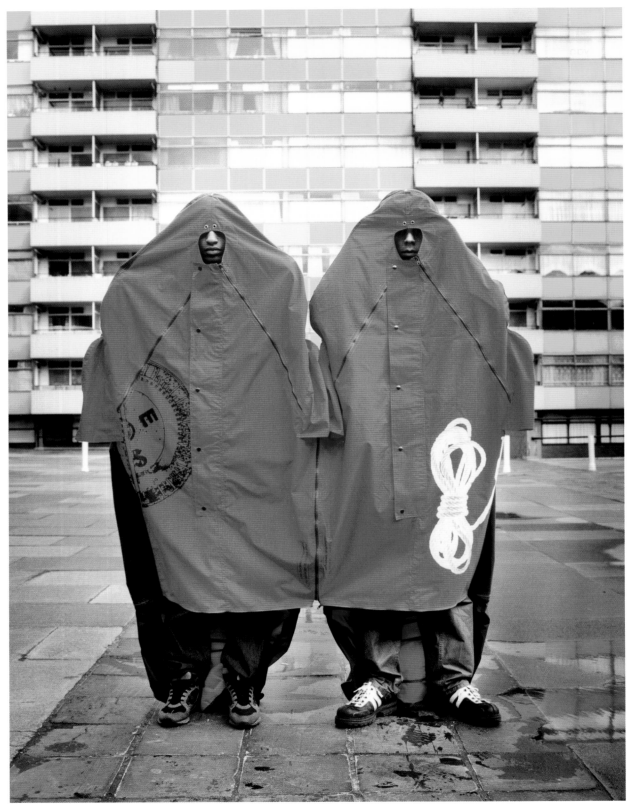

Refuge Wear Intervention London East End, 1998

Introduction

Zoë Ryan

Cutting across art, performance, architecture, and design, the arresting work of Lucy + Jorge Orta deals with fundamental human needs. Issues such as water, food, shelter, and mobility underscore their practice, rendered in their drawings, sculptures, performances, and large-scale installations, as well as in the workshops and conferences they have become known for. Rather than stand-alone projects, their works are often developed in series over a number of years, with various acts that build on one another, reinforcing their mission. Since creating Studio Orta, based in Paris, in 1992, their work has increasingly grown in ambition and scale while retaining a core mission to investigate, challenge, and stimulate dialogue and exchange about social and cultural issues that are rooted in and have come to define contemporary life. "Our goal is to help change people's attitudes and habits, activate debate...and even change current legislation," they assert of their fearless approach.

Trained as a fashion designer, Lucy began her career as an artist in the beginning of the 1990s, with the specific mandate to create works that "respond to a critical and constructive gaze on the most sensitive areas of society." Her ideas were pointedly illustrated in early works such as *Refuge Wear*, created between 1992 and 1998, and *Body Architecture*, created from 1994 to 1998, for which she generated a series of tent-like structures with multiple functions. Drawing on her garment-construction skills, the works could be transformed from overcoats to backpacks to sleeping bags and tents. *Nexus Architecture*, developed between 1994 and 2002, also incorporated wearable structures, in this case bodysuits with attached umbilical cords that joined groups of people in grid-like formations, as a metaphor for social connectivity. Worn by performers in a series of public interventions staged by Lucy in cities across Europe as well as in Havana, Cuba, they came to signal her increased interest in developing projects that interrogate the urban frame, opening up sites of public space for dialogue and exchange and promoting social cohesion by reasserting the collective over individual action.

For Jorge Orta, the urban and rural landscapes have proven fertile grounds for many of his sculptures, performances, and light works. Born in Argentina and trained as a visual artist, Jorge is known for his *Light Works*, large-scale light projections, which incorporate a universally accessible lexicon of signs and symbols drawn from everyday life. Images of animals, birds, a human heart, and an eye are some of the myriad visual symbols that he has projected at the scale of architecture, transforming spaces and landscapes as diverse as the Centre Pompidou in Paris and Machu Picchu in Peru into hieroglyphic message boards. Invited to represent Argentina in the 1995 Venice Biennale, Jorge created *Light Messenger*, a project made in response to the demise of the Argentine pavilion in the Biennale gardens. Undeterred by having no fixed gallery space, he conceived of an ephemeral and mobile artwork and used the water surrounding the

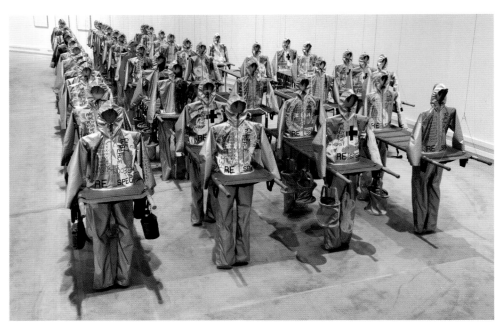

Urban Life Guard N°0317, 2005

city as a mirror from which he reflected his now-familiar vocabulary of images onto the surface of the churches and palaces along the Grand Canal. A poetic response, the overlapping of images prompted alternative readings and personal interpretations of these emblematic structures.

Working together under the signature Lucy + Jorge Orta, the artists continue to generate projects that inspire communal interaction and exchange. *70 × 7 The Meal*, a project now in its thirty-third act, brings people together "to meet, to talk, and to share a moment of reflection." Each act of *The Meal* is for seven guests, who in turn invite seven others, and so on, as a symbolic reference to the biblical notion of infinity, in which an idea has no end, no limit, and no boundary. The project was inspired by the work of Padre Rafael García-Herreros, who organized a series of banquets in the 1960s to raise money for a social development project in Bogotá, Colombia. Reinterpreted by Lucy and Jorge, *The Meal* continues to provide an opportunity to bring communities together and share experiences. In 2000, in Dieuze, northeast France, three thousand people—the entire population of the town—picnicked at a table that ran the length of the main high street, and in 2001 nine hundred guests dined at three locations in Mexico City (including one of the city's oldest convents). The following year, 168 people drawn from different sociocultural groups and nationalities dined together, seated at tables set in a circle in the Waltherplatz, the central piazza of Bolzano, Italy. In 2009, seventy local residents were invited to dine with Lucy and Jorge as well as artists Anne-Marie Culhane and Jo Salter at the Sherwell Church Hall, Plymouth, England, as part of a research project studying rural farming.

 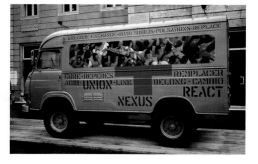

Mobile Intervention Unit, I + II, 2001

Key to Lucy and Jorge's work is their understanding of the need for novelty and surprise in daily life as a way to facilitate cross-generational cultural exploration and social interaction. Working with an ambidextrous approach, they create scenarios based on everyday activities and interactions that provide opportunities for reflection, connecting with audiences through projects that have a universal appeal. The result is a diversity of projects that tackle challenging issues and offer alternative modes of interpretation as a catalyst for social change.

The Ortas' work owes much to historical artistic practices. Their work is rooted in the "happenings" of the 1960s, when artists such as Allan Kaprow, Jim Dine, and Red Grooms devised performances and events that engaged viewers as active participants in their work—whether on a literally physical level through built structures or more viscerally through movement, sound, and light—in an effort to stimulate both emotional and intellectual responses. Correlations can also be made between their work and that of artist Gordon Matta-Clark, who in the mid-1970s famously focused his attention on Manhattan's postindustrial waterfront with works such as Day's End (Pier 52), for which he cut a crescent-shaped hole into the wall of a warehouse on a pier at Gansevoort Street. His action opened up unexpected views across the Hudson River and prompted rediscovery of this largely forgotten area of the city. In addition to these earlier precedents, alignments can also be drawn with artists working today. These include Francis Alÿs, an artist based in Mexico City. Taking cues from the Situationists—whose unplanned dérives, or "drifts," through the streets of Paris in the 1960s fostered new readings and interpretations of the urban structure—Alÿs creates work that deals with issues of place. For a piece called When Faith Moves Mountains, he enlisted the help of five hundred volunteers armed with shovels in a rural area near Lima, Peru, to move a sand dune four inches, essentially remapping the landscape of this area through physical labor. Other works are more directly political, such as Sometimes doing something poetic can become political and sometimes doing something political can become poetic, from 2005, in which Alÿs walked from one end of Jerusalem to the other, carrying a can that dripped green paint. The line of

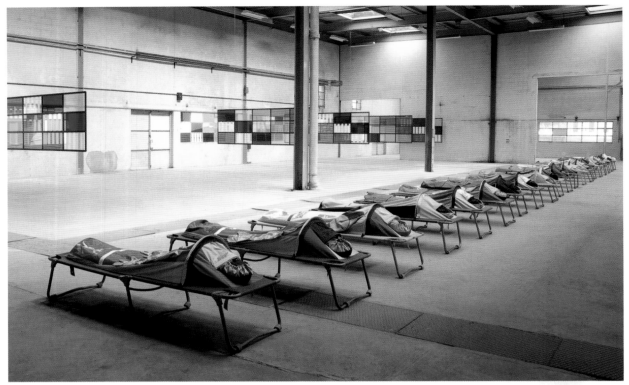

Urban Life Guard, 2008

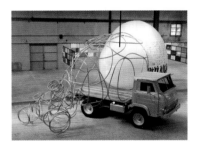

Dwelling X, 2004

dripped paint marked the original Green Line, the border zone determined after the 1948 Arab-Israeli War that indicated land under the control of the new state of Israel, which has since continued to be a site of political conflict. Relationships between Lucy and Jorge's work and those of other collectives such as the Copenhagen-based N55 are also apparent. For their *Land* project, N55 took small plots of land they acquired from regions as varied as northern Norway and the California desert, and then relocated these plots to more populated areas of Denmark, The Netherlands, and Switzerland, as well as to the discarded wastelands of cities such as Chicago, ultimately dedicating the relocated land for public use. In these projects, an emphasis is placed on energizing our relationship to the world around us.

Correlations can also be made between Lucy + Jorge Orta's work and ongoing dialogues centered on critical design, a sphere of practice predominantly associated with London-based designers Anthony Dunne and Fiona Raby, who cite the importance of the conceptual underpinnings of design, as well as the field's potential as a catalyst for debate. Like Lucy and Jorge, they use products and services as a medium to stimulate discussion among the public and industry about the social, cultural, and ethical implications of objects. Many of their projects are collaborative and derive from research undertaken at the Royal College of Art, where Dunne heads the Design Interactions program. Their works—such as *Huggable Atomic*

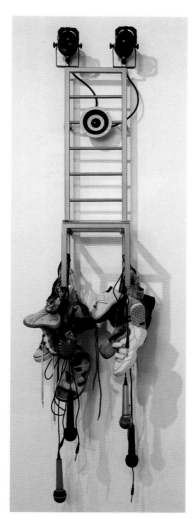

Fallujah—Press Conference Al Jazeera, Study, 2007

Mushroom (2004–5), which you can cuddle if you're worried about a nuclear attack, and *Hideaway Furniture* (2004–5), composed of a series of wooden boxes in which you can hide during times of trouble—address the dangers and fears in our lives, responding to current social and political conditions.

Fundamentally, what binds the output of these artists and designers is an interest in exploring the evolution of the underlying principles of contemporary society, exploiting their inherent properties for reexamination. Lucy + Jorge Orta, however, wish not only to conceptualize these issues through provocative modes of representation, but to discover the functional possibilities of art. By mining a diverse spectrum of artistic disciplines, they provide tools for eliciting change. "We act as a trigger mechanism," argues Jorge, raising awareness of global issues, generating a culture of debate, and ultimately inciting action. As their work indicates, Lucy + Jorge Orta are not afraid to engineer projects that are hard-hitting, both conceptually and in their distinctive visual grammar. Rather than providing a one-solution-fits-all approach, their projects are tailor-made and reference multiple creative disciplines as a call to arms for more collective and imaginative solutions to issues affecting lives worldwide. By imbuing their output with a comprehensible set of symbols that speak to the underlying themes in their work, they make evident the powerful part that images and objects play in our daily lives and the way in which they define the relationships we have with one other and with the world at large. Realizing that their role is only part of the solution, however, Lucy and Jorge rarely work alone, but endeavor to develop teams of experts from multiple fields to contribute to developing projects with a strong message founded on real-life situations and research.

This collaborative aspect of their practice and their interest in fostering experimental research has encouraged them to embark on their most ambitious cooperative project to date, the establishment of an arts center at Moulin Sainte-Marie, a former paper mill in the Brie region of France, just thirty-one miles from Paris. Envisioned as a site for artist-in-residence programs, exhibitions, installations, workshops, and other related practices, the scheme builds on a smaller-scale version of their vision, currently housed in a former dairy nearby, where they have worked on projects with artists ranging from Andrea Zittel to Mark Dion, as well as master's students, educators, and curators from a range of institutions worldwide. Housed across a sixty-acre site, the new complex has the potential to be one of the most influential and vibrant arts organizations worldwide, providing a fixed address for both Studio Orta's productions as well as the work of others interested in similar methodologies and approaches. Currently in development, the project, a multiyear work in process, demonstrates Lucy + Jorge Orta's unwavering commitment and willingness to continuously test the boundaries of their practice in an effort to encourage a new paradigm for collective research and creative output.

FOOD

Food Service:
Setting the Table

Ellen Lupton

Imagine a plain white dinner plate. Printed on the edge is the simple icon of a Red Cross ambulance. If you flip over the plate, searching for a clue or explanation, you will find a full-color press photo showing a scene of displacement, famine, or poverty. One is a portrait of African refugees, their arms burdened with empty water jugs. A thin red crosshair cuts through the image.

The ambulance plate is from a set of seven, produced in an edition of thirty-five in 2002 by Lucy + Jorge Orta for *70 × 7 The Meal*, a series of large group dinners held in public places around the world. The setting, guest list, menu, and plates change from meal to meal, but key elements link the dinners into an ongoing endeavor. Each meal is served on special dishes, some conceived for the event and some borrowed from previous gatherings. A custom-printed fabric runner unifies the banquet tables with a ribbon of color, stretching for hundreds of meters through a cityscape, around a monument, or inside a gallery. Servers wear lime-green, screen-printed aprons. Seven guests invite seven other guests, the group multiplying to populate the scene with people from different social groups: artists, politicians, patrons, farmers, activists, and neighbors. The printed pieces—plates, aprons, table covers—anchor the occasion around a layered language of images and objects. The art lies in the social gathering, pinned into memory by artifacts designed for functions both poetic and mundane.

As a design critic and curator, I am drawn to the collision of ordinary purpose and extraordinary meaning in the work of Lucy + Jorge Orta. In project after project, useful objects mix and propagate to create dynamic assemblies of people, places, and things. Each project channels energy from familiar objects to fuel social experience, trading up the currency of familiarity to change the way we look at everyday life processes.

How does an apron function? At its most basic level, it shields the wearer, protecting the clothes worn underneath. As a social symbol, the apron serves as a uniform, a badge of duty that conveys status and responsibility. It is a unifying mark that ties one event to others.

How does a tablecloth function? Like an apron, its practical purpose is to conceal and protect. Symbolically, it cloaks a plain surface with the trappings of ceremony. At a large group function, it connects a legion of separate tables, unifying space with color, turning many into one.

How does a plate function? Again, like the apron and the tablecloth, it is a membrane of separation between the clean and the unclean. It cradles and divides, protecting the food it holds from the surface underneath. It marks a personal space, distancing people while bringing them together with a shared pattern. A plate conveys messages and meaning using shape, materials, and ornament to speak about taste, history, and custom.

A well-dressed table elevates the status of any occasion, changing how people behave and what they will remember. Table settings transform eating into dining, an orchestrated social ritual. Amplifying the familiar signifiers of decorum, Lucy + Jorge Orta strive to set the table with unexpected intensity. Aprons and runners become banners or flags, vivid beacons that lead the charge rather than holding back in servitude. Dinner plates arrive laden with semiotic abundance: text, diagrams, icons, and voluptuous drawings of hearts and artichokes, symbols of human aspiration that speak to the difficulty, says Lucy, of "reaching the center."

Leftovers

Lucy Orta started experimenting with food service in her 1996 project *All in One Basket*, for which she gathered discarded produce from Paris street markets to make into pickles and jams. At the end of each market day, vendors throw damaged, unsold fruits and vegetables into the gutters, where they are washed away as refuse. Orta began collecting and preserving this condemned produce, packing her home-brewed concoctions in glass jars labeled with the food's urban provenance. She displayed these reclaimed foodstuffs in various ways, including in simple wooden boxes lined with dramatic photographs of abundance and waste. In another piece, she used a single eight-foot-long shelf to organize a row of jars into a linear record of the seasons, from cherries in May to eggplants in November.

Seeking to engage audiences more directly, Orta invited a famous Parisian pâtissier, Stohrer, to create jams and purees to share with the public. The project was hosted in 1997 by a small gallery located in a church near Les Halles, formerly the site of a major fruit and vegetable market, now a shopping mall. While the public sampled the reclaimed food products out on the street, the gallery displayed boxed reliquaries and mobile pantries equipped with audio recordings of gleaners Orta had met on the street. Most of these gleaners were poor, while some were students and others were people who simply stopped to pick up food off the ground. Some homeless people dismissed the practice altogether, explaining that gleaning is only for those rich enough to have a refrigerator and a place to keep their found provisions.

Wasted food is hardly unique to Paris. Grocers and street vendors in prosperous societies around the world routinely discard milk, bread, produce, and other foods that are deemed unfit for sale or simply in over-supply. Sellers commonly pulp or contaminate unsold food, destroying it lest it diminish demand for fresher goods. Saving food for those too poor to shop requires a system for collection and distribution—it takes effort to recover value from a bruised apple or a redundant cucumber. The city of Munich provides bins to help vendors salvage and sort refuse, while New York's City Harvest, a private organization, delivers food from restaurants to shelters

and soup kitchens. For *HortiRecycling*, a project in Vienna, Lucy Orta provided market vendors with brightly colored, screen-printed totes, which served as handy food-recycling receptacles for the vendors while advertising the process as it took place. Lucy and Jorge created mobile kitchens out of shopping carts and utilitarian hardware elements that enabled them to collect, clean, and cook food right on the street when hooked up to water and electricity in the marketplace.

Trigger Objects

As in many Studio Orta projects, *HortiRecycling* and *All in One Basket* yielded a variety of constructed objects—rolling carts, mobile kitchens, and shelves stocked with preserved vegetables—as well as live social engagements. Primitive kitchens appear in other Orta projects as well, including *Antarctica*, an ambitious expedition that used the accoutrements of Antarctic exploration to speak of rootless existence in a not-yet-sovereign territory. *Antarctica* includes a series of parachutes laden with emergency supplies, including a floating kitchen that bears clattering clumps of cooking utensils.

Such physical objects concretize the Ortas' social activities, serving as physical repositories of events. Each object provides an additional way for people to engage in the process of the work, whether viewing it in a gallery or purchasing it to take home. While larger-scale objects play a role in the collectors' market and the museum world, Lucy + Jorge Orta's smaller items are affordable to people who might not otherwise purchase a work of contemporary art. A dinner plate or a jar of pickles offers a lasting memento of an event intended to change perceptions of everyday activities (eating, dining, cooking, shopping).

These simple objects resemble everyday things with everyday functions, while the more elaborate constructions (tents, garments, life jackets, architectural structures) often have little or no real utility, employing forms and materials in excess of what might be needed to complete a task. In an interview with Lucy Orta, curator Nicolas Bourriaud suggested the term "functioning aesthetics" to describe the studio's work, but she interjected the phrase "operational aesthetics" instead. The French word *fonctionnel* is equivalent to the English word "functioning," thus bearing connotations of blunt instrumentality and lacking any dimension of poetic surplus and cultural critique. The Ortas began using the word "operational" in connection with their ongoing project *OPERA.tion Life Nexus*, an endeavor that uses workshops and large-scale projects to raise awareness of organ donation around the world. "Opera" suggests a larger collaboration with curators, scientists, technical experts, and others. "Operation" suggests an open process, perhaps with unknown results—a sequence of possible actions rather than a solution to a given problem.

Lucy Orta is often asked if she is a designer. Her answer, insistently, is no. And yet the studio's methodology bears strong affinities with design practice, and Orta is no stranger to the profession. She trained as a fashion designer at Nottingham Trent University and worked professionally in Paris for more than a decade, specializing in knitwear for men. Jorge Orta studied simultaneously at the faculty of fine arts (1972–79) and the faculty of architecture (1973–80) of the Universidad Nacional de Rosario in Argentina. Many of the Ortas' project drawings resemble design drawings, with detailed instructions to be executed by a fabricator, complete with measurements and material samples.

Despite Lucy's strenuous disavowal of the field today, she is a model and inspiration for many designers. She is a professor of Art, Fashion and the Environment at the London College of Fashion, University of the Arts London, and her work has been featured in numerous volumes on experimental fashion. From 2002 to 2005 she was head of the Man & Humanity master's course at the Design Academy in Eindhoven, where her colleagues included Hella Jongerius and other leading designers. Jongerius, whose projects range from stitched ceramics and soft silicone vases to factory-made dinner plates with built-in flaws and irregularities, seeks to upend expectations about how materials behave. While Jongerius focuses on the physicality of material goods, the Ortas address their social effects. The objects are not ends in themselves, but rather "trigger objects" designed to function as social catalysts, moving people to think and act in new ways about familiar processes. While Jongerius puzzles over the sculptural form a dinner plate, the Ortas treat their dishes as generic blanks. The basic plate form selected for the ongoing 70×7 project has no articulated rim, offering up a seamless ground for text and image. As physical objects the plates are elegant but interchangeable; variations result from context and conversation, food and message.

Studio Orta is sometimes identified with "relational aesthetics," a term coined by Bourriaud to describe anti-monumental art practices based in everyday social activities. A key figure for Bourriaud is Rirkrit Tiravanija, who began cooking and serving Thai food inside gallery spaces in the early 1990s, as well as Gordon Matta-Clark, who founded the restaurant Food in 1971. Matta-Clark's legendary meals included *Bones*, a repast consisting of frogs' legs, oxtail soup, and roasted marrow bones. Such works emphasize art's capacity as a publicly consumed, socially shared experience. Studio Orta takes that experience out of the gallery and onto the street (or into the canal, the prison, the natural history museum, or the frozen landscape of Antarctica). The first 70×7 meal took place in the French town of Dieuze in 2000. A local youth center wanted to bring together people from the town and asked Lucy+Jorge Orta to participate. A tablecloth, screen-printed by hand in the artists'

studio on long rolls of nylon fabric, snaked through the town, tying together dozens of tables into one vast communal picnic. The event was advertised via newspaper to the village's three thousand residents, and streets were closed to traffic. All guests received tickets entitling them to buy their own dinner plates if desired. Although the organizers initially objected to the idea of using and selling real china dishes (too expensive, too difficult), more than 750 plates were sold, attesting to the enthusiasm of the guests and their eagerness to hold on to the experience.

Since then, each meal has pursued its own social and culinary agenda. An event focused on foraging featured *panna cotta* made with algae as a thickening agent as well as a variety of roots and greens gathered from local fields and forests. A dinner held in collaboration with Italy's Fondazione Slow Food focused on the plight of the Andean potato, a threatened staple of Argentina's local economy. Staged in the restored Venaria Reale, a regal palace in Turin, the event featured tables piled with carrots, potatoes, peppers, garlic, celery, zucchini, and more. During the dinner, a team of cooks cut and trimmed the vegetables, packing bags for guests to carry home and make into their own soup.

The most spectacular dinner in the series has been planned and visualized but not yet held: spanning London's Millennium Bridge, the dinner would cross the Thames with a continuous, red-clothed dinner table, linking two halves of the city via a shared meal. After breaching the river, the tables would meander through other public areas, seating upwards of five thousand guests. Commissioned by ixia, a public art think tank in the United Kingdom, the project exists through written plans and carefully simulated photomontages, published in book form as a kind of model or manual for how to conceive and execute a large-scale urban art project.

A Seasonal Practice

While the London dinner party remains, for now, a virtual proposal, most Studio Orta projects are resolutely concrete. The couple's artistic enterprise revolves around a hands-on studio life. In contrast, many artists today work primarily from their computers, arranging the fabrication of pieces via phone and email and relying heavily on galleries to store their work and look after the details of shipping and installation. Although the Ortas' pieces are fabricated in part by specialists in metalwork, porcelain manufacture, and tent-making, most works are finished by hand in their studio spaces, which include a reclaimed dairy in the Brie region east of Paris and a small building near their home in the city.

The dairy, built in the late 1900s as one of the first industrial dairies in France, is now the site of a new kind of industry. It serves as a shipping dock, storage unit, and screen-printing workshop, as well as the site for woodworking, plaster casting, painting, and

assembling. One small room in the dairy is stocked with box after box of carefully labeled plates from the dinner series, available for purchase by collectors or for use in future 7 × 70 meals where funds aren't available to produce custom plates. The Ortas are also leading the development of a pair of former paper mills—Moulin de Boissy and Moulin Sainte-Marie, located three kilometers from the dairy—into a state-of-the-art network of galleries, artist studios, a research center, and public parks, giving this rural community a new identity and revived economic opportunities. Meanwhile, the unheated dairy has minimal amenities, making it usable only in warm weather. Thus the Ortas write, draw, and think in the winter and build, print, and assemble in the summer, working with a team of assistants who come and go as the weather changes. Following an intense cycle keyed to the seasons, Studio Orta is a family-run farm whose produce happens to be contemporary art.

The Ortas' public dinners and experimental kitchens coincide with a worldwide renewal of interest in the politics of food. Communities around the world—working from the scale of global food networks down to local methods for farming and cooking—are seeking ways to make the food system better serve the needs of people and the planet. After decades of success in the production of massive quantities of cheap food, policymakers and citizens are recognizing the environmental and social costs of this process. The over-industrialization of food has forced small farms to surrender to agribusiness, reduced biodiversity in favor of monoculture crops, and assaulted communities with debilitating chronic diseases. Studio Orta illuminates issues of scarcity and waste while drawing people into a reflective experience of eating, drinking, cooking, and dining. The experience is a collective one, engaging individuals in a public process.

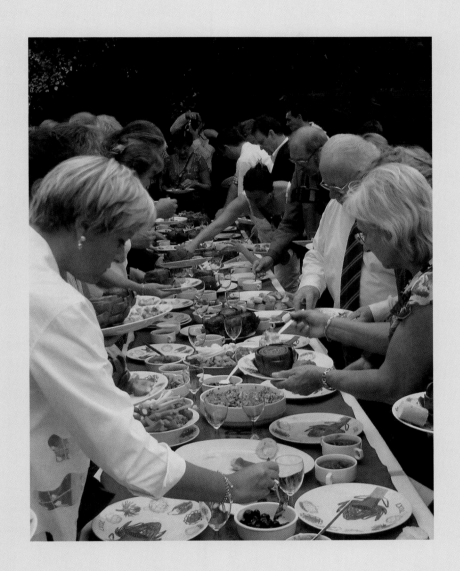

All in One Basket, act I, 1997
Buffet of compotes created from discarded fruit
from local markets and cooked by Parisian
pâtissier Stoher, to coincide with the opening of
the solo exhibition *Dans Le Meme Panier* at
Galerie Saint-Eustache, in Les Halles, Paris,
France.

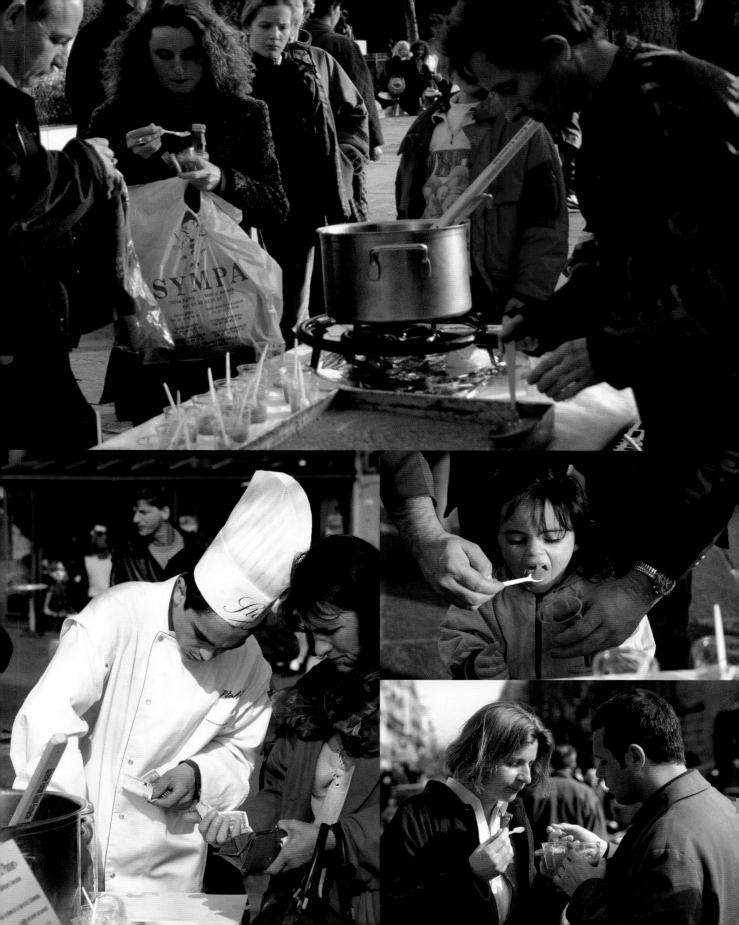

HortiRecycling Enterprise, act II, 1999
Pilot recycling enterprise to collect, transform, and distribute discarded fruit and vegetables in the Naschmarkt, with delicacies cooked by Staud's of Vienna, to coincide with the opening of a solo exhibition at Wiener Secession, Vienna, Austria.

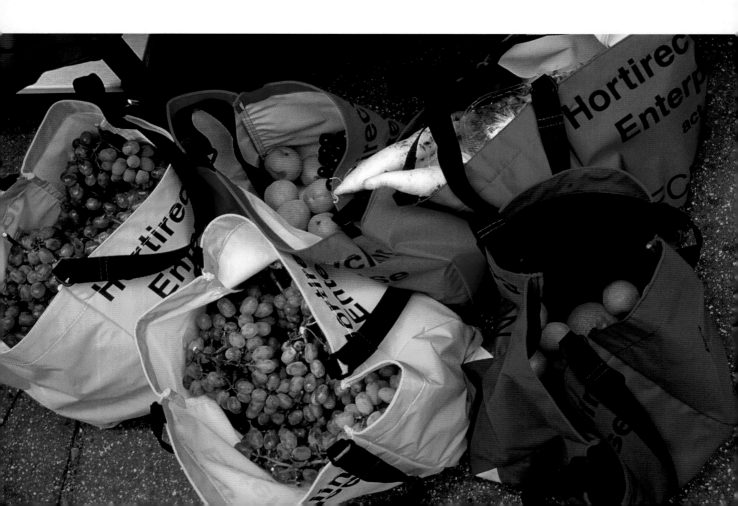

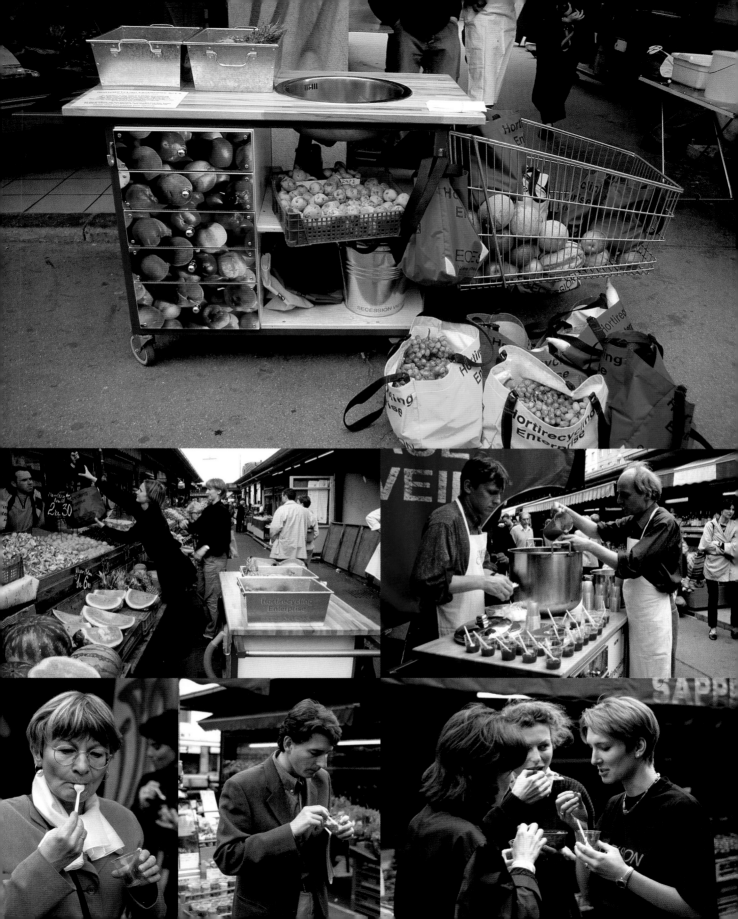

70 × 7 The Meal, act IV Dieuze, 2000
Installation stretching 500 meters from the
salt mine to the town hall for the entire
population of Dieuze, France. Table set for
3,000 guests with silkscreen-printed table
runner and edition of 2 sets of 1,500 Royal
Limoges porcelain plates.

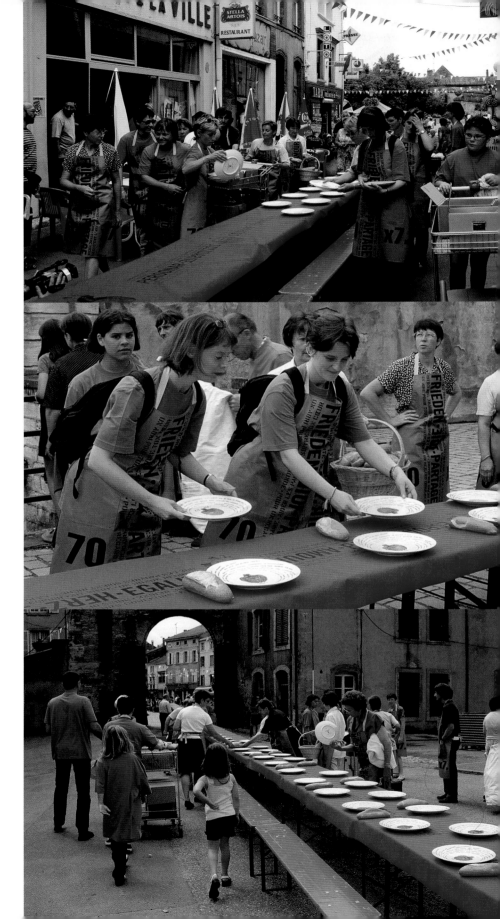

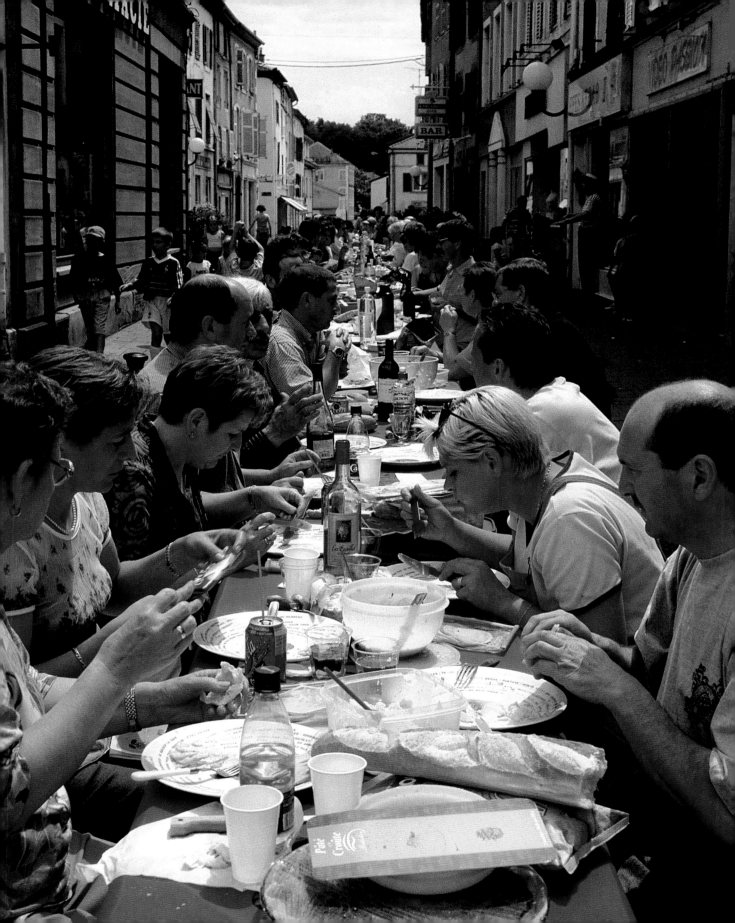

70 × 7 The Meal, act III Innsbruck, 2000
Installation for the exhibition *The Invisible Touch*, to form the setting for 2 dinners in the Kunstraum Innsbruck, Austria, created from discarded organic, local and imported fresh produce from nearby markets. Table set for 14 guests with silkscreen-printed table runner and edition of 490 Royal Limoges porcelain plates.

Beechwood box containing 7 Royal Limoges porcelain plates.

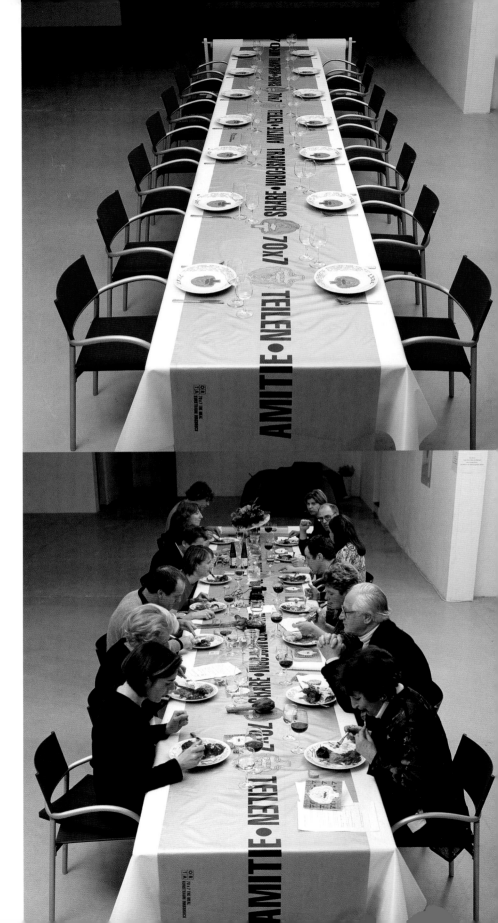

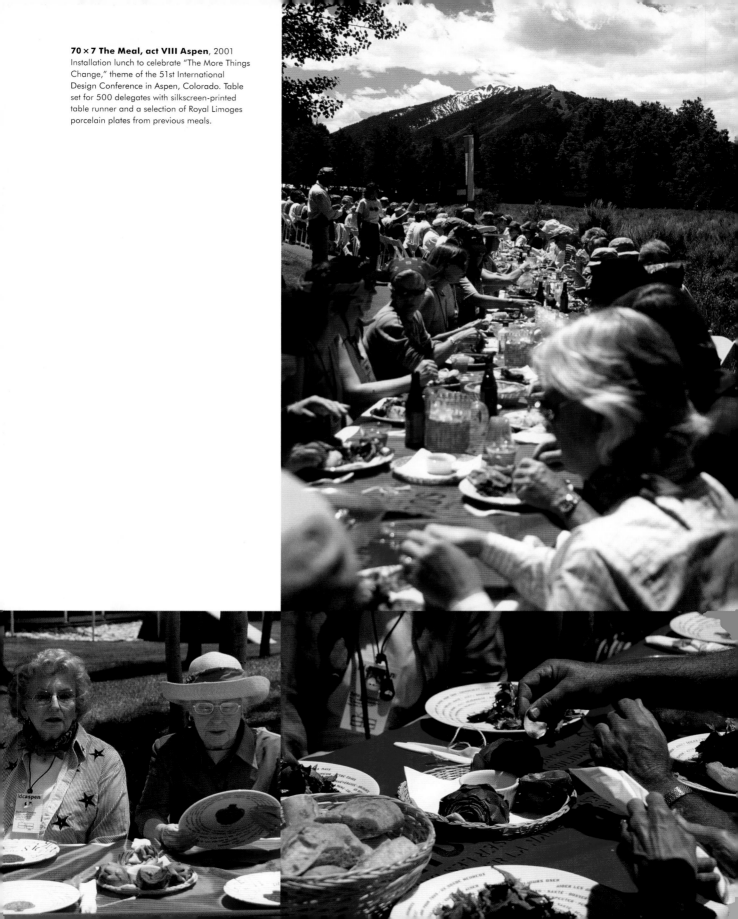

70 × 7 The Meal, act VIII Aspen, 2001
Installation lunch to celebrate "The More Things Change," theme of the 51 International Design Conference in Aspen, Colorado. Table set for 500 delegates with silkscreen-printed table runner and a selection of Royal Limoges porcelain plates from previous meals.

70 × 7 The Meal, act XII Amiens, 2001
Open-air picnic in the Parc de Beauvillé to celebrate the Year of Mexico festival in Amiens, France. Inkjet picnic cloth measuring 1,500 meters, designed to be cut into sections for passers-by.

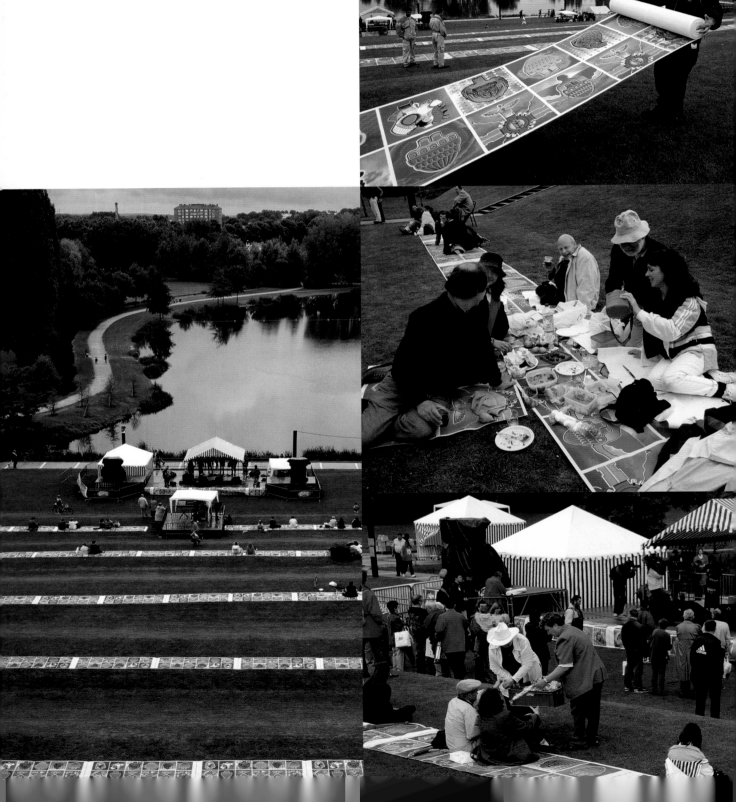

70 × 7 The Meal, act XVI Bolzano, 2002
Installation dinner in Waltherplatz piazza, in the
Province of Bozen, Austria. Table set for 170
guests with silkscreen-printed table runner and
edition of 490 Royal Limoges porcelain plates.

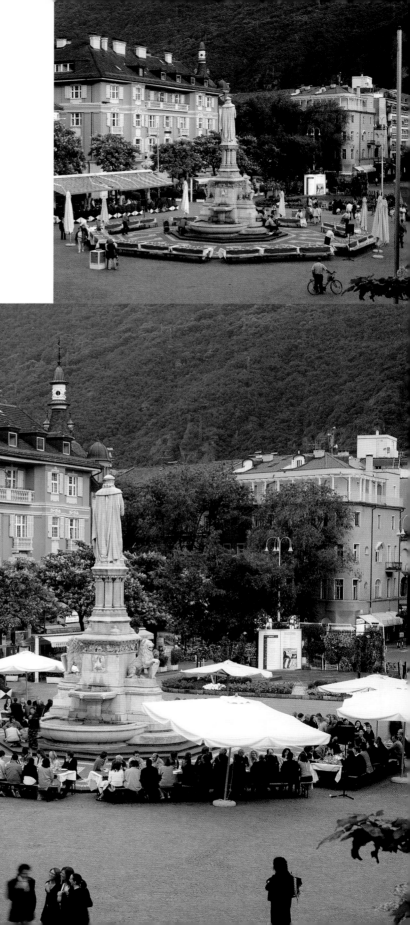

70 × 7 The Meal, act XVII Toulouse, 2002
Open-air picnic along the banks of the
Garonne River to celebrate the annual Rio
Garonne festival in Toulouse, France.
Silkscreen-printed picnic cloth for 400 people.

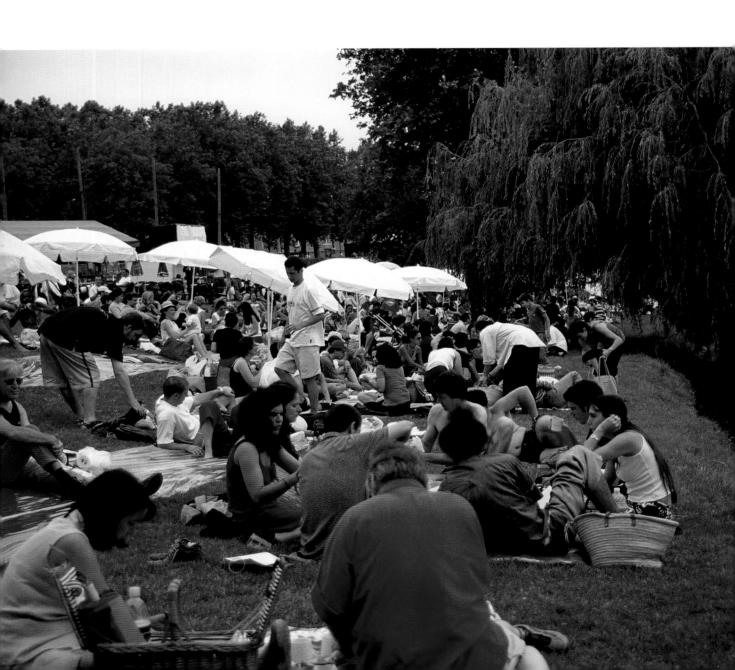

70 × 7 The Meal, act XXII Hasselt, 2005
Installation and open-air buffet in the gardens
of Z33 Centre for Contemporary Art and
Design, to inaugurate the Hasselt Triennial in
Belgium. Buffet table set with silkscreen-printed
table runner and edition of 210 Royal Limoges
porcelain plates.

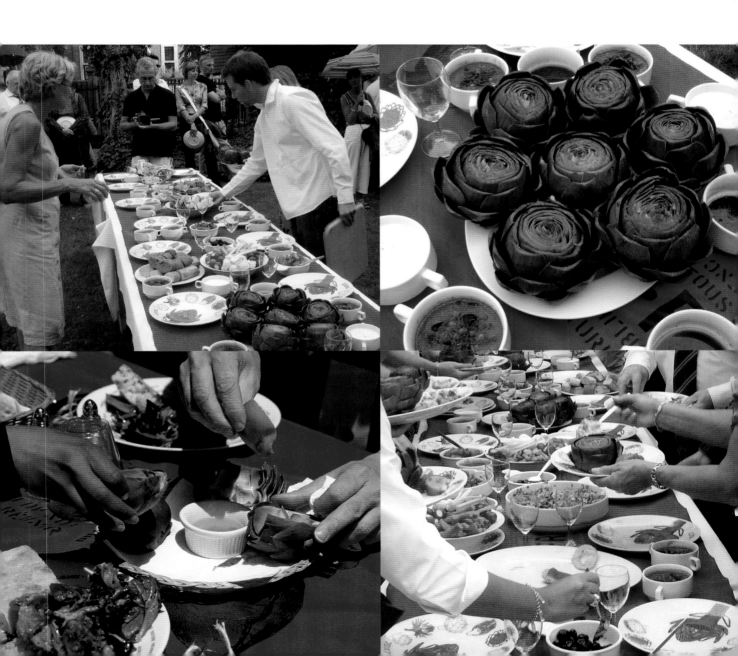

70×7 The Meal, act XXVII Albion, 2007
Installation and fundraising dinner to support
the Medical Foundation for the Care of the
Victims of Torture, and to coincide with
the group exhibition *The Politics of Fear* at the
Albion Gallery in London. Table set for 99
guests with silkscreen-printed table runner and
edition of 100 Royal Limoges porcelain plates
with 7 different designs created in collaboration
with Reza Aramesh, Shilpa Gupta, Kendell
Geers, Rachid Rana, Aveshek Sen, and Xu Bing.

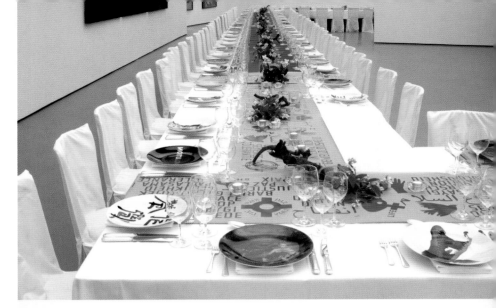

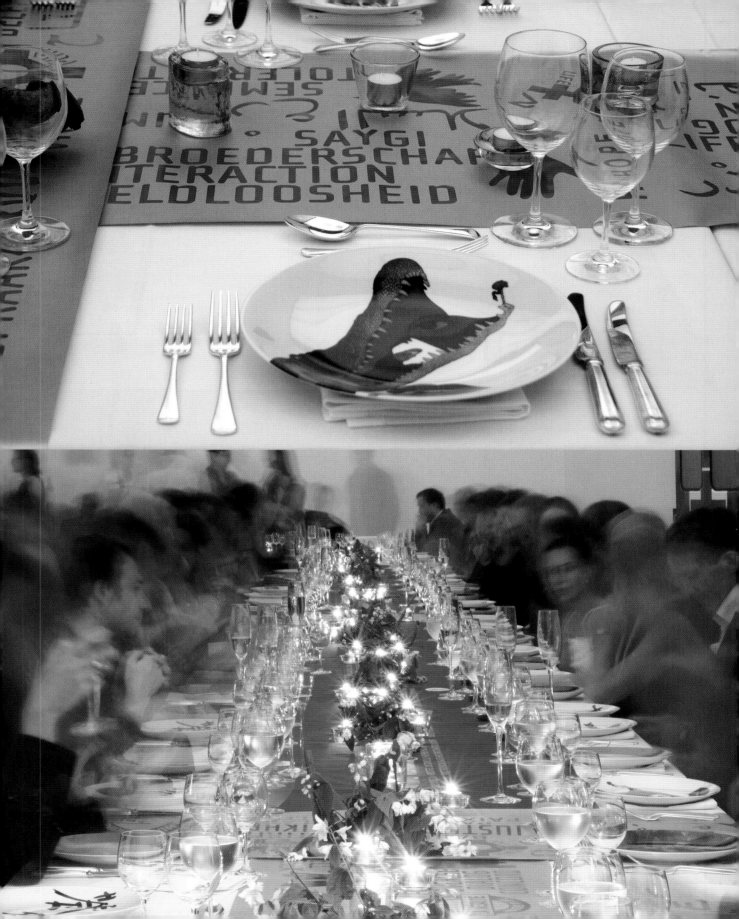

70 × 7 The Meal, act XXVIII Monaco, 2008
Installation and dinner in the presence of His
Serene Highness The Sovereign Prince of Monaco
at the Villa Ephrussi de Rothschild, to launch the
collaboration between the United Nations Art
for the Environment Programme and the Natural
World Museum. Table set for 50 guests with
silkscreen-printed table runner and edition of
100 Royal Limoges porcelain plates.

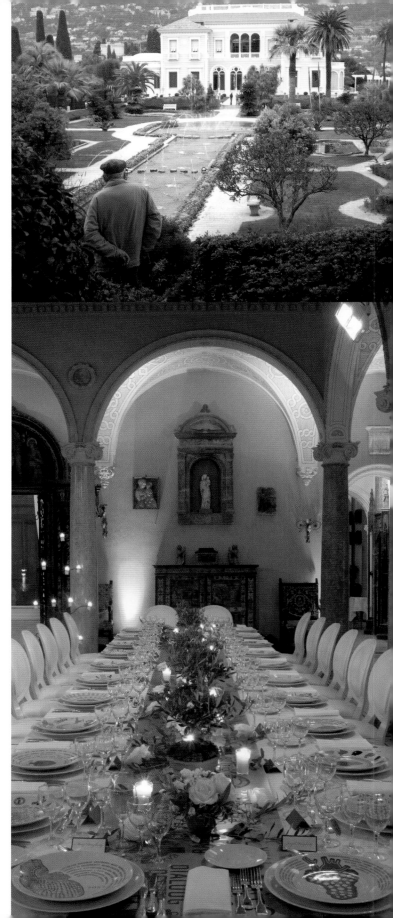

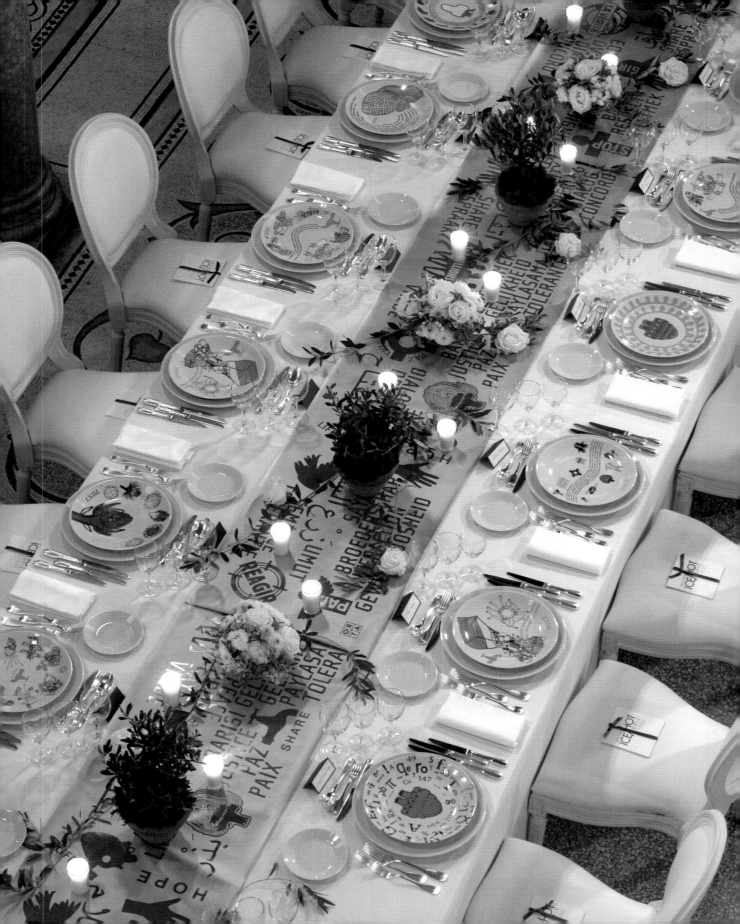

70 × 7 The Meal, act XXIX La Venaria Reale, 2008

Performance and dinner staged inside the historic Savoy palace of Venaria Reale to launch the collaboration with Fondazione Slow Food per la Biodiversità Onlus in support of the Andean potato research project founded by the Cooperativa Cauqueva in Argentina; performance of preparation of basic ingredients for vegetable soup, to be distributed to each guest at the end of the meal. Soup menu created by chef Alfredo Russo, from Dolce Stil Novo. Table set for 150 guests with silkscreen-printed table runner and edition of 150 Royal Limoges porcelain plates.

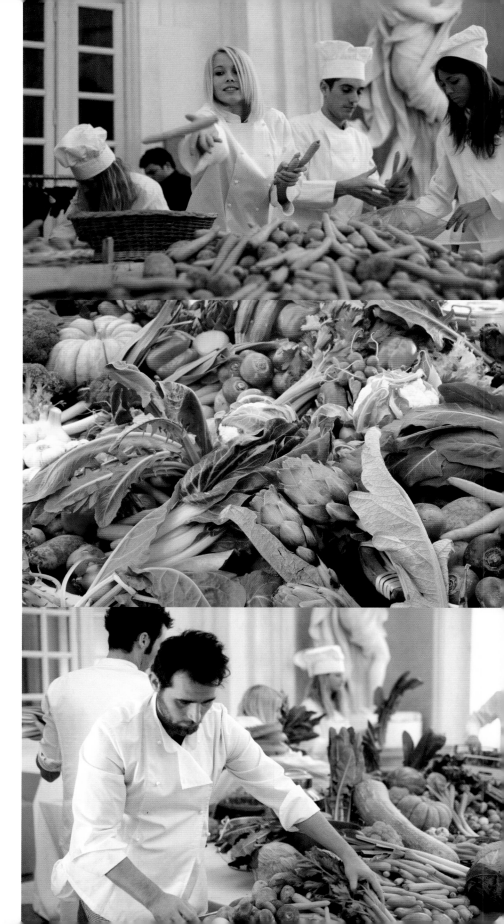

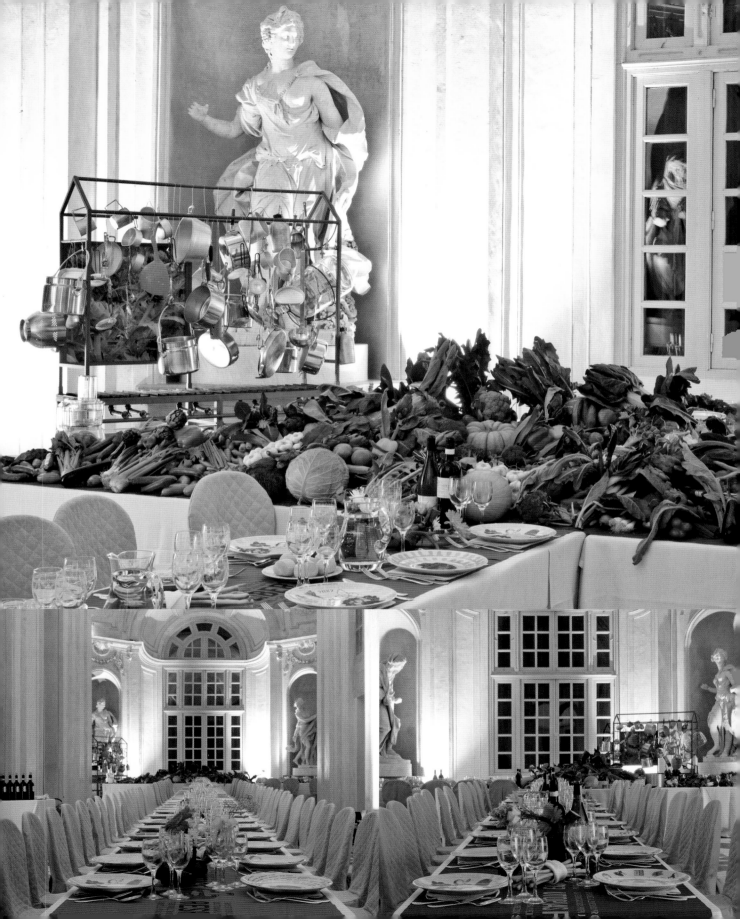

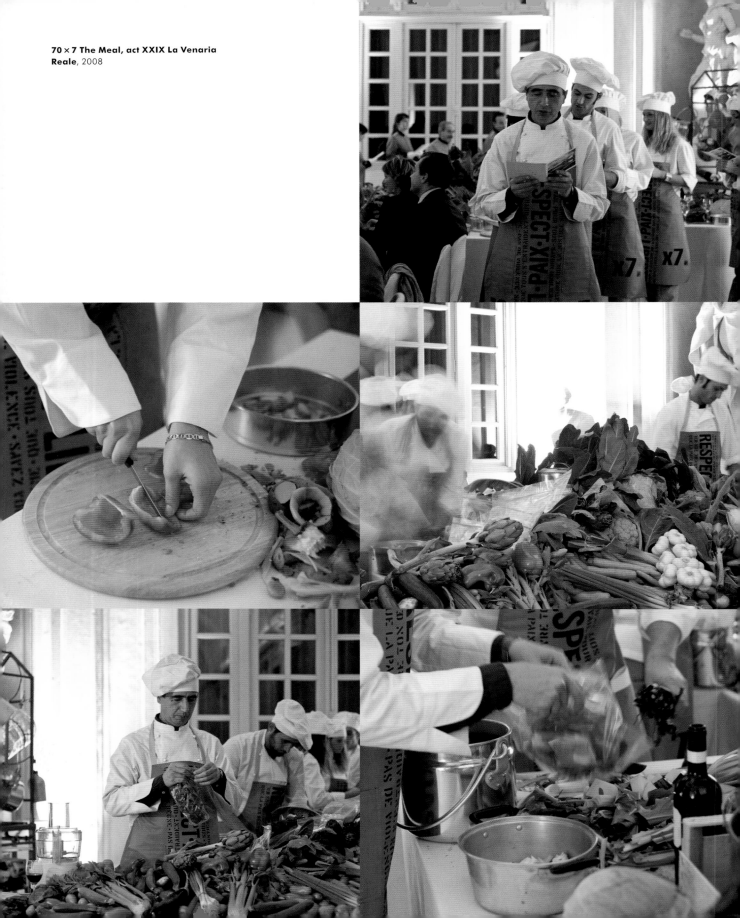

70 × 7 The Meal, act XXIX La Venaria Reale, 2008

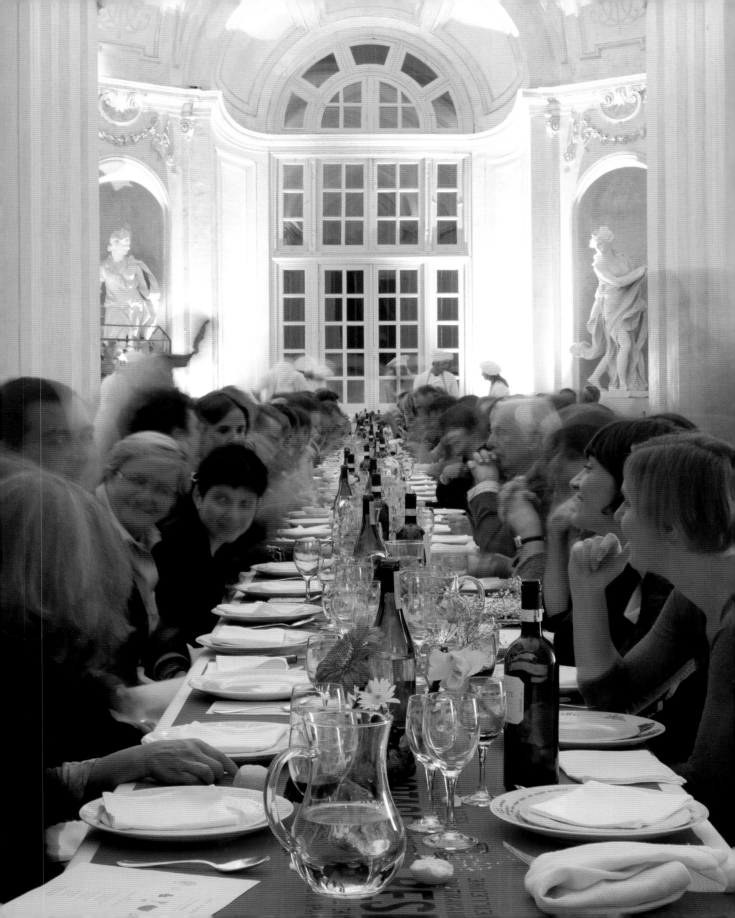

70 × 7 The Meal, act XXXI Plymouth, 2009

Installation and dinner in collaboration with local artists Jo Salter and Anne-Marie Culhane, to celebrate sustainable methods of collecting, preparing, and sharing food. Cooking by Caroline Davey and chef Justin Ashton. Table set for 70 guests with silkscreen-printed table runner and Royal Limoges porcelain plates from previous meals.

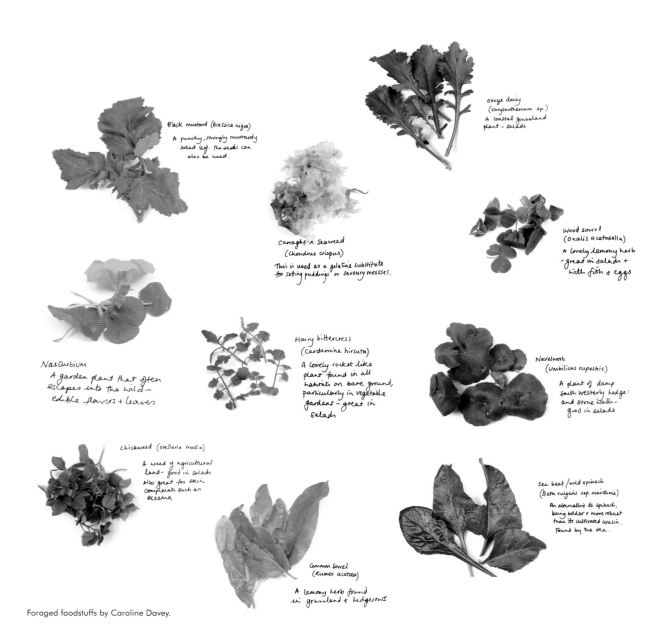

Black mustard (Brassica nigra)

A punchy, strongly mustardy salad leaf. The seeds can also be used.

oxeye daisy (chrysanthemum sp)
A coastal grassland plant - salads

carraghe'n seaweed (Chondrus crispus)

This is used as a gelatine substitute for setting puddings or savoury mousses.

Wood sorrel (Oxalis acetosella)
A lovely lemony herb - great in salads + with fish & eggs

Nasturtium
A garden plant that often escapes into the wild - edible flowers + leaves

Hairy bittercress (Cardamine hirsuta)
A lovely rocket like plant found in all habitats on bare ground, particularly in vegetable gardens - great in salads

Navelwort (Umbilicus rupestris)
A plant of damp south westerly hedges and stone walls - good in salads

chickweed (stellaria media)
A weed of agricultural land - good in salads. Also great for skin complaints such as eczema

sea beet/wild spinach (Beta vulgaris ssp. maritima)
An alternative to spinach, being bolder + more robust than its cultivated cousin. Found by the sea.

Common Sorrel (Rumex acetosa)
A lemony herb found in grassland & hedgerows

Foraged foodstuffs by Caroline Davey.

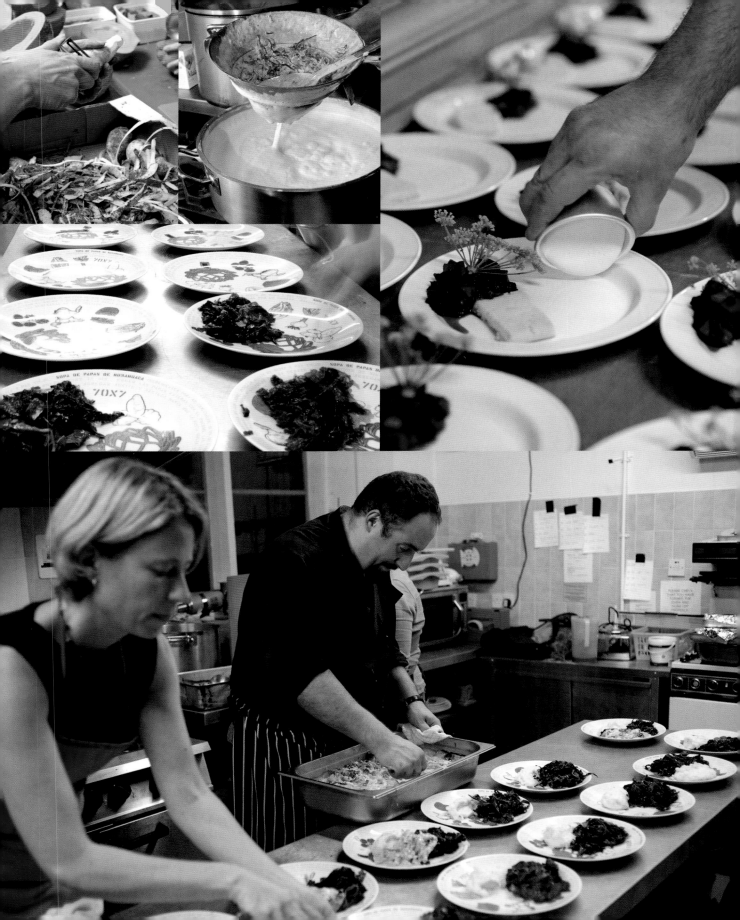

70 × 7 The Meal, act L City of London, 2006–ongoing
Proposal for open-air dinner across the City of London,
from the Tate Modern across the Millennium Bridge
to Saint Paul's Cathedral, along King and Queen Street to
the Guildhall. Table to be set for an estimated 8,000 guests
with silkscreen-printed table runner and edition of Royal
Limoges porcelain plates.

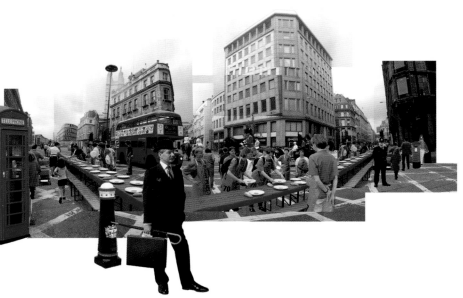

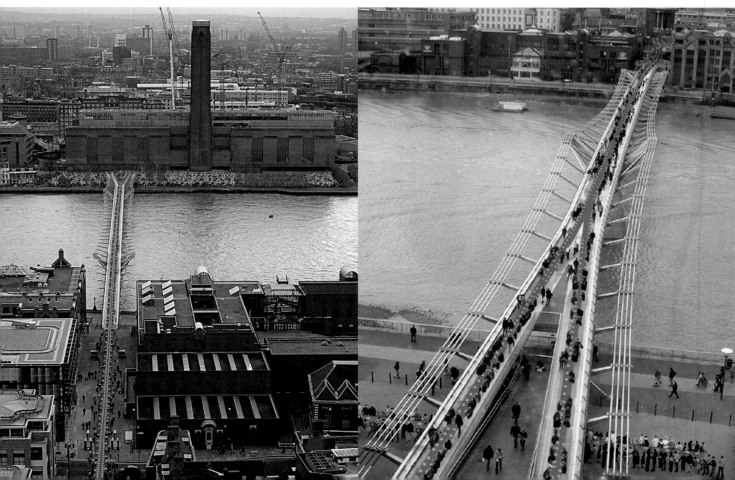

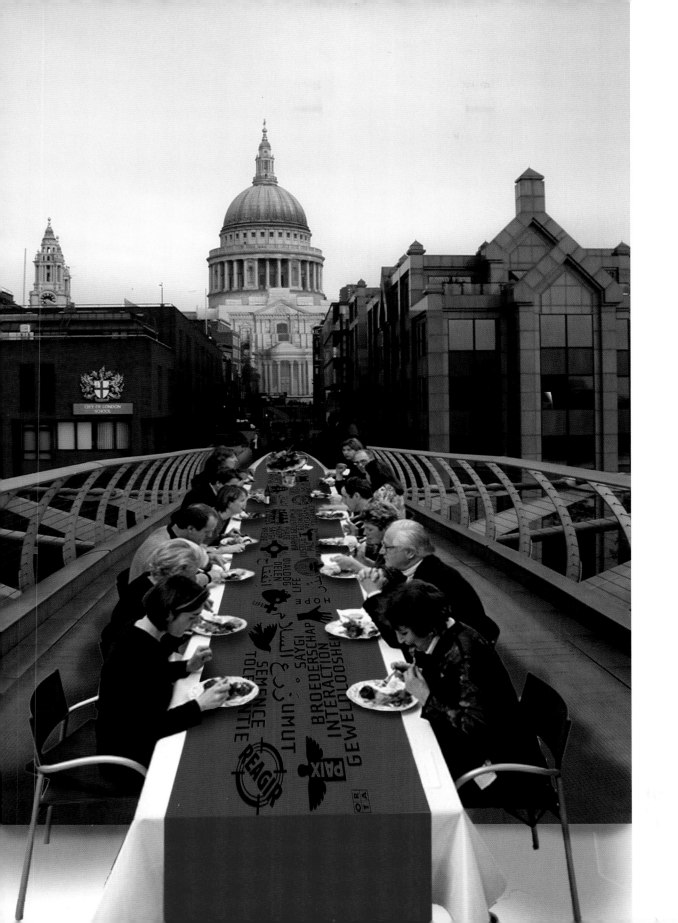

Act III Innsbruck, 2000

Act IV Dieuze, 2000

Act V–VII Mexico City, 2001

Act × Napa Valley, 2001

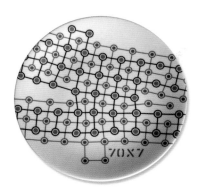

Act XI Antwerp, 2001

Act XIII Colchester, 2001

Act XVI Bolzano, 2002

Act XVII Toulouse, 2002

Act XIX Einhoven, 2002

Act XX UNESCO, Paris, 2003

Act XXI Neude Square, Utrecht, 2005

Act XXII Hasselt, 2005

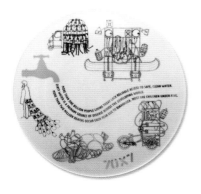

Act XXIII Barbican Art Gallery, London, 2005

Act XXIV ArtAids, Amsterdam, 2006

Act XXV Open House, 2006

Act XXV Open House, 2006

Act XXVIII Monaco, 2008

Act XXVIII La Venaria Reale, 2008

70 × 7 The Meal—Crystal Table, 2005

70 × 7 The Meal, act XXI—Table Runner, 2005

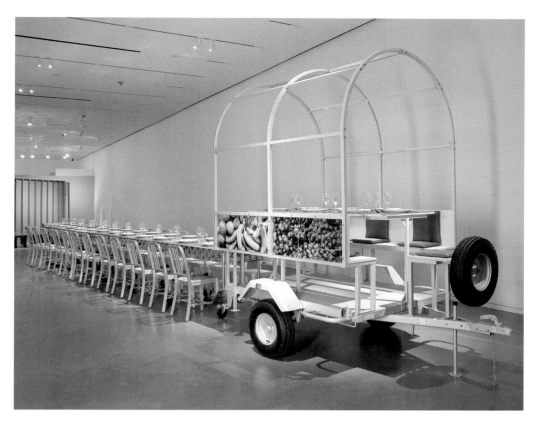

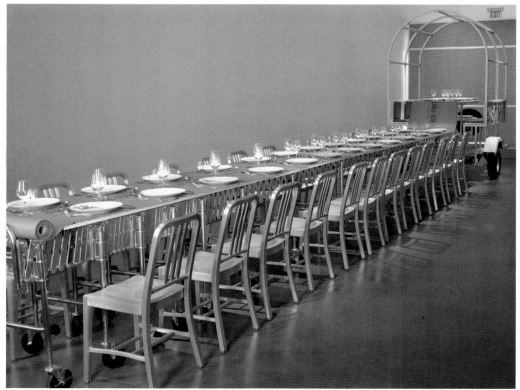

70 × 7 The Meal, act X—M.I.U. V (COPIA, Napa, California), 2002

All in One Basket—Buffet Tables, 1997

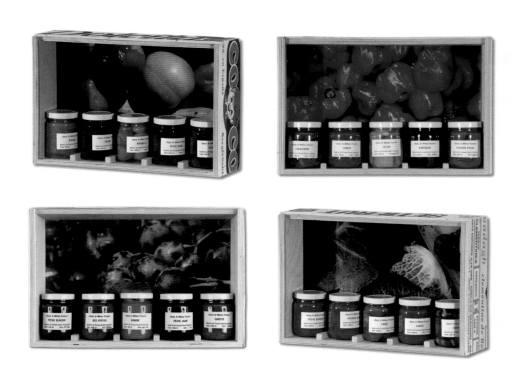

All in One Basket—Reliquary, 1997

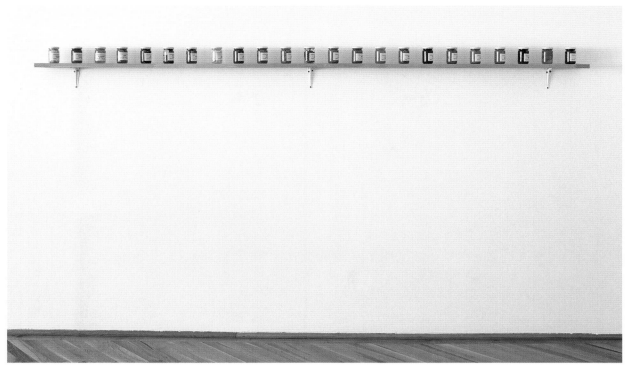

HortiRecycling Enterprise, act II—Reliquary Jars, 1997–99

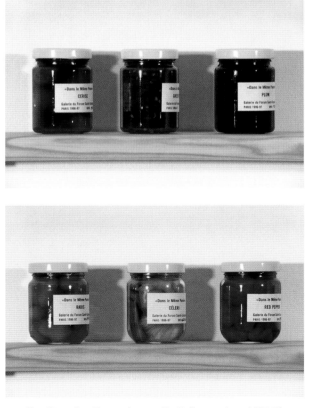

HortiRecycling Enterprise, act II—Reliquary Jars, 1997–99

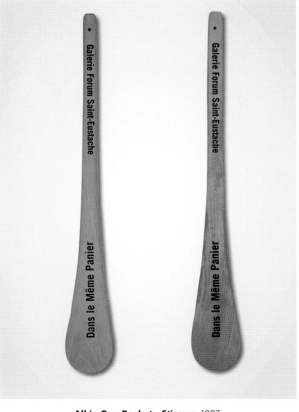

All in One Basket—Stirrers, 1997

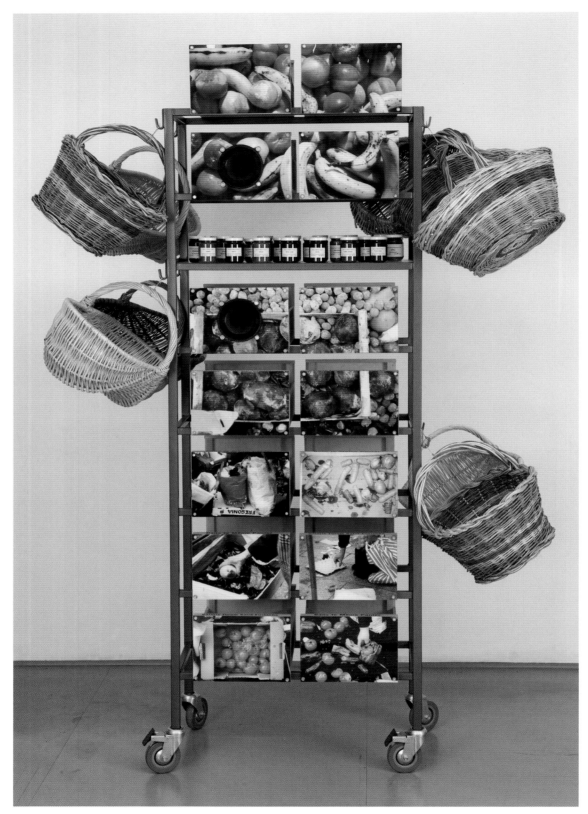

HortiRecycling Enterprise, act II—Conservation Unit, 1997–2005

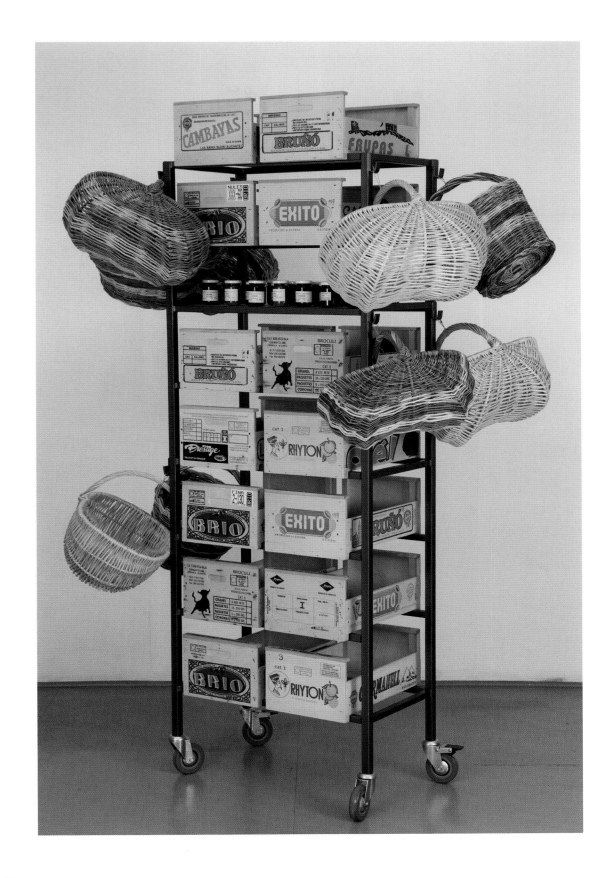

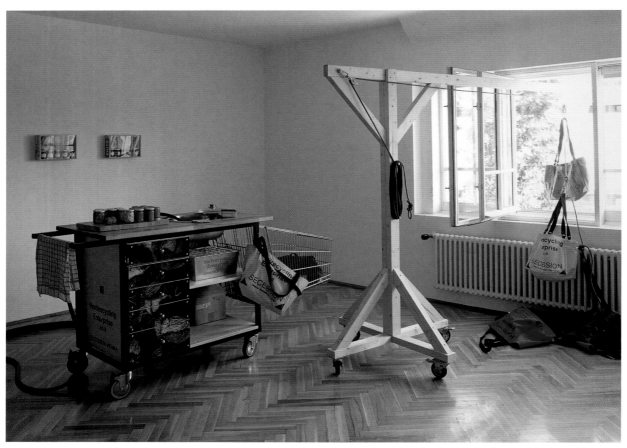

HortiRecycling Enterprise, act II (Wiener Secession, Vienna, Austria), 1999

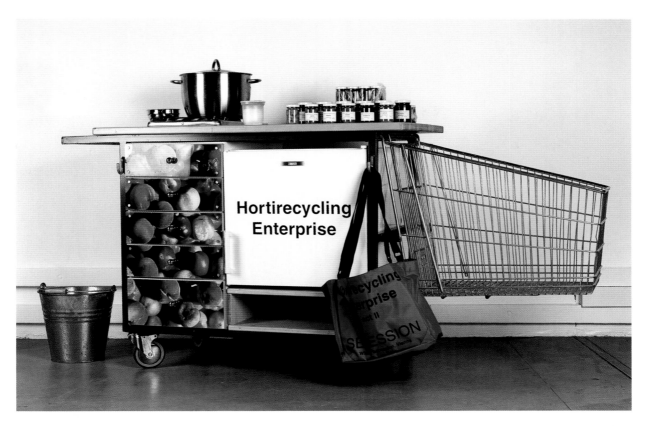

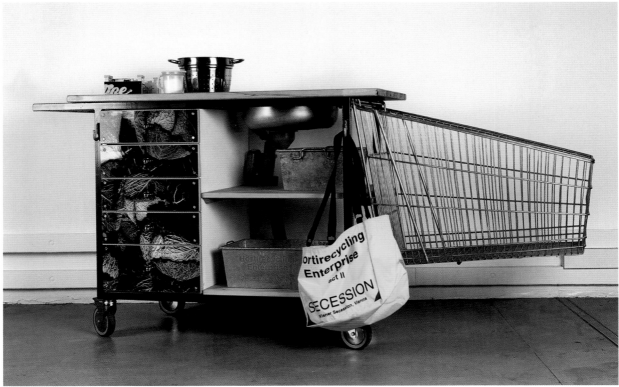

HortiRecycling Enterprise, act II—Processing Units, 1999

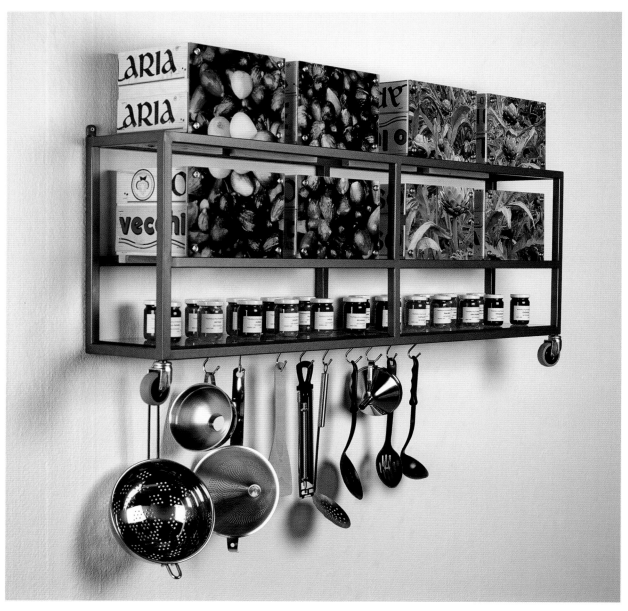

HortiRecycling, 1997–2005

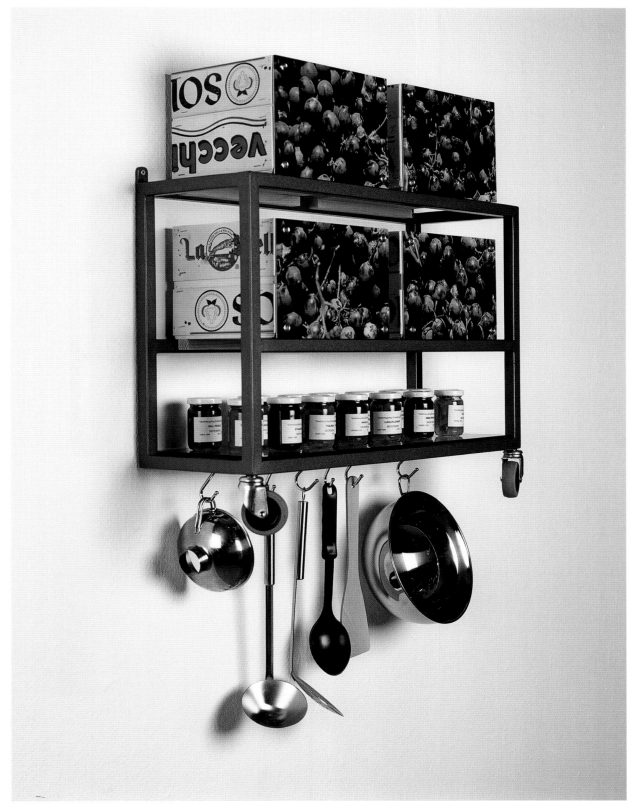

HortiRecycling, 1997–2005

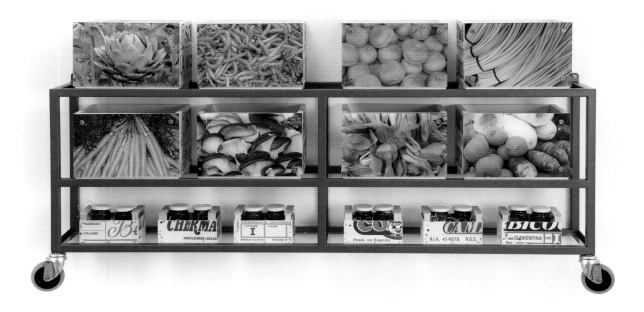

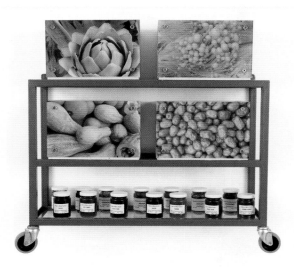

HortiRecycling Enterprise, act II—Vitrines, 1997–2008

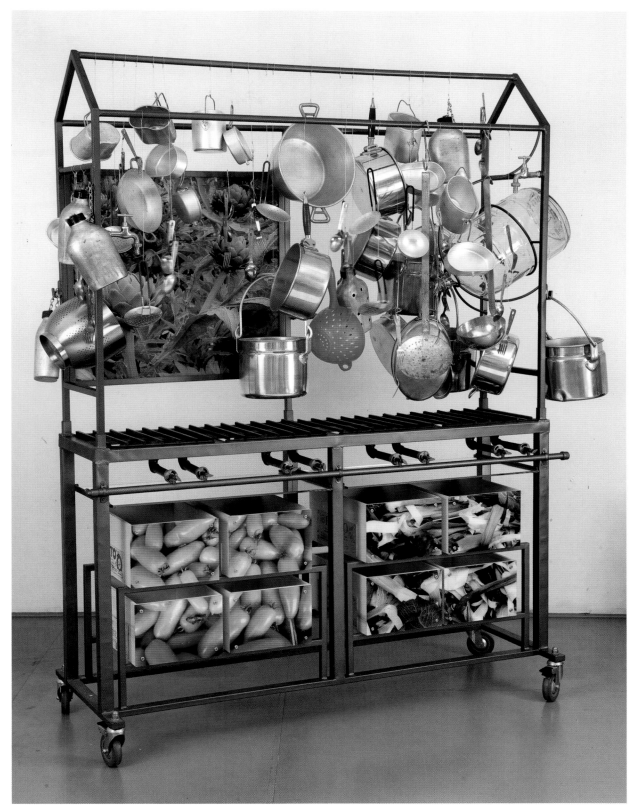

HortiRecycling—Mexican Kitchen, 1997–2008

WATER

Life Science: *OrtaWater*

Zoë Ryan

Increasingly, Studio Orta has focused their practice on environmental concerns. "We look to tackle issues not being addressed as much as they should be," asserts Lucy Orta. The social and environmental challenges facing the Earth's natural water resources have continued to be a topic of discussion in their work. The life-supporting properties of water need not be explained—it is one of the world's most valuable resources. However, water has become a subject of much debate and concern in recent decades as natural resources are being rapidly consumed. Although water covers about two-thirds of the Earth's surface, only 3 percent of this amount is freshwater, and about two-thirds of that is ice. Much of the remainder is locked underground.[1] Therefore, a mere fraction of a percent of the Earth's water supports all life on land. Water is also an issue for underprivileged communities. The statistics are staggering: it has been estimated that about a billion people across the globe still do not have access to clean water.

Much of the Ortas' work is driven by issues of survival and safety, and for that reason water has been a subtext for many of their projects, including *70 × 7 The Meal*, *HortiRecycling*, and *Antarctic Village—No Borders*, a recent project where Jorge Orta and a team of photographers and filmmakers trekked to this remote area of the world, where the problem of climate change is increasingly giving cause for serious concern. However, in *DrinkWater*, the exhibition they devised for the fifty-first Venice Biennale in 2005, the issue of water took center stage. An invitation by the Fondazione Bevilacqua La Masa, a contemporary art center along the Grand Canal in Venice, to develop a new body of work seemed the ideal setting for *OrtaWater*—a project that deals with water. Together with students from Fabrica—a research center in Treviso, Italy—Studio Orta developed a series of interactive works exploring water purification, distribution, and consumption.

Envisioning a time when freshwater might be so scarce that we would need to develop new solutions for extracting, cleaning, and processing it from our local waterways, Lucy + Jorge Orta took advantage of the waterside setting of the Fondazione Bevilacqua La Masa and utilized its galleries almost like a factory. They set up a small production plant that pumped water from the Grand Canal into a purification system developed by Italian engineers, which used a kit-of-parts of ideas drawn from earlier works, such as the process units for *HortiRecycling*, as well as newly developed elements. The result was a complex network of tubes, containers, and pumping mechanisms, all of which alluded to and made visible the process of waterextraction, storage, cleansing, and distribution. As part of the project, the water from the canal, once cleaned, was bottled and distributed to gallery visitors in specially created, reusable glass bottles. A souvenir edition of the project, the bottles also made reference to the privatization of many of the world's freshwater sources.

In addition to developing the water purification plant in Venice, *OrtaWater* was later tested out again in Rotterdam, at the Museum Boijmans Van Beuningen, with water filtered from the adjacent Amstel River. Here, Studio Orta worked with students from the Willem de Kooning Academie, the Delft University of Technology, and the Design Academy in Eindhoven—all schools in the Netherlands—to generate research projects that would provide real data about water shortage and waste. In a section of the gallery, metal water gourds—some pierced with holes as a metaphor for water waste and loss—were stamped with bar codes that visitors could scan to access information, including statements from world leaders such as Kofi Annan ("Water is likely to be a growing source of tension and fierce competition between nations, if present trends continue, but it can also be a catalyst for cooperation") as well as horrifying predictions ("By 2050, the number of countries facing water stress or scarcity could rise to 54, with their combined population being 4 billion people—about 40 percent of the projected global population of 9.4 billion").

Although much of the Ortas' output is ephemeral (performances, interventions, and installations) and lives on through photography, film, and video, there is a body of materials (objects, sculptures, and drawings) generated for each project that is equally essential, acting both as independent artworks and as extensions of their installations and events, as symbolic signifiers of the issues at the heart of their work. Rather than serving as stand-alone components, these elements form part of an integrated system, a chain of works that build on one another, strengthening their ideas. At once representations of the conceptual thinking behind a project, they are nonetheless plausible solutions made apparent by their functional properties. For *OrtaWater*, for example, Lucy and Jorge generated a series of objects incorporating visual elements drawn from throughout their oeuvre that were embedded with issues relating to survival, safety, security, and the necessity for transportable solutions that can reach communities in need. They included *Urban Life Guards*—wearable garments hung with metal flasks or attached to stretchers and life preservers—as well as *Mobile Intervention Units*, made from bicycles, canoes, even several Piaggio Ape 50 three-wheeled vehicles, and equipped with plastic jerricans, buckets, sinks, and water pipes. Crafted from found and customized objects, these pieces had a do-it-yourself quality that demonstrated how we can all contribute on some level, however small, to issues of global concern with home-grown solutions. The Ortas assert that their work is founded on a belief that "the individual creative potential of people needs to be fully acknowledged. By recognizing this potential and harnessing it through our work, we aim to mobilize an increasingly wide audience in actively supporting and providing solutions to world problems, whether they are ecological, political, humanitarian, or economic."

In addition to the collection of objects, a series of drawings accompanied *OrtaWater*. Based on the same principles and directives as the objects, these works consisted of visual imagery taken from the project's key themes, including water bottles, tricycles, boats, cooking utensils, life preservers, and clothing. Together, these objects represented human effort and participation. Using a lexicon of two- and three-dimensional signs and symbols that are repeated throughout their work, Lucy and Jorge provide a frame or context for their ideas that is readily and universally understandable. These images and objects surpass linguistic, national, and cultural boundaries, encouraging dialogue and debate across a wide range of people. Rather than being explicit or absolute in their meanings, they are purposefully open-ended to encourage interpretation on multiple levels based on their associated parts.

As theorists Carlo Vezzoli and Ezio Manzini have noted in relation to the preconditions of environmental sustainability, "our society, and hence the lives of our and future generations, depends on the long-term functioning of the complicated ecosystems that we happen to simply call nature...systemic conditions where neither on a planetary nor on a regional level do human activities disturb the natural cycles more than planetary resilience allows, and at the same time do not impoverish the natural capital that has to be shared with future generations."[2] This thinking is at the heart of many of Studio Orta's projects. What makes *OrtaWater* so relevant is that it addresses an issue of increasing concern to daily life: water. By focusing on this essential topic, an area that is often overlooked or taken for granted, Lucy + Jorge Orta position themselves at the forefront of contemporary discussions, ensuring their work remains a pertinent platform for exploration and debate.

By bringing together expertise from multiple fields as well as several years of research undertaken by their own studio, and by following their now tried-and-tested, multifaceted approach—combining workshops, objects, photography, and installations—Studio Orta makes clear its determination and commitment to probing issues of import to people globally. Often labor-intensive, this integrated method of working enables them to create work that is taken seriously on a conceptual level, as well as to suggest credible solutions to issues such as water preservation, distribution, and consumption. Ultimately, what makes projects such as *OrtaWater* stand out is that rather than being a series of individual elements, the combined production of a single project provides a powerful set of tools that helps strengthen their message and contribute to the larger narrative embedded within all of their output: the social and cultural well-being of people worldwide.

NOTES

1 http://water.org/learn-about-the-water-crisis/facts/.
2 Carlo Vezzoli and Ezio Manzini, *Design for Environmental Sustainability* (London: Springer Verlag, 2008), 6.

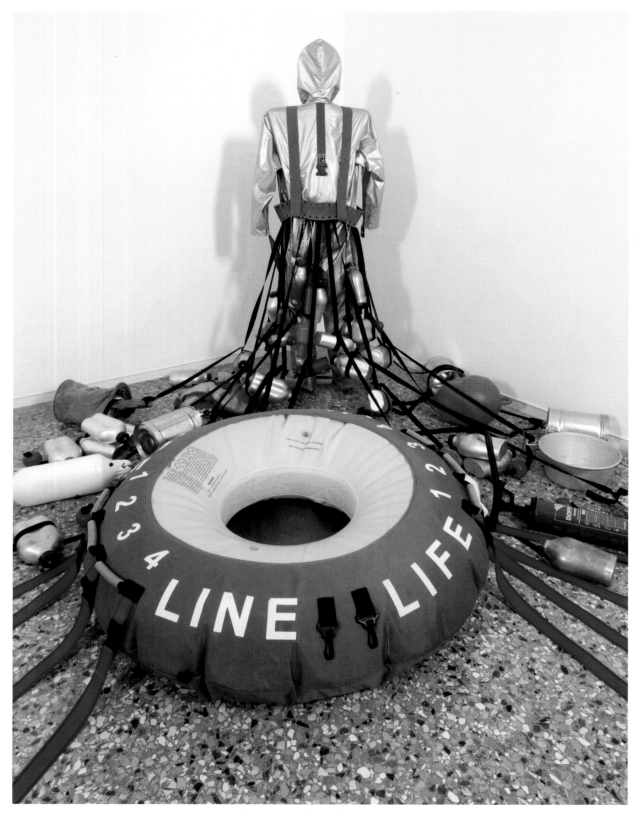

OrtaWater—Urban Life Guard, 2005

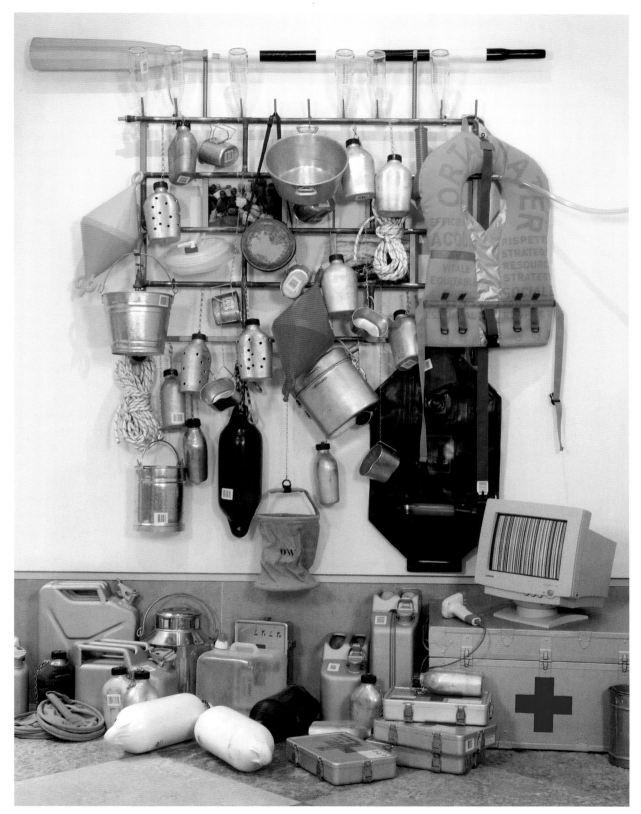

OrtaWater—Barcode, 2005

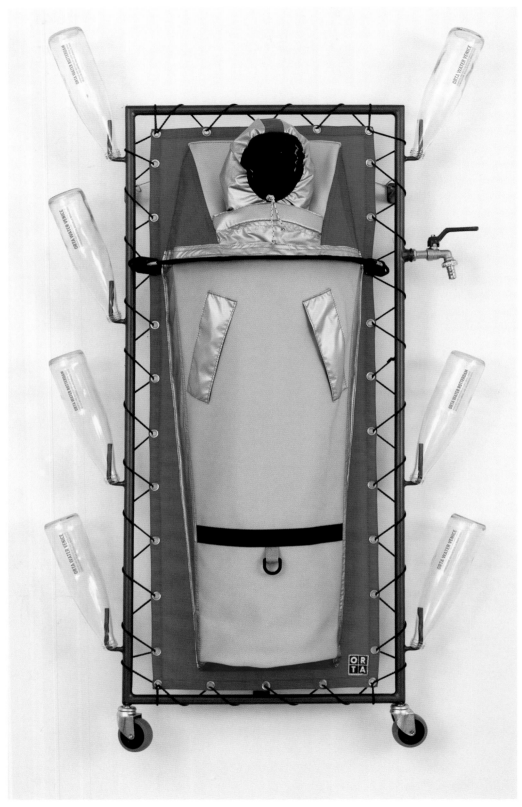

OrtaWater—Sleeping Suspension, 2005–7

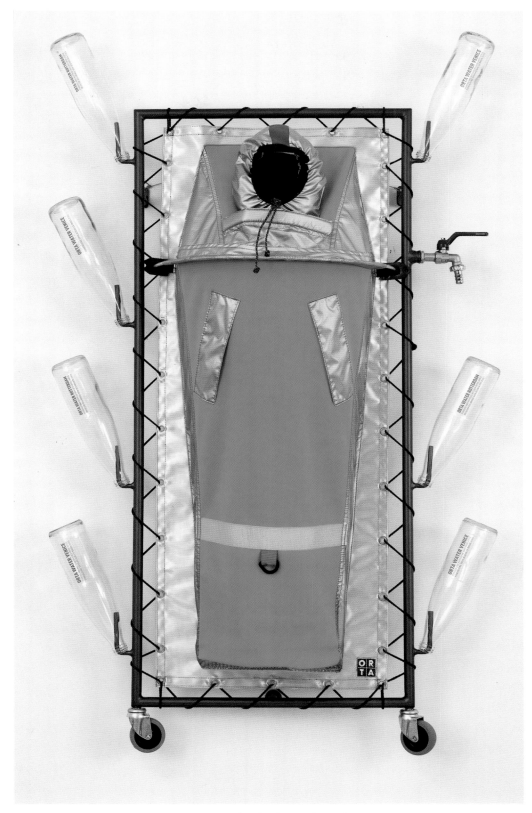

OrtaWater—Sleeping Suspension, 2005–7

OrtaWater—Vitrine, 2006

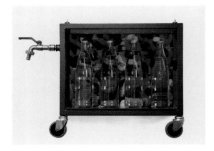

OrtaWater—Vitrine, 2005

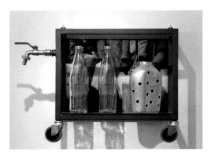

OrtaWater—Vitrine, 2005

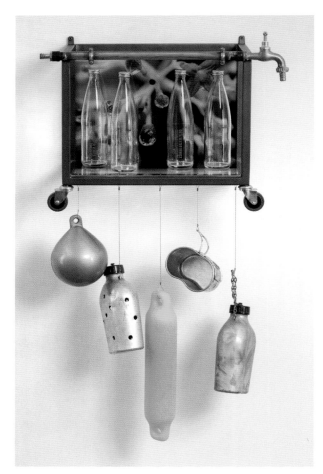

Amazonia—Vitrine, 2010

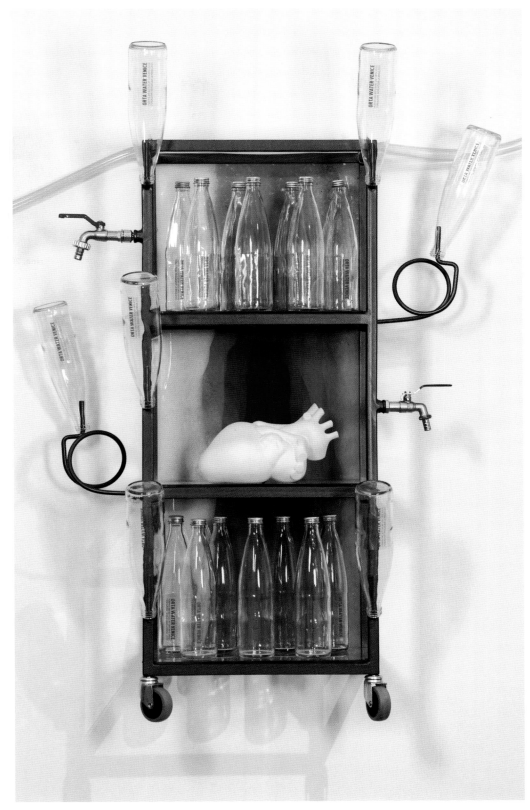

OrtaWater—Glacier Wall Unit, 2005

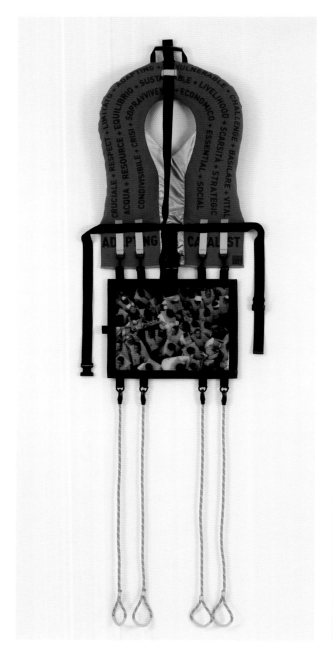

OrtaWater—Life Line, 2005

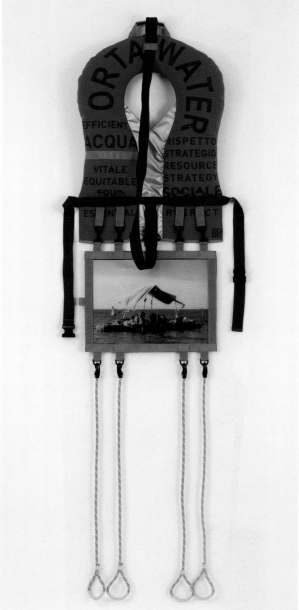

OrtaWater—Life Line, 2005

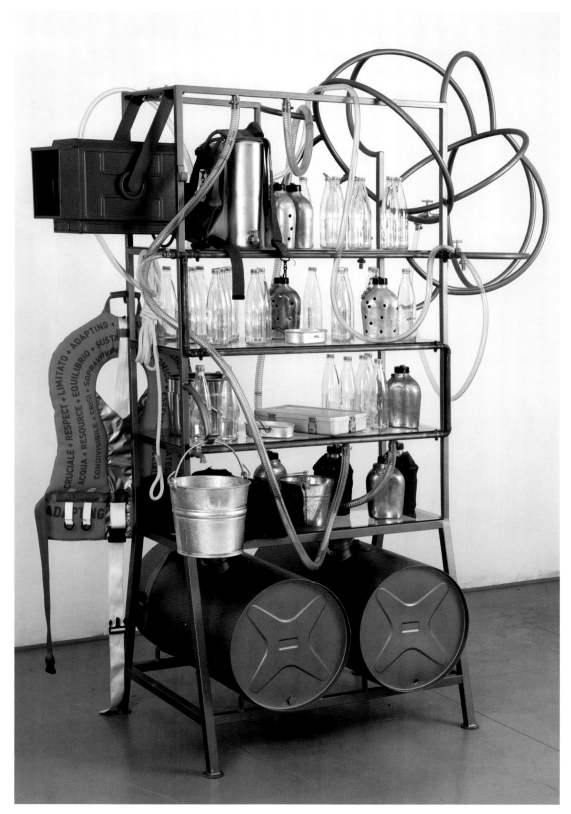

OrtaWater—Storage Unit, 2005–8

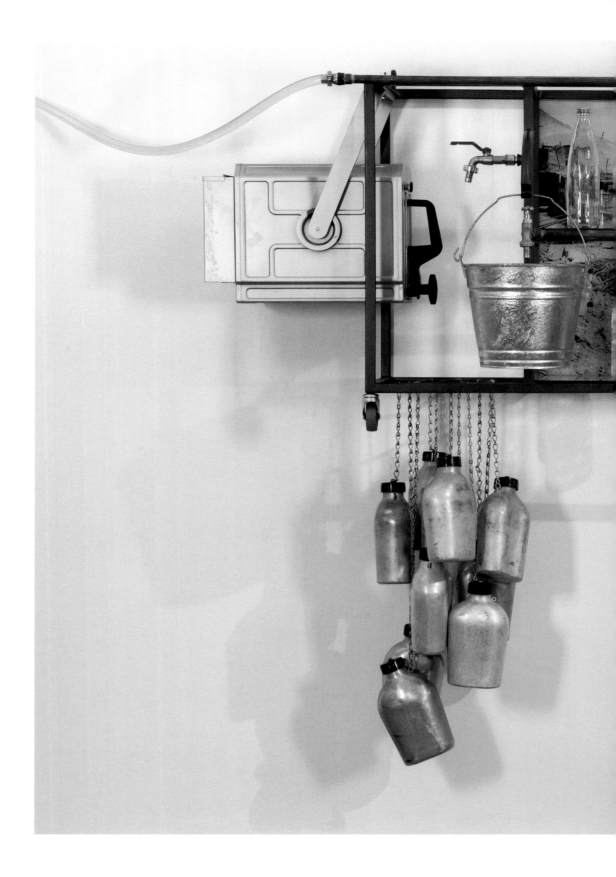

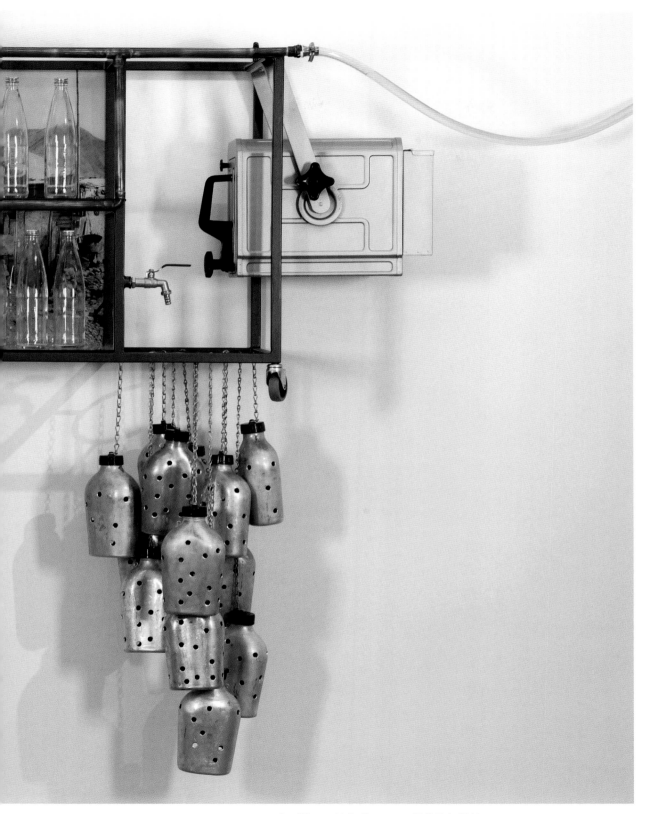

OrtaWater—Light Messenger Wall Unit, 2005

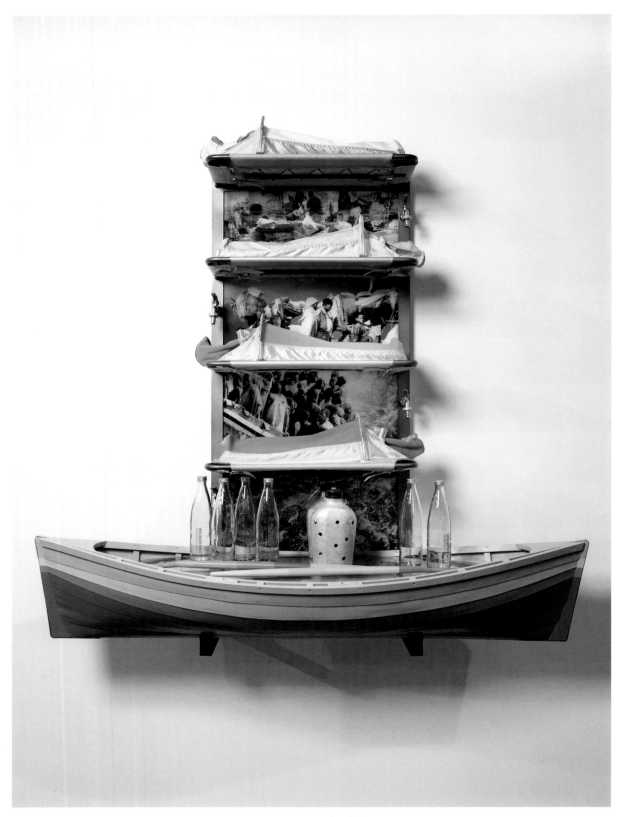

OrtaWater—Exodus, 2007

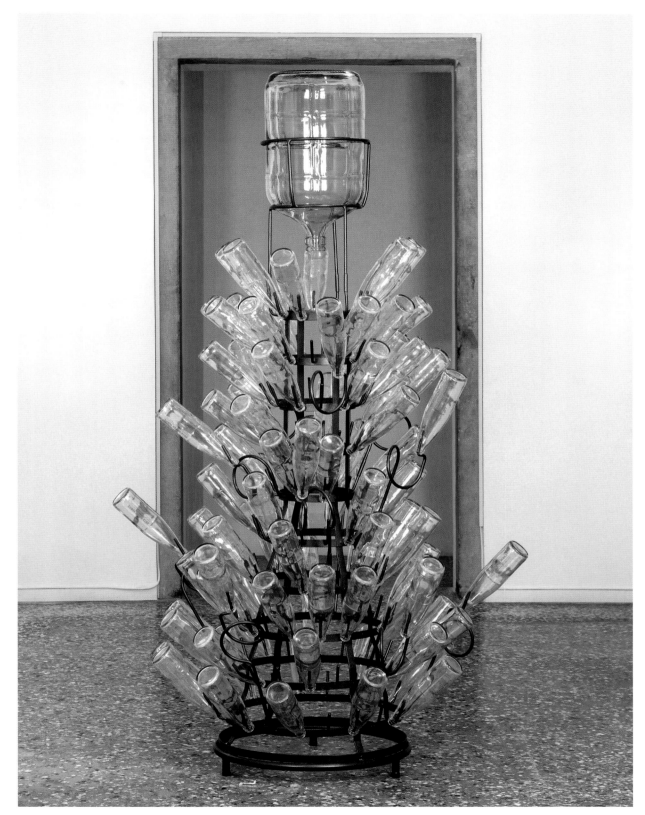

OrtaWater—Bottle Rack, 2005

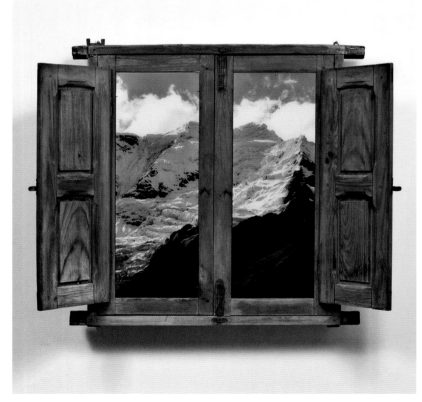

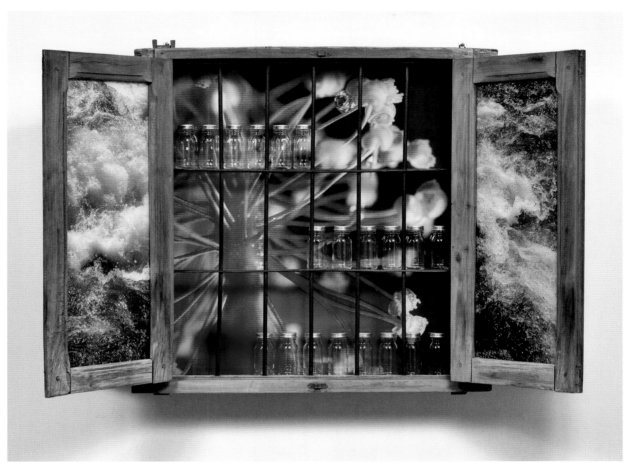

Amazonia—Window on the World, 2010

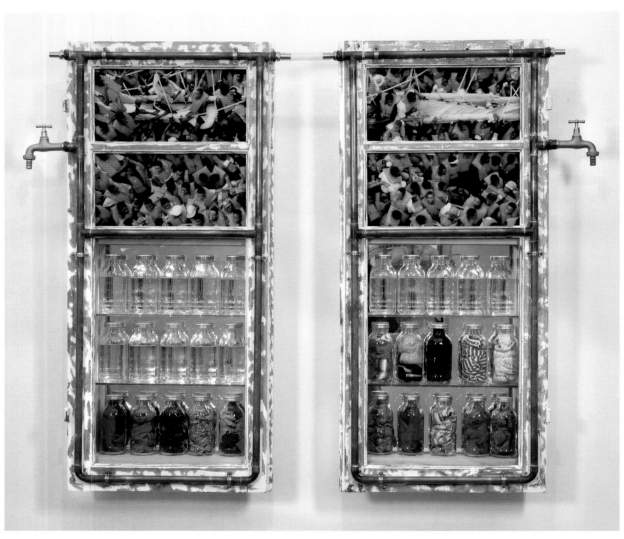

OrtaWater—Window on the World, 2005

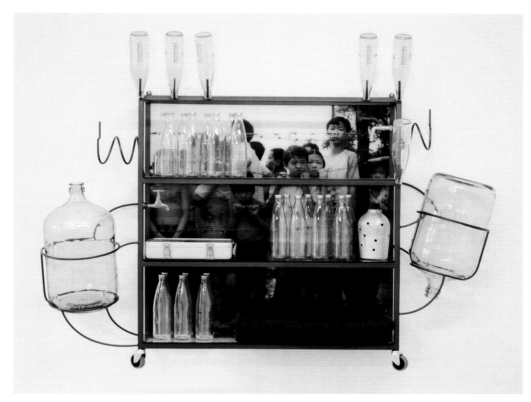

OrtaWater—Vitrine, 2005–6

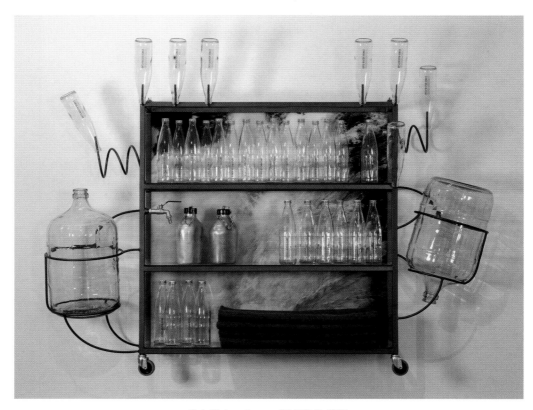

OrtaWater—Iguazu Wall Unit, 2005

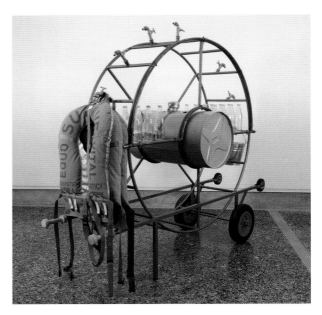

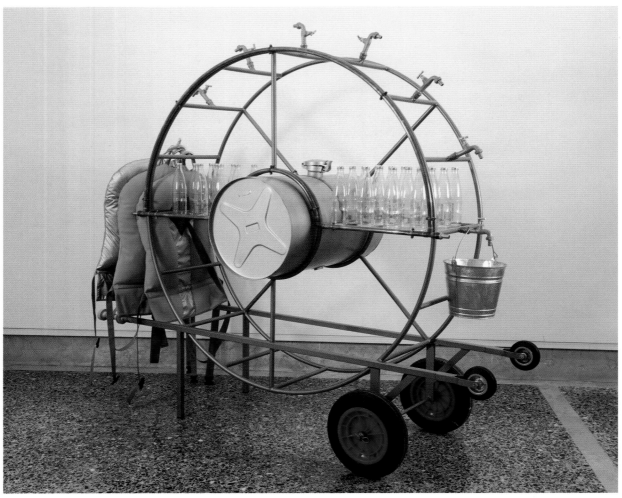

OrtaWater—Portable Water Fountain, 2005

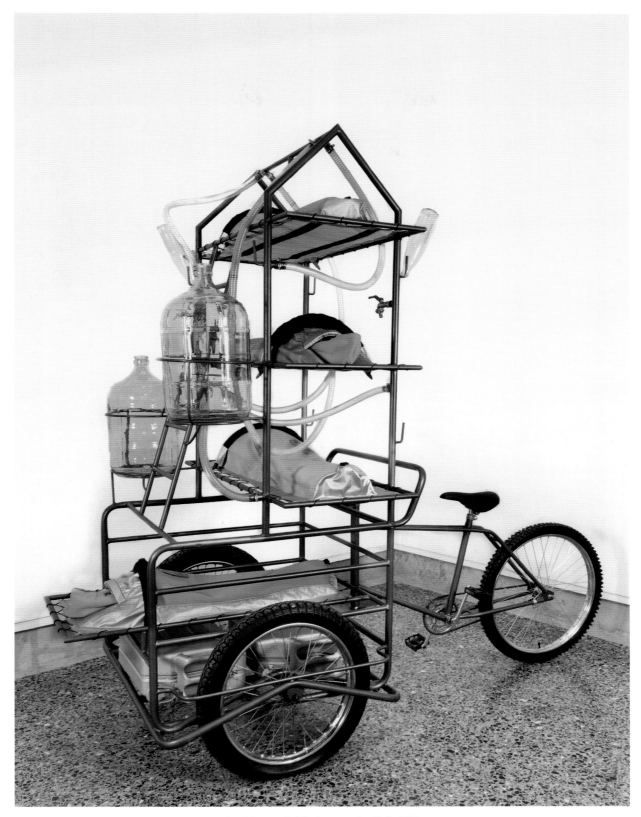

OrtaWater—Mobile Intervention Unit, 2005

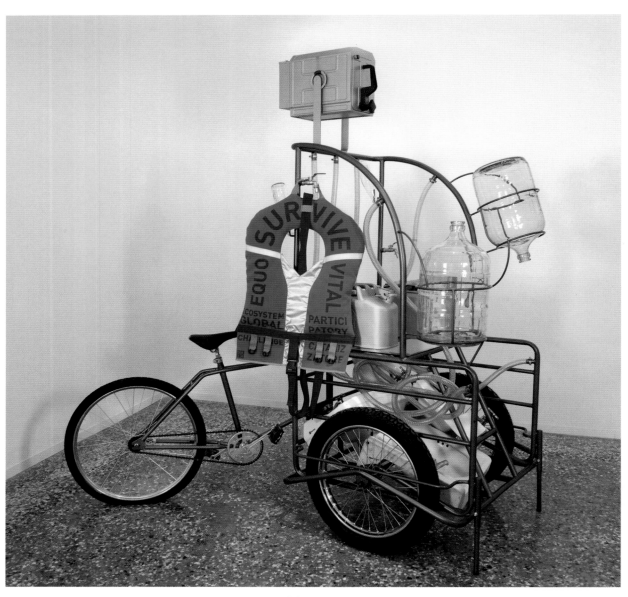

OrtaWater—Mobile Intervention Unit, 2005

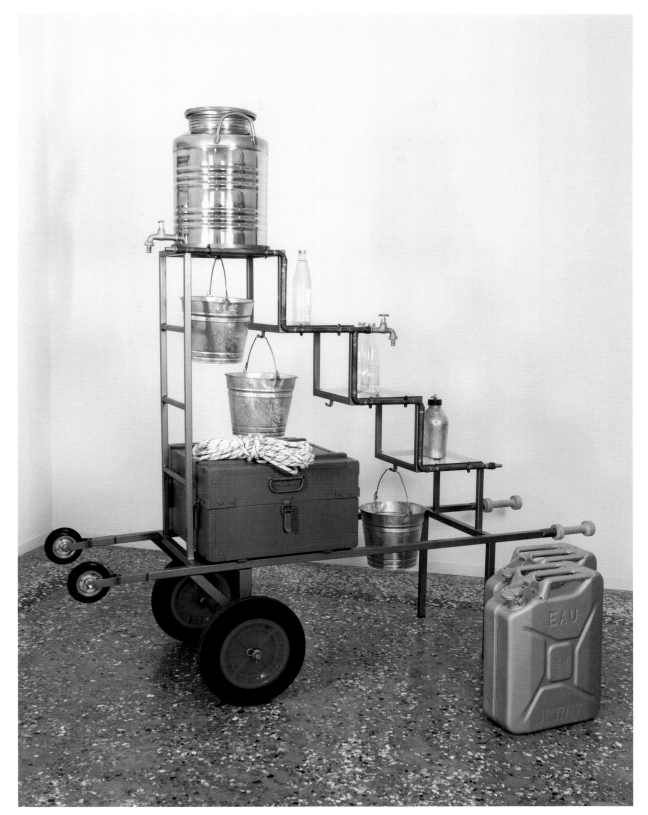

OrtaWater—Trolley Unit, 2005

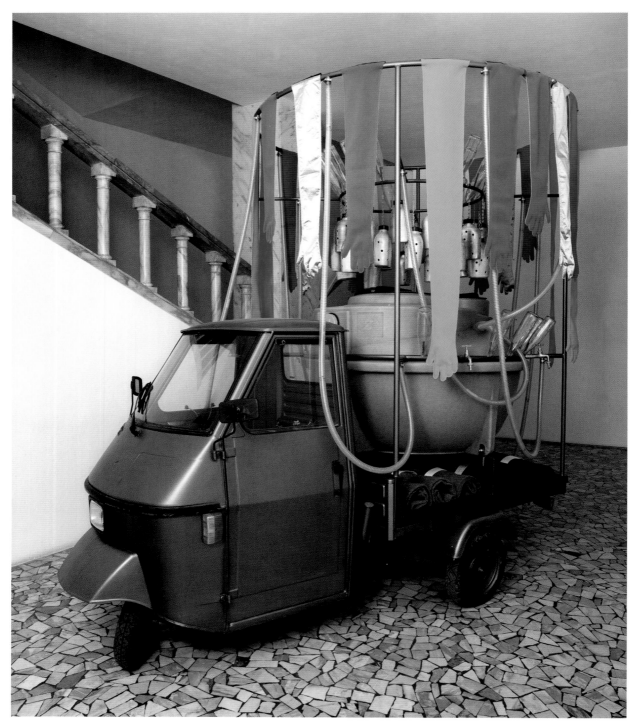

OrtaWater—M.I.U. Reservoir, 2007

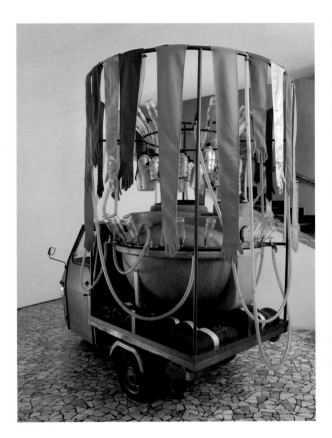

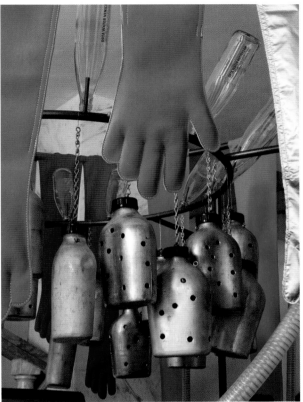

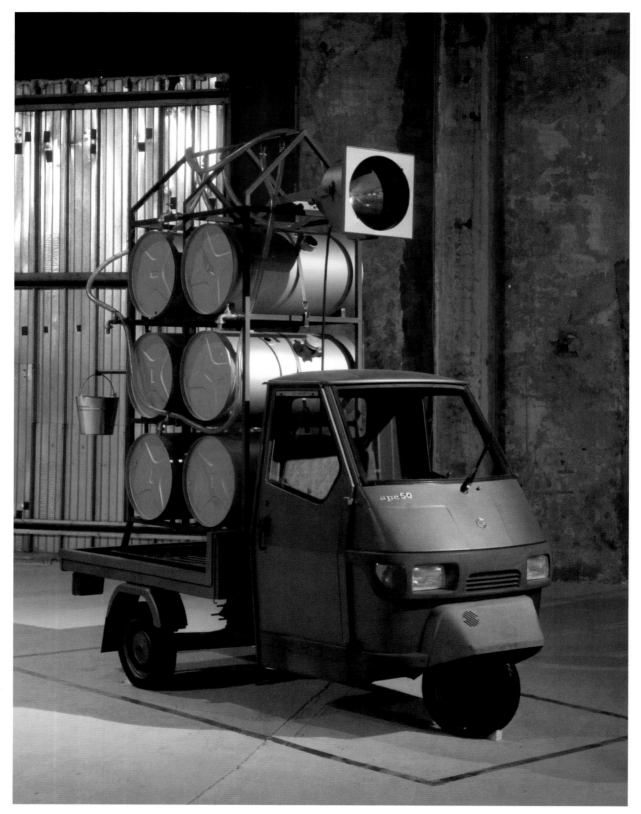

OrtaWater—Mobile Storage Tank Unit, 2005

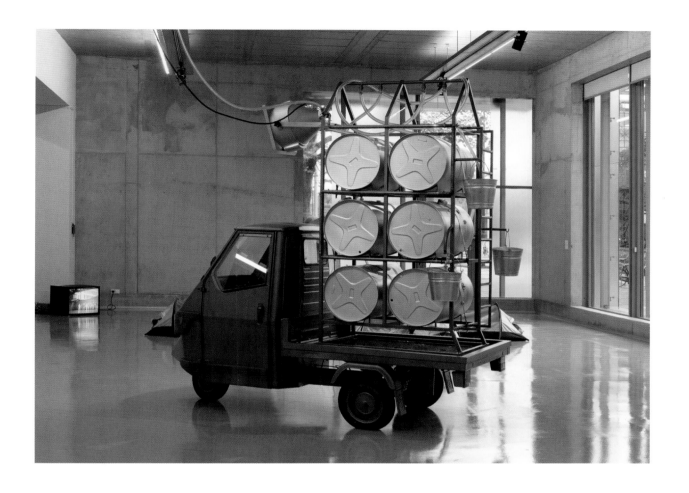

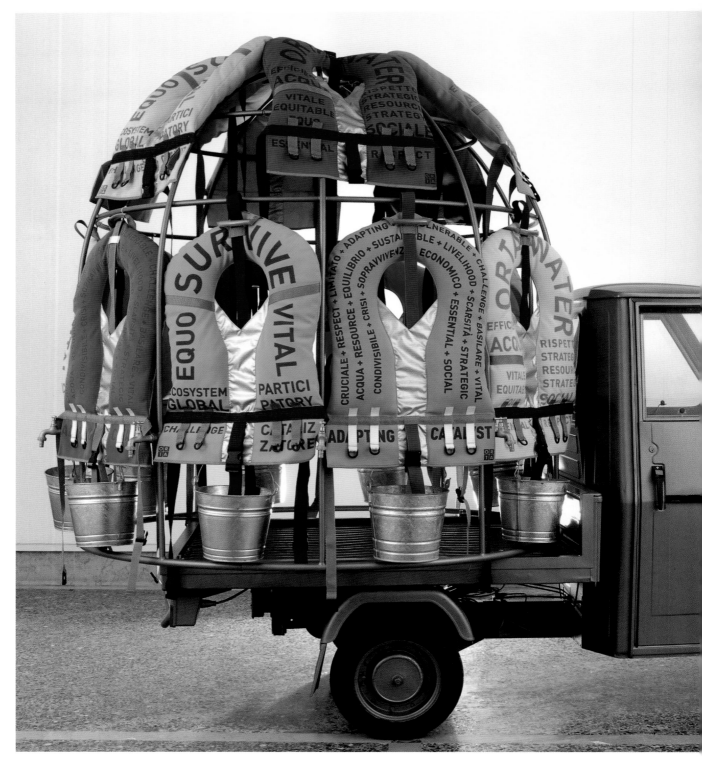

OrtaWater—M.I.U. Life Line, 2005

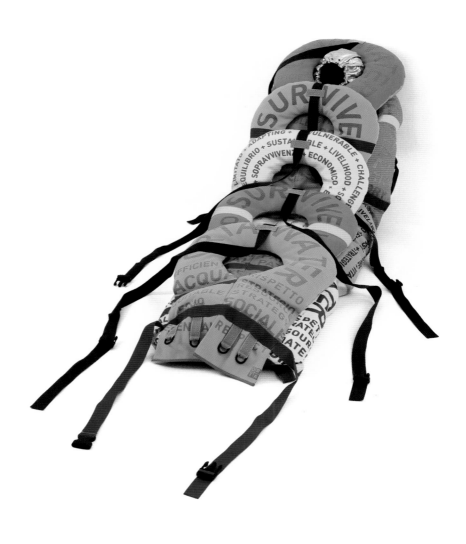

OrtaWater—Refuge Wear 0816, 2005

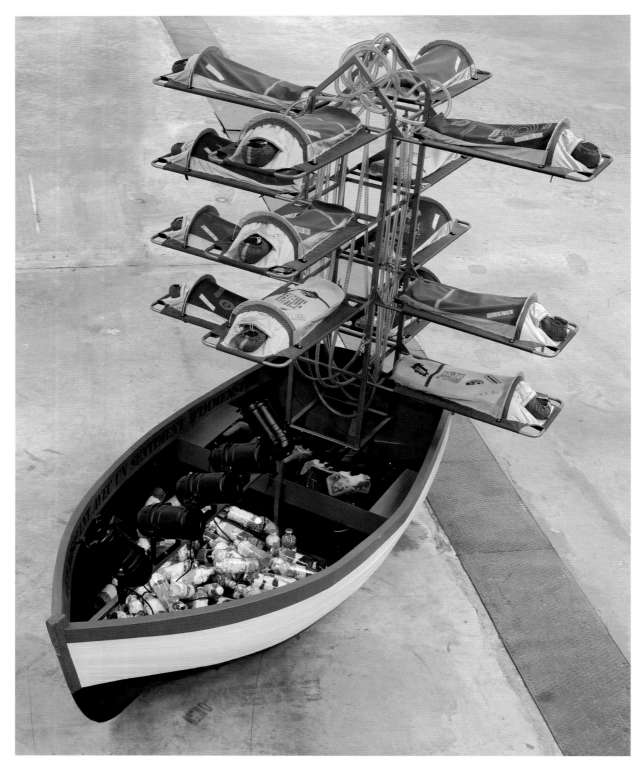

OrtaWater—Antarctica Fluvial Intervention Unit, 2005–8

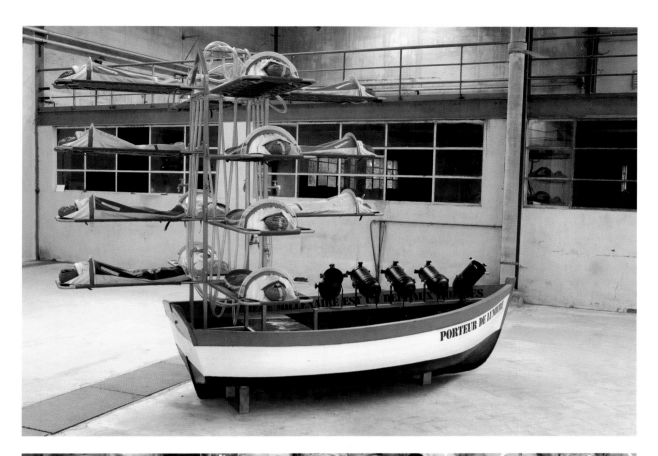

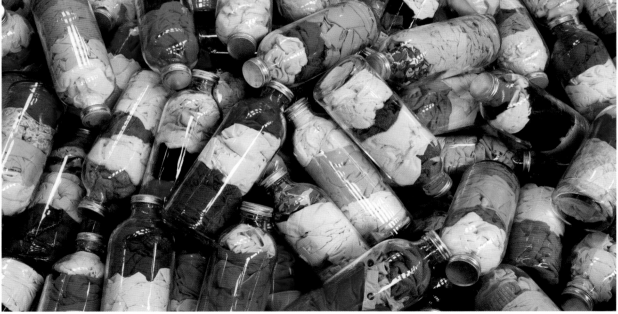

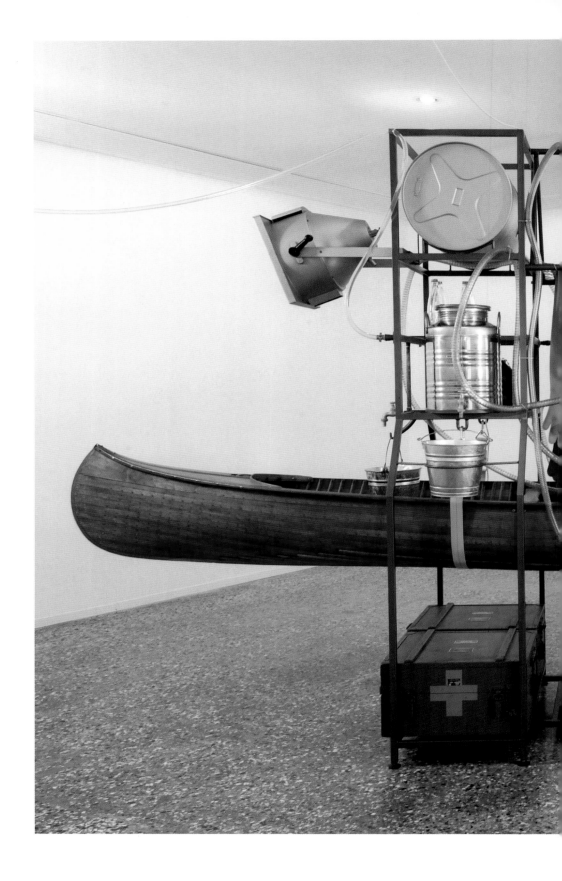

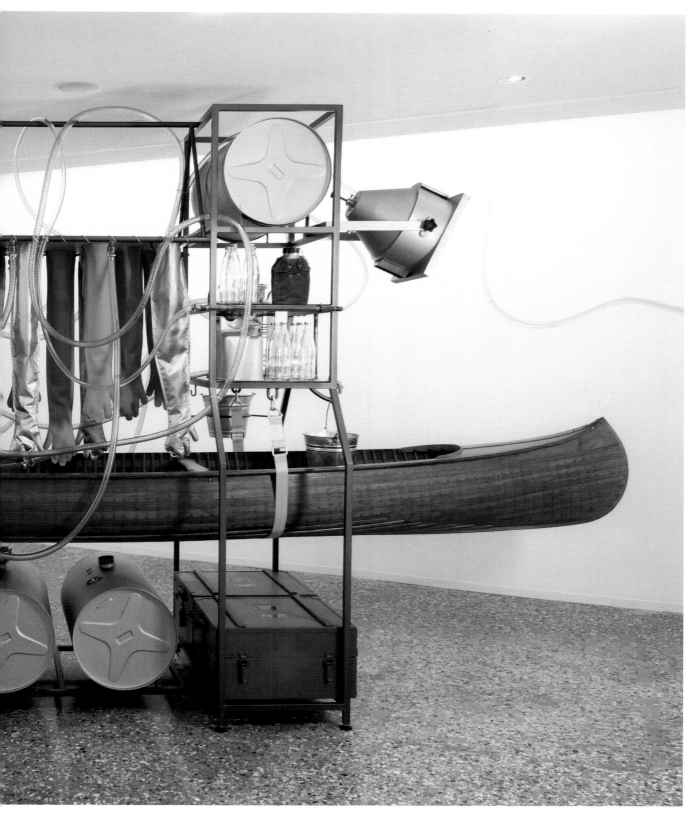

OrtaWater—Fluvial Intervention Unit, 2005

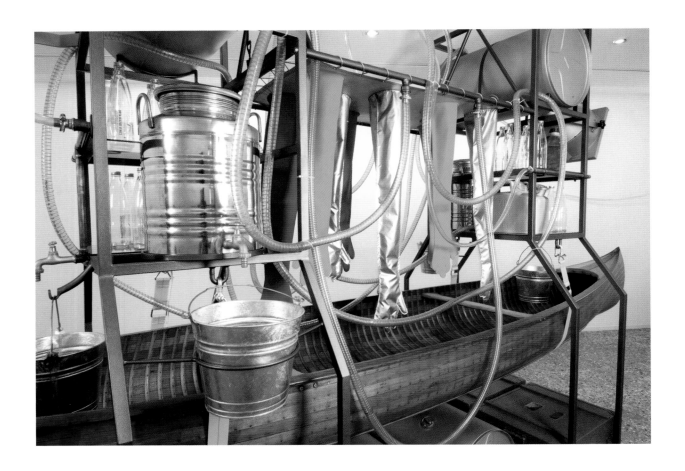

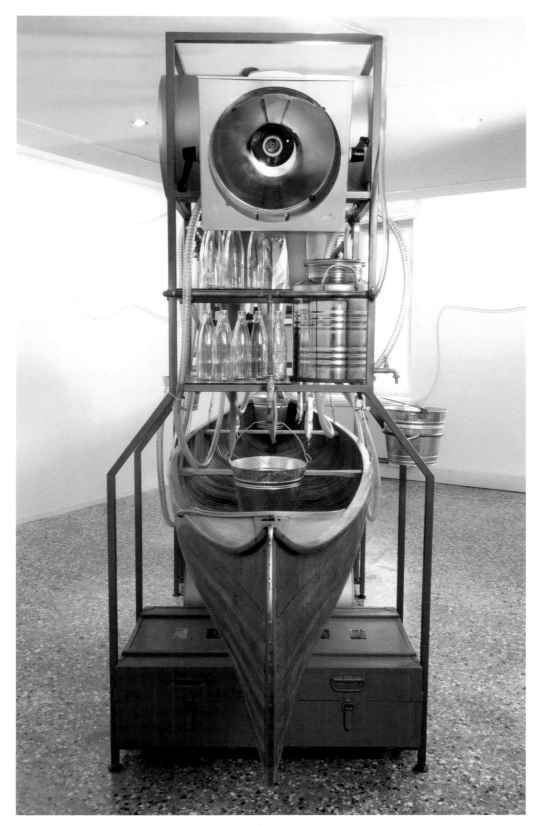

OrtaWater—Fluvial Intervention Unit, 2005

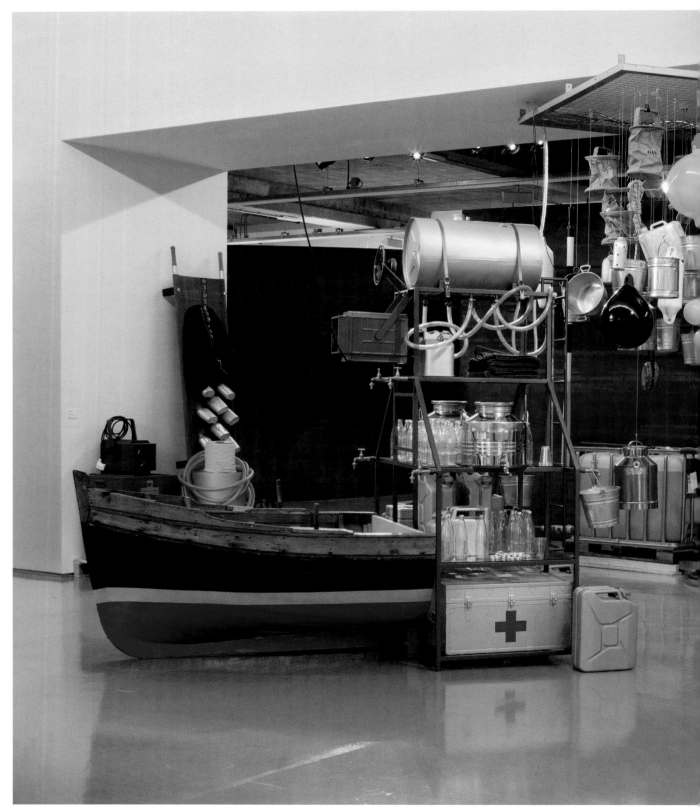

OrtaWater—Purification Station (Museum Boijmans Van Beuningen, Rotterdam, The Netherlands), 2005

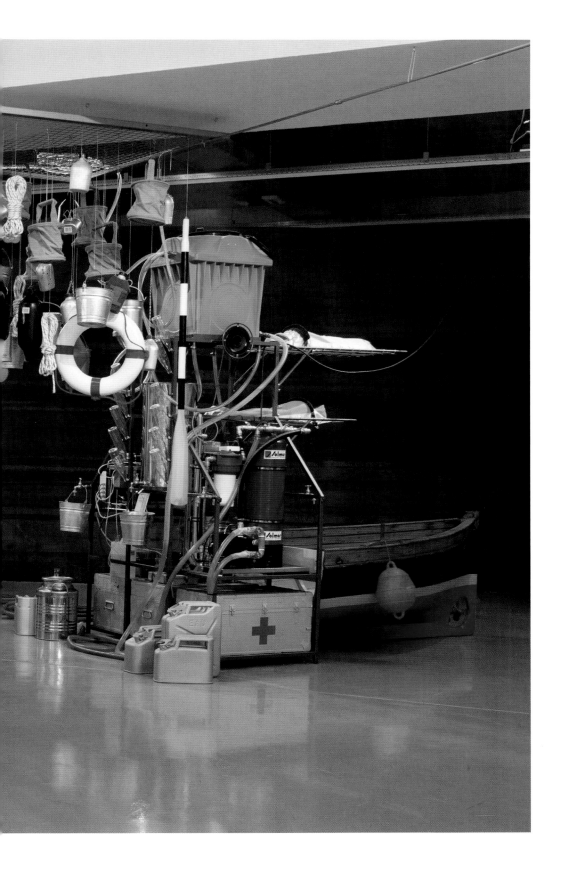

LIFE

Subject = Object: *Antarctic Village— No Borders*

Judith Hoos Fox
and Ginger Gregg Duggan

Because Lucy + Jorge Orta's *Antarctic Village—No Borders* body of work marks two distinctly new directions in their way of working, our understanding of their practice needs to shift. The Antarctica project represents, on the one hand, a move toward a more specific subject, and on the other, a more abstract object. While still absolutely linked, the relationship between subject and object has expanded, making room for our participation.

Subject

The Ortas' collaborative endeavors are typically driven by their research into subjects that are not geographically circumscribed, but rather touch all of us. They are concerned with conditions that define survival, such as the availability of food—642 million people in Asia and the Pacific Islands are hungry, as are 265 million in sub-Saharan Africa—and the diminishing supply of water—more than a billion people lack access to clean water, and that figure is growing exponentially.[1] With *Antarctic Village—No Borders,* Lucy + Jorge Orta turn their humanitarian and artistic efforts to a specific geographic location as an emblem for issues there that are, in fact, global. Antarctica, oxymoronically, provided fertile ground for their first body of work generated by a specific location.

The preamble to the 1959 Antarctic Treaty introduces us to this unique place:[2]

> Recognizing that it is in the interest of all mankind that Antarctica shall continue forever to be used exclusively for peaceful purposes and shall not become the scene or object of international discord;
>
> Acknowledging the substantial contributions to scientific knowledge resulting from international cooperation in scientific investigation in Antarctica;
>
> Convinced that the establishment of a firm foundation for the continuation and development of such cooperation on the basis of freedom of scientific investigation in Antarctica as applied during the International Geophysical Year accords with the interests of science and the progress of all mankind;
>
> Convinced also that a treaty ensuring the use of Antarctica for peaceful purposes only and the continuance of international harmony in Antarctica will further the purposes and principles embodied in the Charter of the United Nations.[3]

The treaty elaborates, through fourteen additional articles, that Antarctica is to be a place free from weapons, nuclear activity, and military presence. Scientific investigations undertaken there will be collaborative in both process and in the sharing of results, and should there be disputes, article XI notes:

Those Contracting Parties shall consult among themselves with a view to having the dispute resolved by negotiation, inquiry, mediation, conciliation, arbitration, judicial settlement or other peaceful means of their own choice.

The treaty has forty-eight member nations, from Argentina to Venezuela, the most recent joiner being Monaco in 2005. Scientific experiments conducted in Antarctica range from the investigation of ice as a radio-frequency radiator to the protection of marine life. Studies on the effects of isolation on the population of researchers— sequestered there for months at a time, across 4.5 million square miles—have also been conducted.[4]

This international community—not defined by divisive political borders, but dedicated to learning about, and hopefully arresting, the deterioration of the planet—inspired the Ortas to launch *Antarctic Village—No Borders*, and the artists have created a vocabulary of forms that expresses the values and aspirations embodied in this to-date-successful experiment. Antarctica becomes the synecdoche for collaborative human existence defined by freedoms rather than restrictions. A similar approach to content through subject can also be seen in the Ortas' *Fallujah* project, lasting from 2002 to 2007, and in *Amazonia*, a new body of work in development based on their 2009 expedition along the Madre de Dios River—a tributary of the Amazon, the second-longest river in the world—from its source in Calillona, Peru, to its mouth in northeastern Brazil.

Object

It is the zone of frisson between theater and life, object and metaphor, that the Ortas' collaborations singularly occupy. With roots in the social sculpture of Joseph Beuys—a notion ratified by the numerous works on paper, editioned objects, and posters announcing performances by Beuys that fill the walls of the artists' Paris home—the trajectory of their practice brings us into new and important territory. First, the objects they create are arresting, powerful, engrossing, and evocative. In terms of manufacture, they are designed and engineered to meet any industry's standards. In contrast with Beuys's monotone, cerebral objects, Lucy + Jorge Orta celebrate color and texture; bring together found and fabricated objects; re-create two-dimensional images (such as photographs) in three-dimensional forms; and have even used sound as part of their sculptural pieces. Theirs is work that embraces the public, invites participation, and incites thought and action. The social intervention aspect that defines Lucy's own practice and the architectural ambition of Jorge's support each other. But the defining point in the Ortas' work is that here, metaphor and actuality merge, and subject becomes object. Sculptures about the purification of water in fact

purify water, and pieces about the scarcity of food and wanton waste are actual stations for food preparation. And this is unique.

More often, the objects made by performance artists are remnants, reminders: Robert Rauschenberg and John Cage's 1951 work *Automobile Tire Print*, the snapshots of Allan Kaprow and Vito Acconci acts, the videos of Yoko Ono's performances. The nearest precedent for this subject/object conflation might be Joseph Beuys's *7000 Oaks*—initiated in 1982 at Documenta 7 in Kassel, Germany— which began as a pile of as many basalt posts, dwarfing the entry to the Museum Fridericianum. Beuys led the effort to plant seven thousand trees in Kassel over the next several years, and a basalt post was placed by each tree. With the planting of each tree, the war-flattened city grew more verdant, and the mountain of stone on the lawn in front of the exhibition hall diminished. This project was to be the beginning of a worldwide environmental effort. More common today, in our increasingly meta world, is the web-based project *Joseph Beuys' 7000 Oaks*, created by Eva and Franco Mattes in 2007.[5] Here, the basalt posts—images of them, that is—are heaped on the Goethe-Institut's island site in the virtual-reality world of Second Life, ready to diminish as Second Life participants "plant" trees across that alternate and imaginary world, a conceptual greening of the globe. This is a good idea, maybe, but more than ideas is needed.

With the Antarctica project, the connection between object and action is more amorphous, less specific, than in the Ortas' water and food works. For instance, when we scrutinize the project's huts, called *Dome Dwellings*, we see that they are not actually habitable, and the piece's *Drop Parachutes* function as symbols rather than tools. The artists' description of the project opens with statistics that draw a vivid picture of this place:

> Antarctica, *the end of the world*: boasting the most hostile climatic conditions, the coldest place on earth with temperatures reaching -80°C in winter, the largest frozen desert in the world, containing 90 percent of the world's ice (approximately 70 percent of the world's fresh water), no permanent human residents, and no indigenous population.[6]

The contrast between the Eden-like mandate for the place and its extreme geography is reiterated in all the work that comprises *Antarctic Village—No Borders*. Some fifty domed habitats—or more accurately, emblems of habitation—populate white, sheer sheets of Antarctic ice pack, each tent made from the flags of the member nations of the Treaty. Garments and gloves are joined to their surfaces, which also hold silkscreen–printed texts that state, "Everyone has the right to move freely and circulate beyond the state borders to a territory of their choice." Also stenciled is the Ortas' proposal for a new article to the United Nations declaration.

Encampments of these domed structures are situated sequentially at four locations across the continent. The artists' log describes the harsh weather conditions: "South Village—lat.64°14' south, long.56°37' west, visibility 100 to 900 meters, with snow and haze. Temperature -9°C with 12km/h winds. The first day of sufficiently clement weather for the operation." Encampments followed at North Village, then East Village and West Village.[7] The tents embody freedom of movement, the crossing of borders that are so often artificially imposed and politically driven. Those without a country—marooned in the wrong place—need moveable shelters, and above all, the right of free passage. The tents' vivid colors against the whiteness and their notion of home in such inhospitable surroundings are some of the clashing elements that define *Antarctic Village—No Borders*.

When picked up by the arctic winds, the gloves attached to the tents flap and flutter, appearing either to reach out to make contact or to poignantly signal that help is needed. Both readings make sense. Auguste Rodin explored the power of gesture—how even if isolated, it is eloquent. Before him, Michelangelo depicted the reaching and near touching of hands to great symbolic effect. The Ortas provide an updated exploration. The hand—and by proxy, the glove—is a loaded image, a symbol for what separates mankind from the animal kingdom, as a user of tools in need of human connections.

Drop Parachutes and *Life Line—Survival Kit*, two major parts of the overall body of work, incorporate dueling points of view: help is urgently needed / help has arrived. The Ortas' merging of flags with text, as was done on the tents, continues the litany of our quest to survive, physically, emotionally, and spiritually. Laden with the tools of survival—some addressing the need for water, others for food, children's toys for comfort, clothing, or medical supplies—*Drop Parachutes* and *Life Line* signal urgency and emergency. Oddly, the parachute and life saver are not common images in art, even though the tension between being aloft and aground, and the many plausible readings of these opposites, would seem fruitful images for artists.

Staked into the ice, a wind-ruffled flag "destined to become the flag of the planet and the human beings it represents, to be raised as a supranational emblem of human rights," marks this remote place as one that could represent the future.[8] The artists took the flags of numerous nations and bled their distinct designs together, creating a pattern that speaks of international cooperation, a world where borders are soft.[9] Lucy + Jorge Orta called this flag the *Métisse Flag*, in reference to the French term *métissage culturel*—a consciously chosen mixing of cultures—which has no precise English translation, perhaps because the concept is largely foreign to us.

Symbol

Heads or Tails, Tails or Heads is a series of soccer matches launched by the Ortas that opened and concluded their expedition. Meteorologists, paleontologists, and geologists from the Marambio Antarctic Base played an "all nations" match wearing team shirts made by the artists. Each shirt's front was made from one country's jersey, and its back came from another, making it impossible for the players to decipher offense from defense, their own team members from their adversaries. Jorge Orta comments, "This match mirrors human behaviour. Appearances are often deceiving. Someone we think is a friend may actually be playing against us, while a total stranger can surprise us with an act of solidarity. It is not appearances that count, but rather decisive actions in critical moments. We hope that our voyage to Antarctica and the spirit of cooperation that we gained there will generate greater awareness of the plight of refugees across the world."[10] These Antarctic games are in the spirit of the soccer matches staged by Sir Ernest Shackleton when, during the winter of 1915, his expedition was marooned on Antarctic ice, just a day from their destination. These games were part of Shackleton's successful efforts to maintain the morale of his crew. The first *Heads or Tails, Tails or Heads* game occurred en route to Antarctica, in Ushuaia, Falkland Islands. England played against Argentina, in remembrance of a disingenuous, two-and-a-half-month 1982 conflict between the two nations that claimed nearly one thousand lives, yet resulted in no actual changes in the governance of the British-dependent Falklands.

The foundation of *Antarctic Village—No Borders* is the *Antarctica World Passport*, an object and effort that began in 1995 and will continue until it culminates at the United Nations.[11] The first edition of the *Antarctica World Passport* is a symbolic proposal for a new nation of humanity. The passport may be issued to any person wishing to become a citizen of this continent, allowing them to travel freely throughout the world, but the artists request in return that each citizen take responsibility for their actions. The new world citizen will dedicate him- or herself to combating acts of barbarity, fighting against intimidation and poverty, supporting social progress, protecting the environment and endangered species, safeguarding human dignity, and defending the inalienable rights to liberty, justice, and peace in the world. The *Antarctica World Passport* recognizes the inherent dignity of every member of the human race, and supports an amendment to Article 13 of the 1948 Universal Declaration of Human Rights—*Art. 13:3*: "Every human being has the right to move freely and cross frontiers to their chosen territory. No individual should have inferior status to that of capital, trade, telecommunication and pollution, all of which have no boundaries."[12]

Ten thousand numbered and signed booklets, which have all the components of and share their appearance with the standard passport, ensure a grassroots movement. The artists have set up passport office installations for the distribution of these documents, and the recipients can enter an online database (http://antarcticaworldpassport.mit.edu/citizens/new)—conceived in collaboration with Massachusetts Institute of Technology's Visual Arts Program—that will be part of the eventual presentation to the United Nations.

The link between subject and object within *Antarctic Village—No Borders* is more ambiguous than in the Ortas' earlier work, the function less direct in its relationship. The passport symbolizes the significance of this shift, and as the driving idea behind *Antarctic Village*, it highlights the new role that each of us play in the function. The participation of all of us who sign up for and receive a passport is implicit. Yes, we now own a wonderful multiple, but we have also joined a movement. We have signed a pledge. The work of Lucy + Jorge Orta, morally driven, brings art and its viewers into new territory, an arena defined by ethics and action.

NOTES

1 According to the Food and Agriculture Organization of the United Nations' most recent figures (Oct. 2009) and "World Hunger and Poverty Facts and Statistics 2010," World Hunger Education Service, http://www.worldhunger. org/articles/Learn/world%20hunger%20facts%202002.htm; and, "Global Water Crisis," *Nature*, http://www.nature.com/nature/focus/water/.

2 "The Antarctic Treaty," The Antarctic Treaty Secretariat, http://www.ats.aq/e/ ats_treaty.htm.

3 "The Antarctic Treaty (1959)," National Environment Research Council (NERC)/British Antarctic Survey (BAS), http://www.antarctica.ac.uk/about_ antarctica/geopolitical/treaty/update_1959.php.

4 "Ask the Experts," *Scientific American*, http://www.scientificamerican.com/ article.cfm?id=has-anyone-ever-done-scie.

5 "Reenactment of Joseph Beuys' *7000 Oaks*," Eva and Franco Mattes, http://0100101110101101.org/home/reenactments/performance-beuys.html.

6 Lucy Orta, quoted in "*Antarctic Village—No Borders*, A Project by Lucy and Jorge Orta," by Ann Marie Peña, *Diversifying Fashion* (June 2007), 14.

7 Bartolomeo Pietromarchi, ed., *Lucy + Jorge Orta: Antarctica* (Milan: Mondadori Electa, 2008), 104–5, 109.

8 Ibid., 124.

9 The term "soft borders" comes from Julie Mostov's book *Soft Borders: Rethinking Sovereignty and Democracy* (New York: Palgrave Macmillan, 2008).

10 Orta and Peña, "*Antarctic Village—No Borders*," 18.

11 *Antarctic 2000, Land of Welcome-Transparence* (Paris: Editions Jean-Michel Place, 1996), 120.

12 Orta and Peña, "*Antarctic Village—No Borders*," 15.

Antarctic Village—No Borders, 2007
From February through March 2007, the
artists and their team traveled to the Antarctic
Peninsula to install the Antarctic Village.
The incredible journey, which originated from
Buenos Aires, took place during the austral
summer. The ephemeral installation coincided
with the last of the scientific expeditions
before the winter months, when the ice mass
becomes too thick to traverse. Aided by
the logistical crew and scientists stationed at
the Marambio Antarctic Base, the artists
scouted the Antarctic Peninsula by helicopter
searching for different locations for the north,
south, east, and west encampments of the
50 Dome Dwellings.

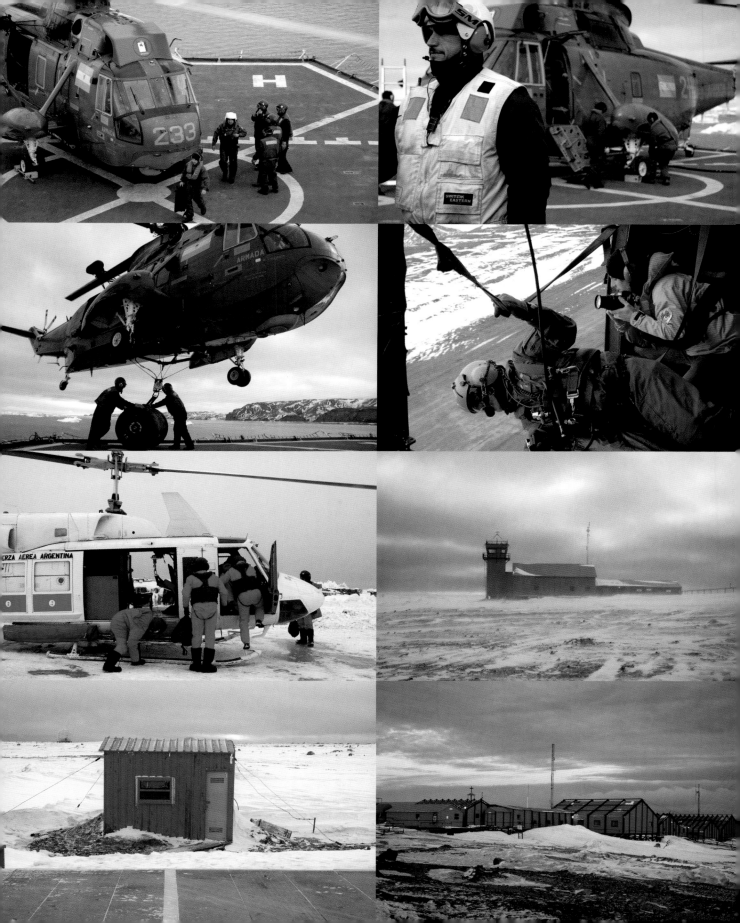

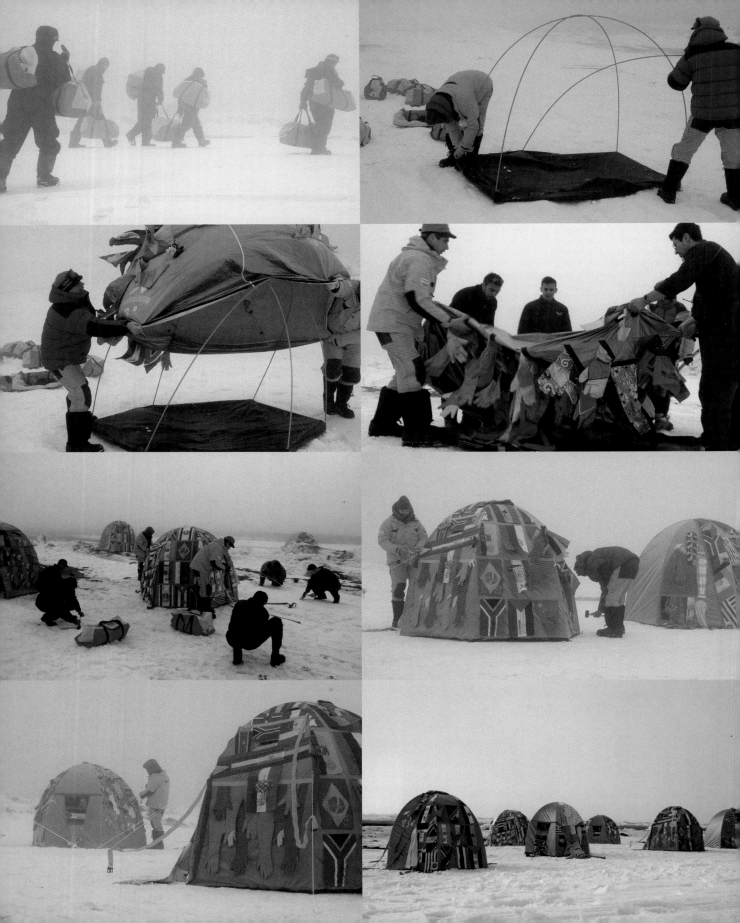

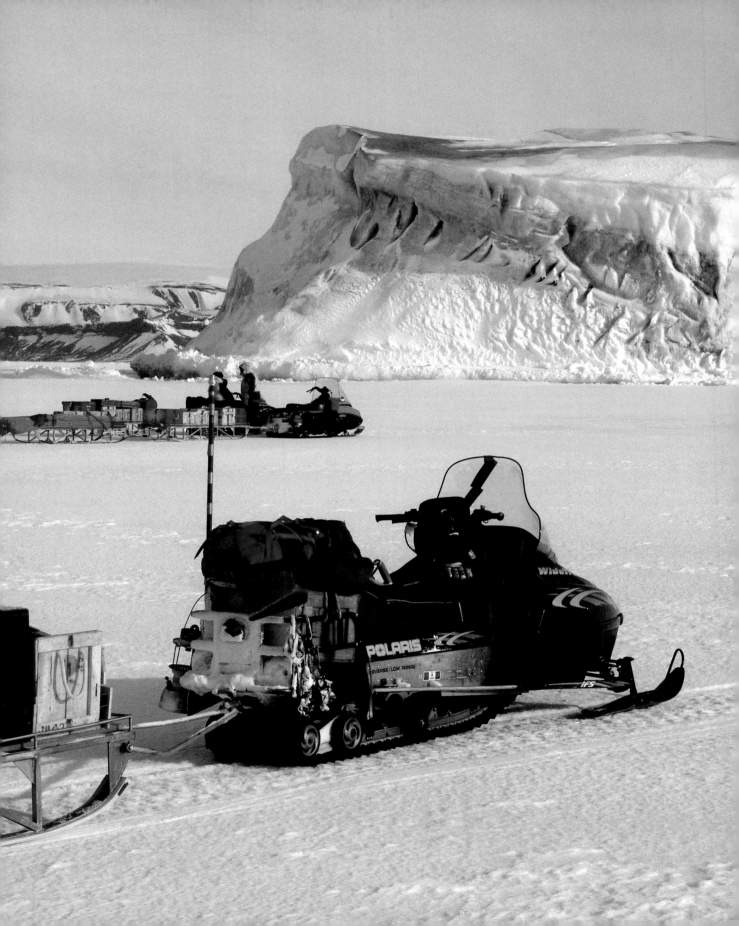

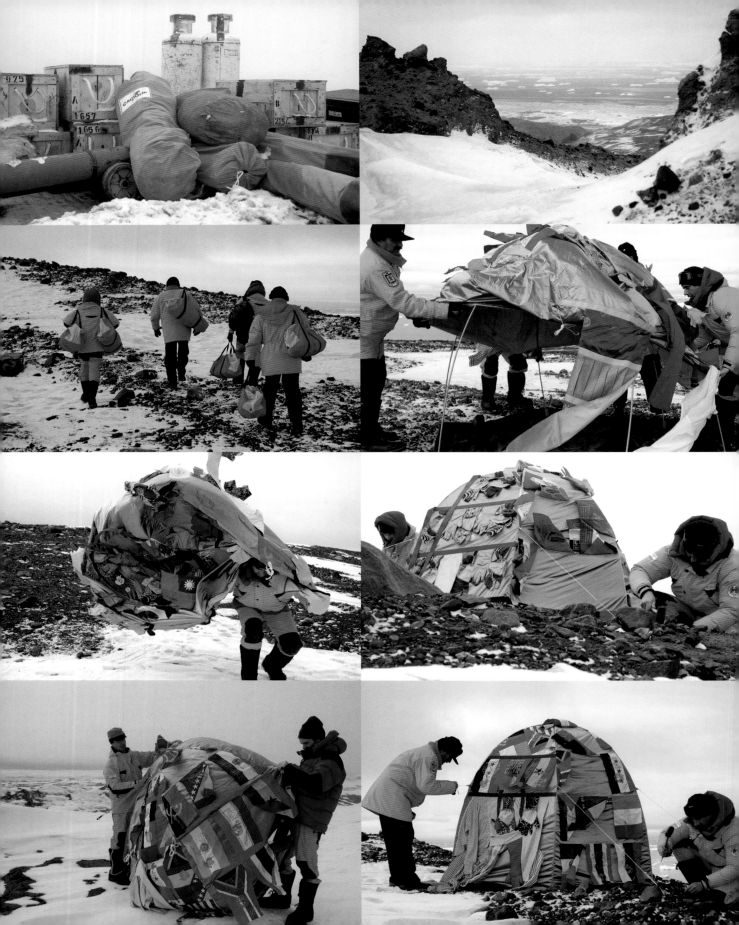

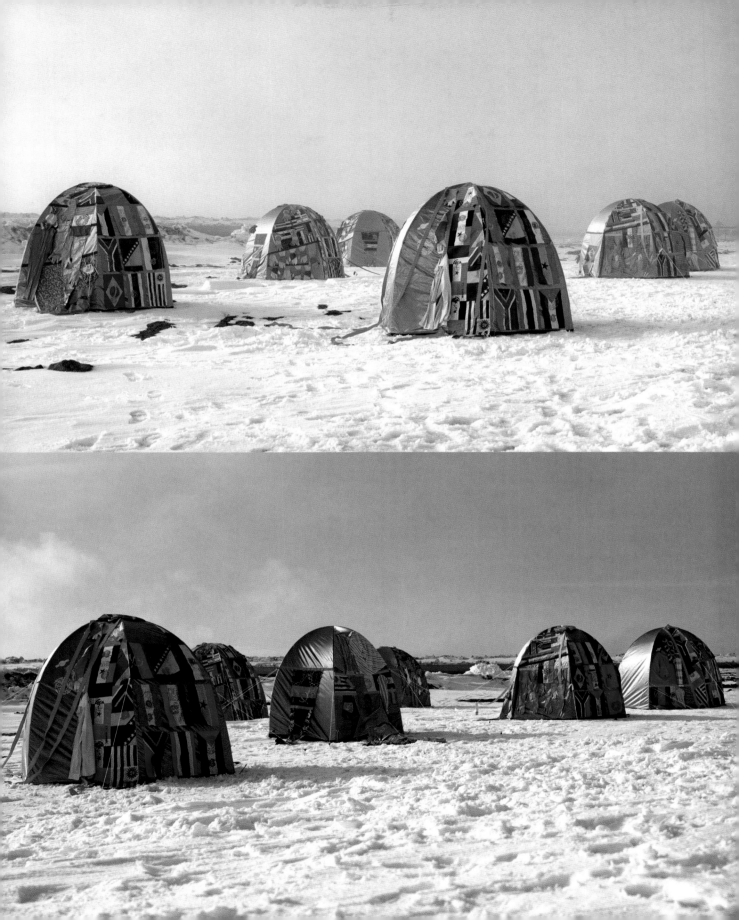

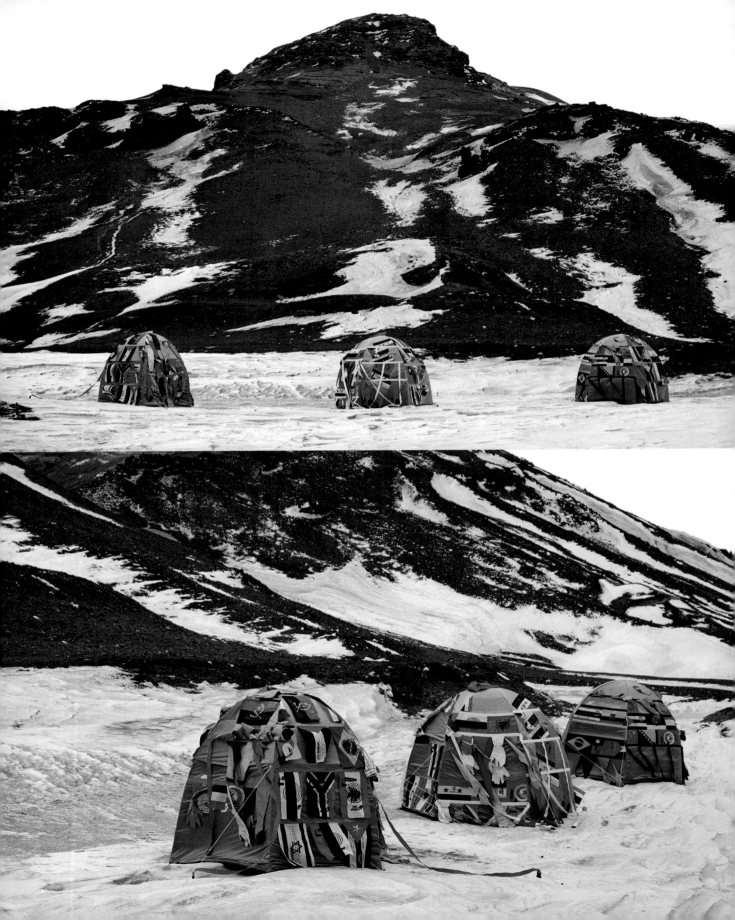

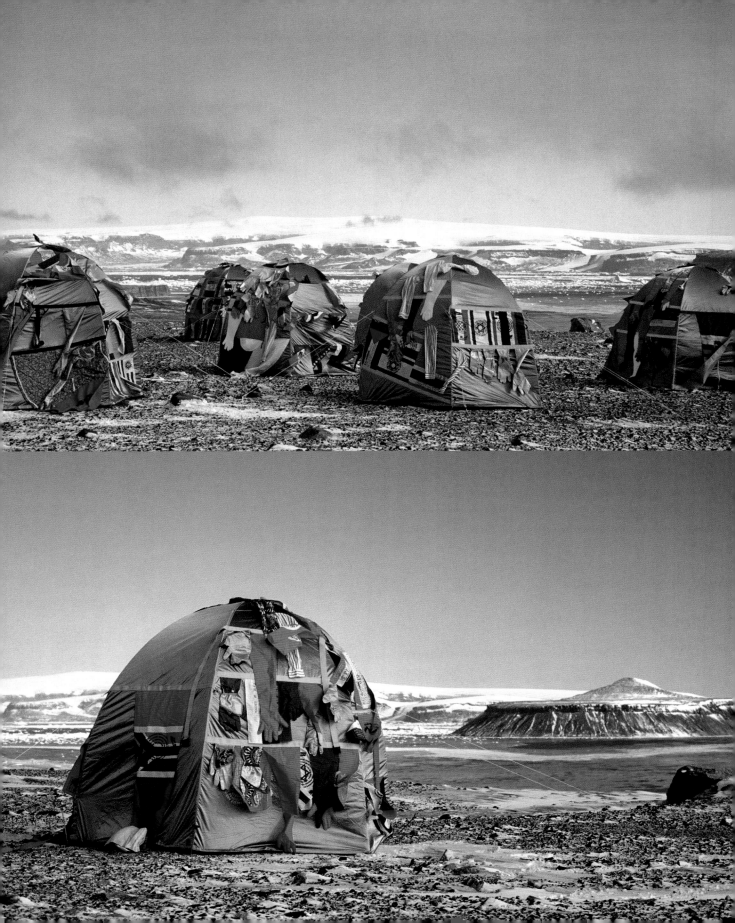

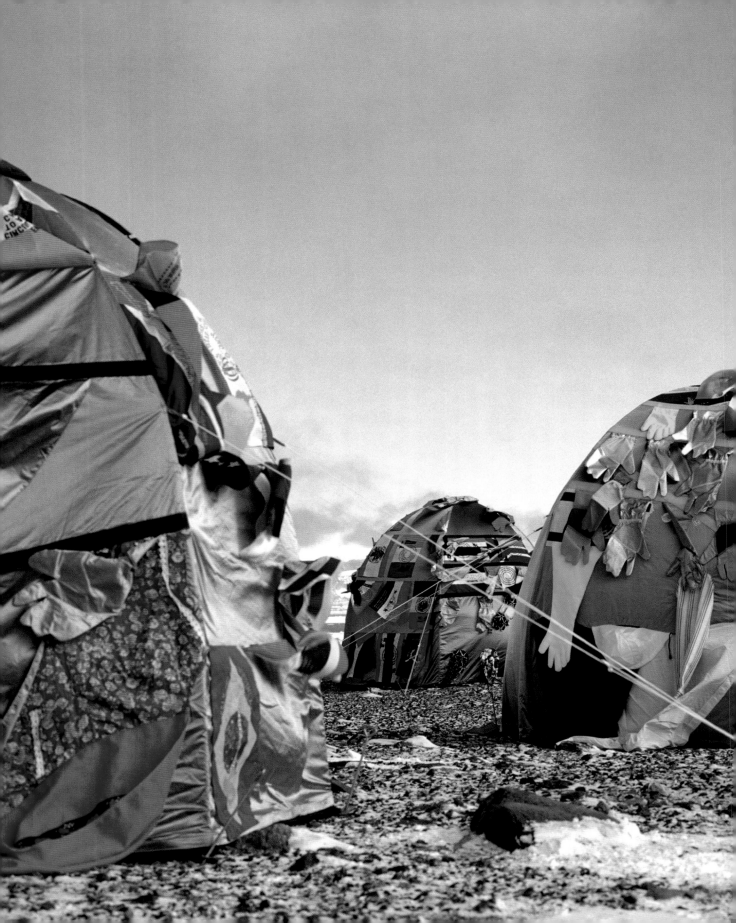

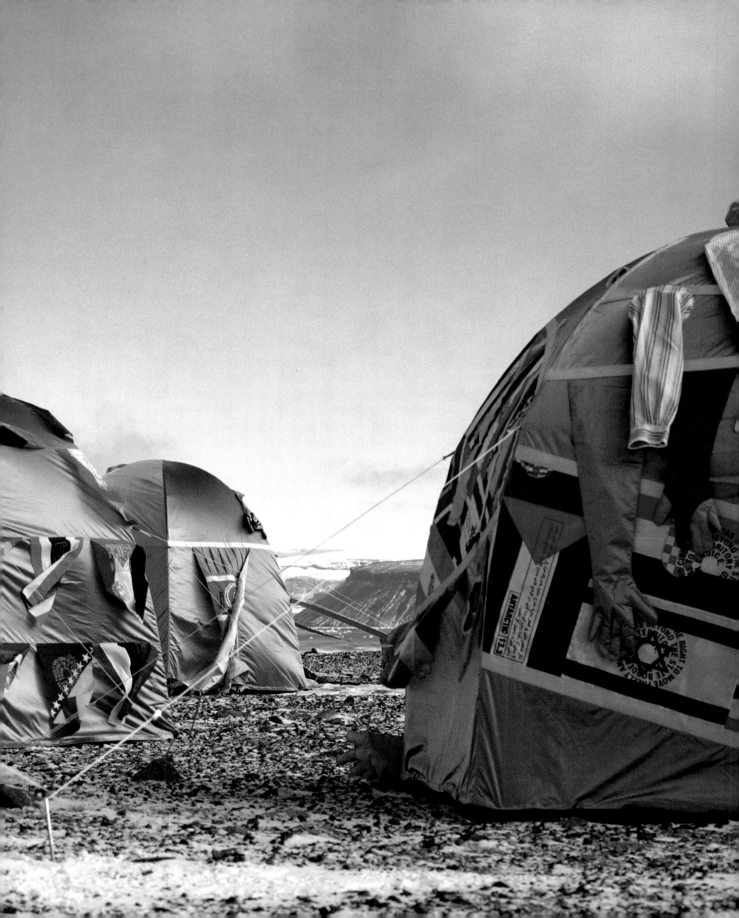

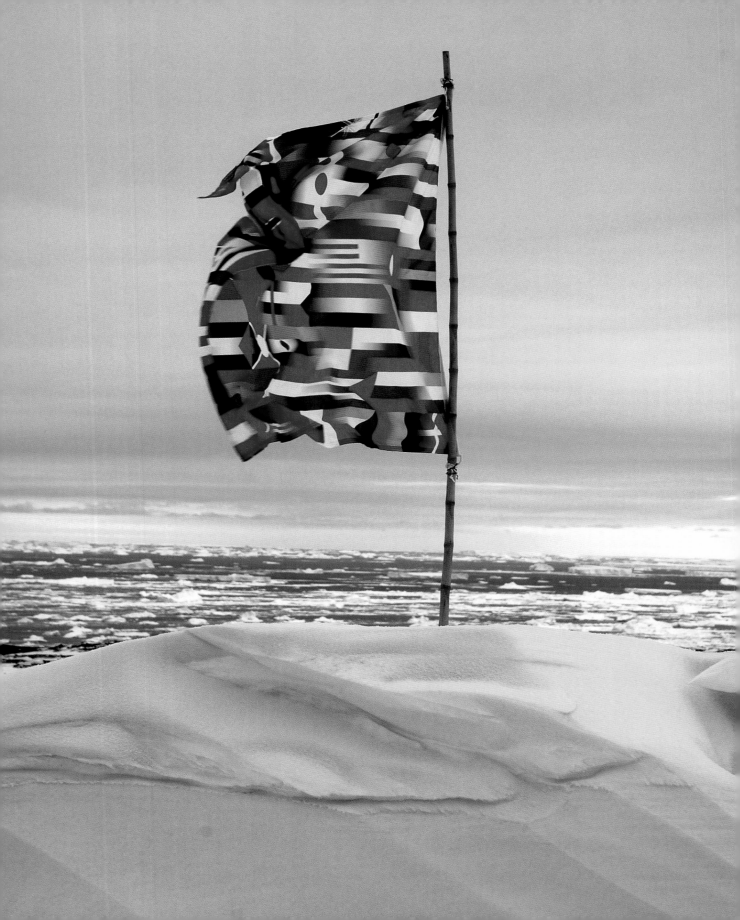

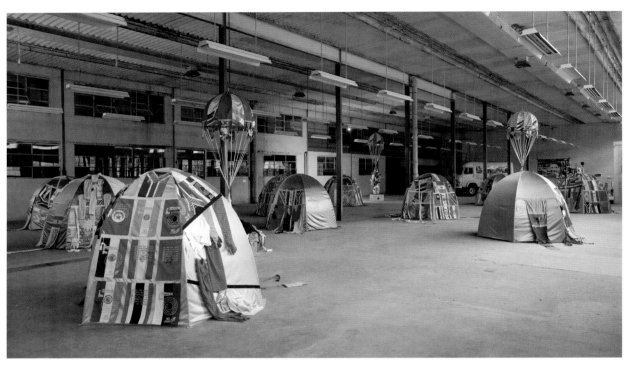

Antarctic Village—No Borders (Galleria Continua, Le Moulin, France), 2007

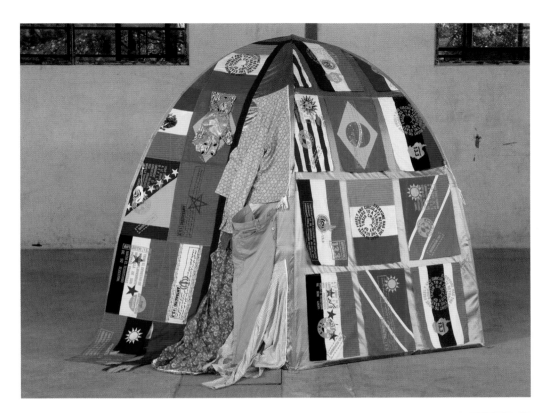

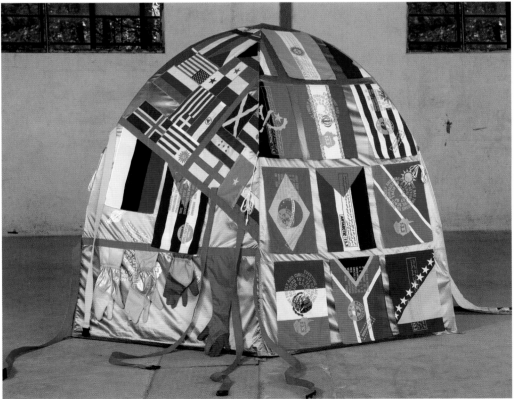

Antarctic Village—No Borders, Dome Dwelling, *2007*

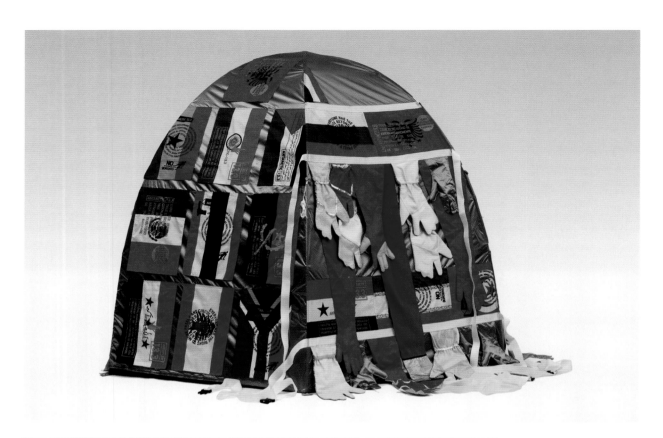

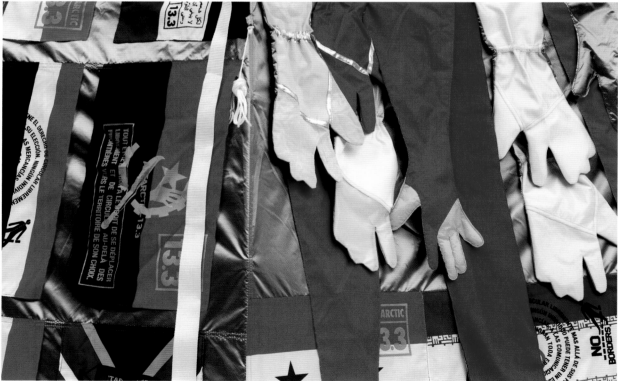

Antarctic Village—No Borders, Dome Dwelling, 2007

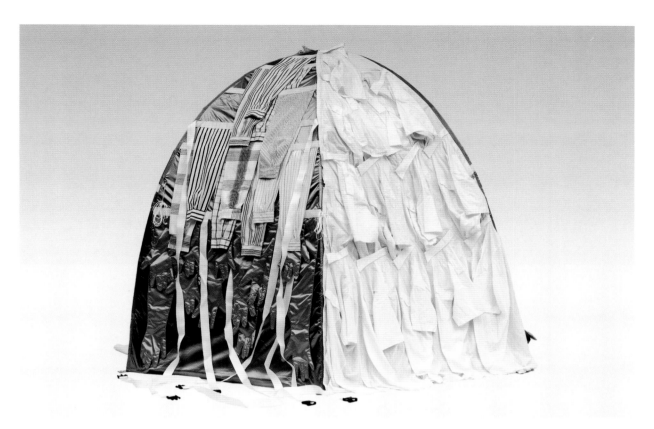

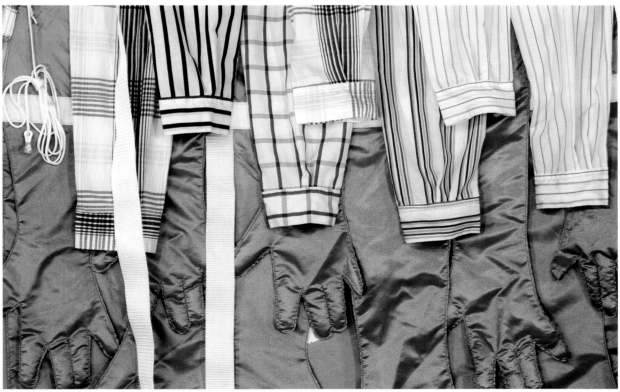

Antarctic Village—No Borders, Dome Dwelling, *2007*

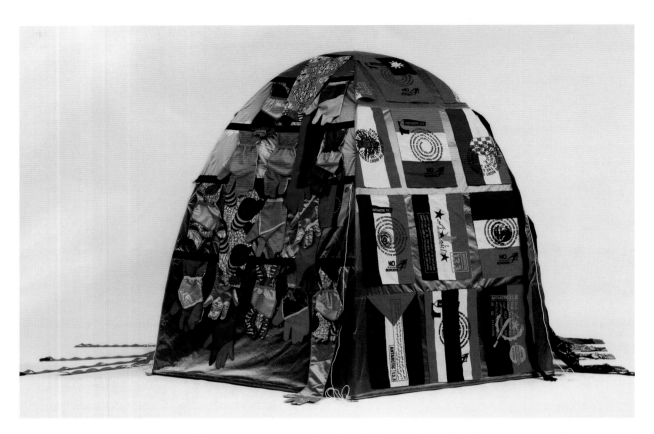

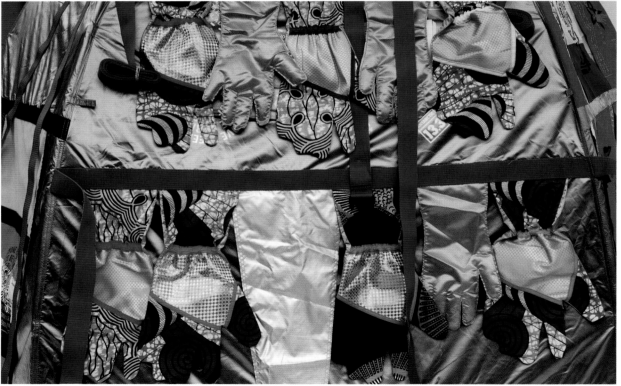

Antarctic Village—No Borders, Dome Dwelling, 2007

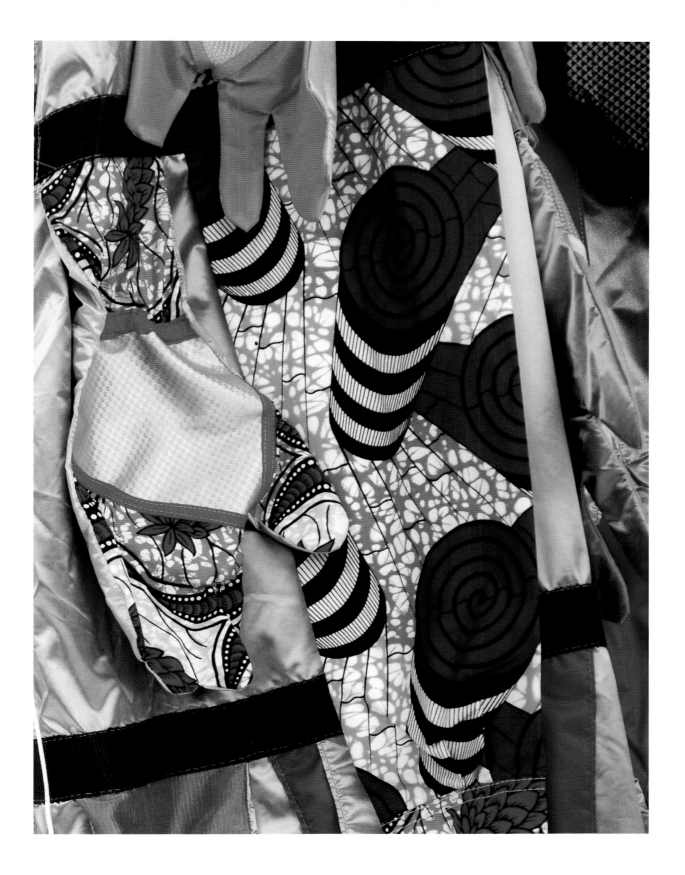

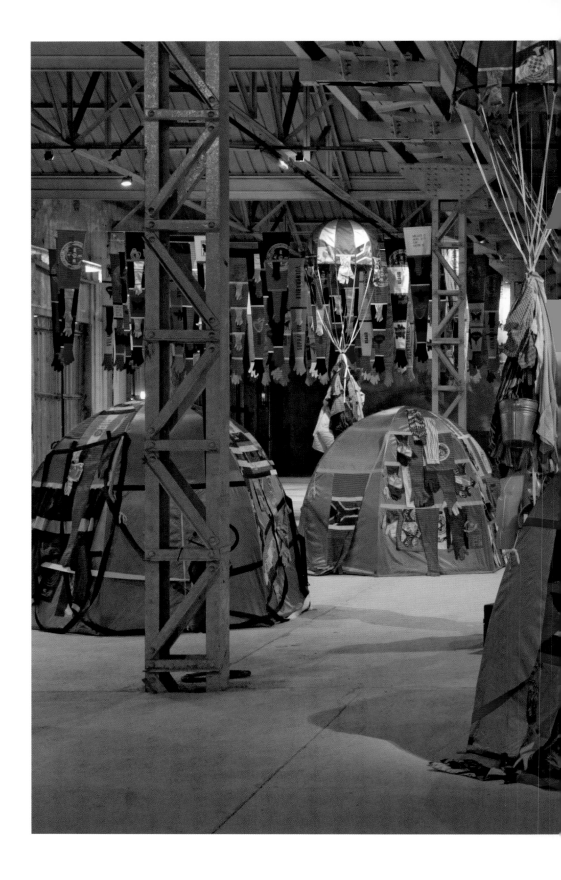

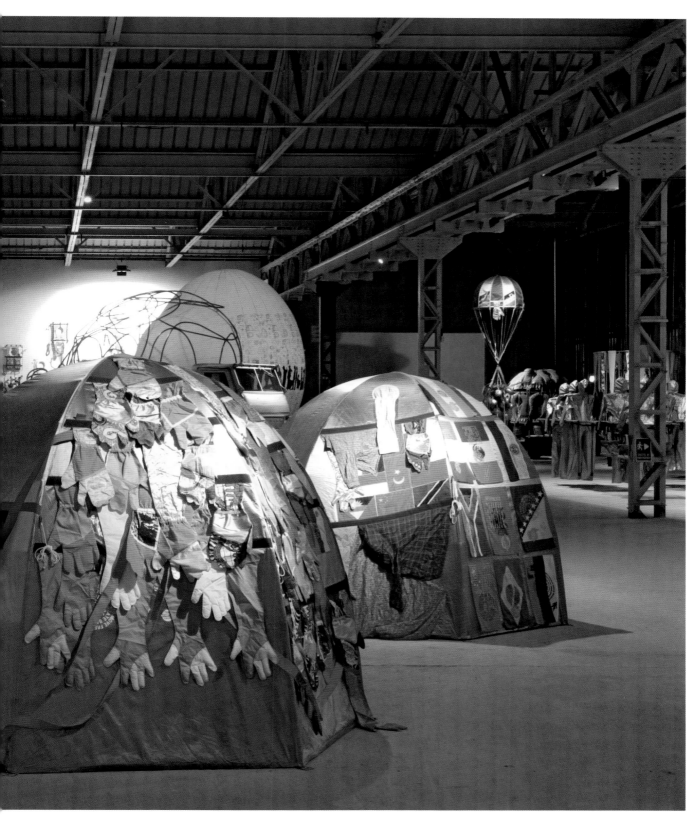

Antarctic Village—No Borders (Hangar Bicocca, Milan, Italy), 2007

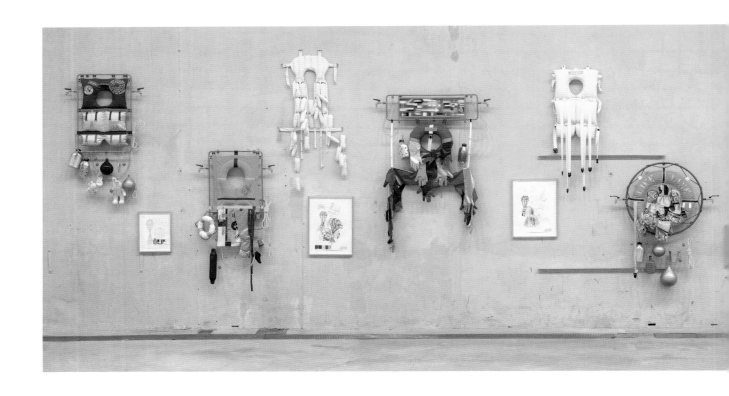

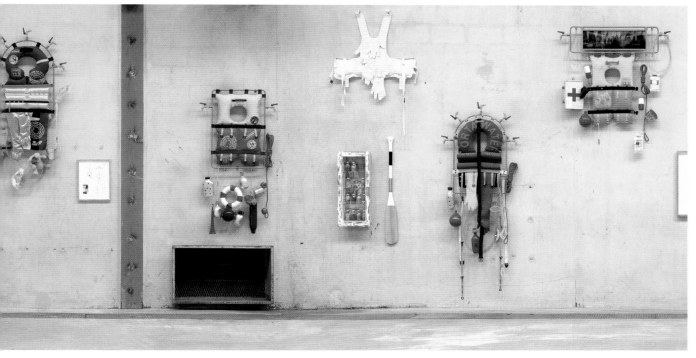

Life Line—Survival Kit (Galleria Continua, Le Moulin, France), 2008

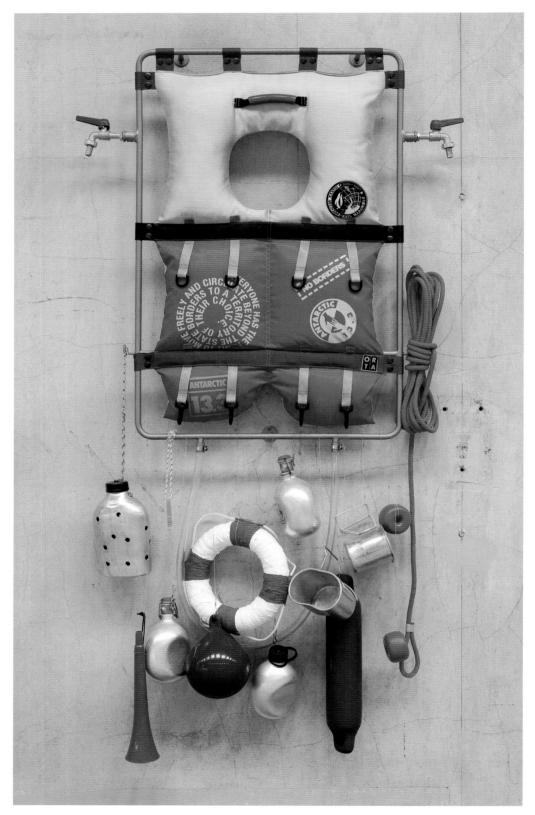

Life Line—Survival Kit, 2008

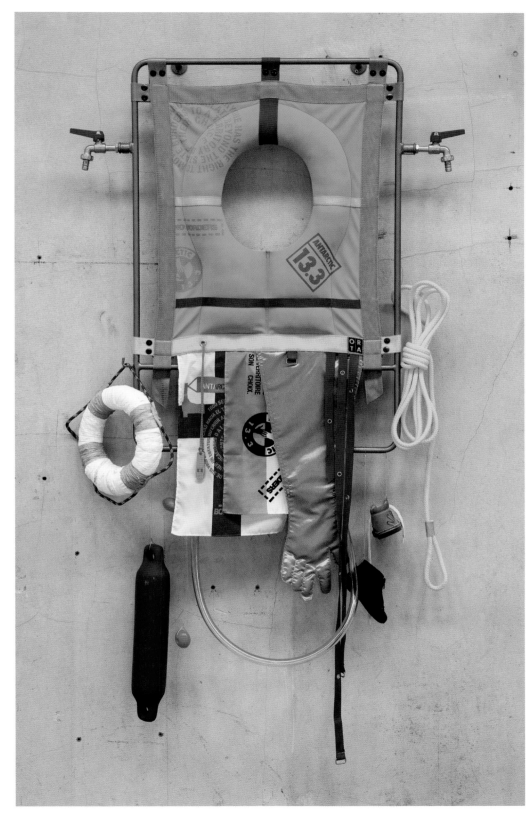

Life Line—Survival Kit, 2008

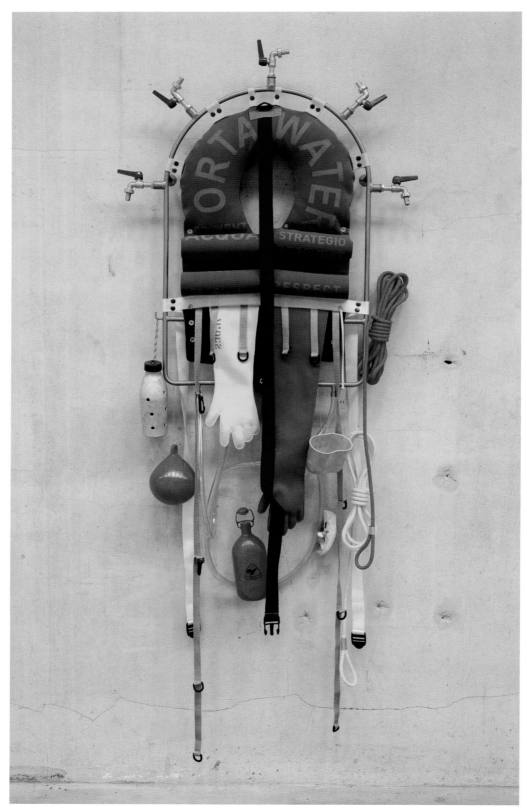

Life Line—Survival Kit, 2008

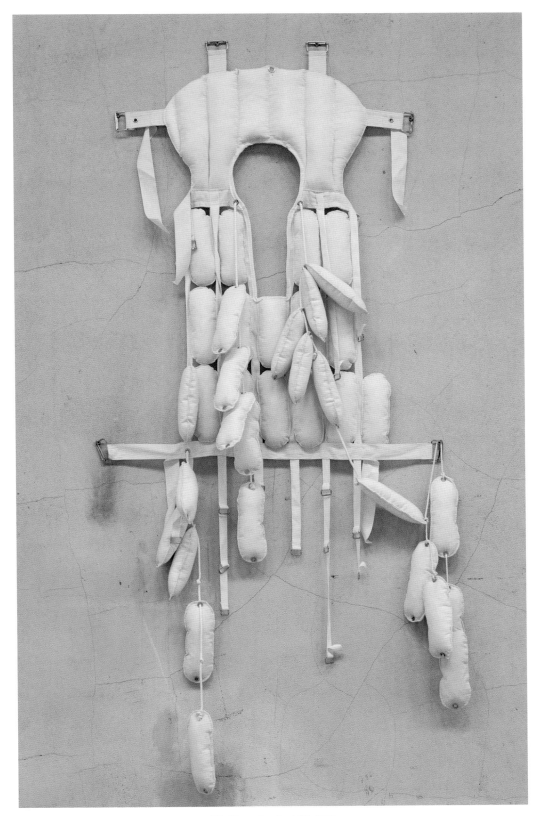

Life Line—Survival Kit, 2008

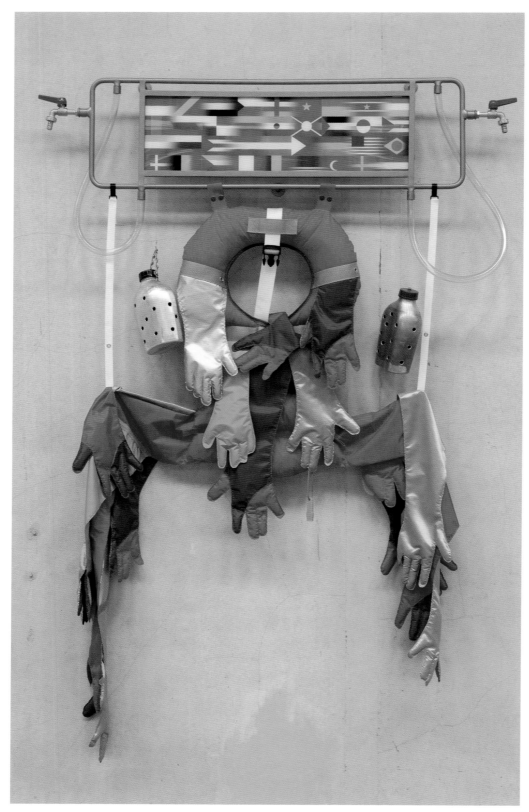

Life Line—Survival Kit, 2008

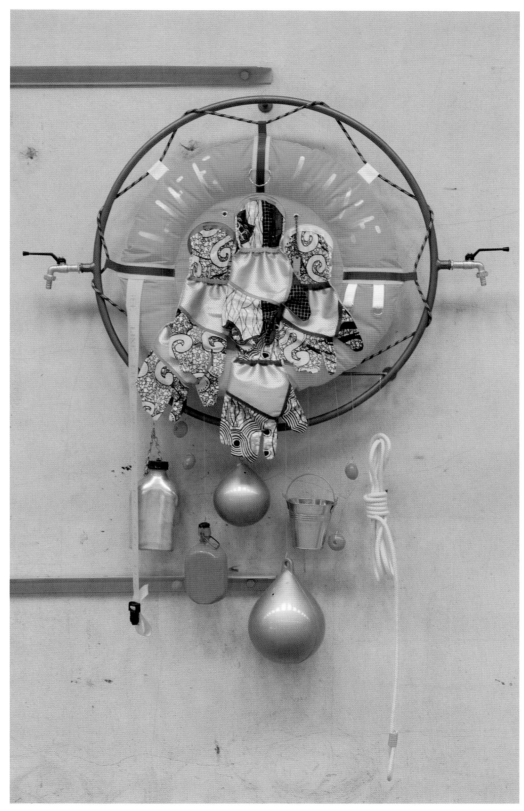

Life Line—Survival Kit, 2008

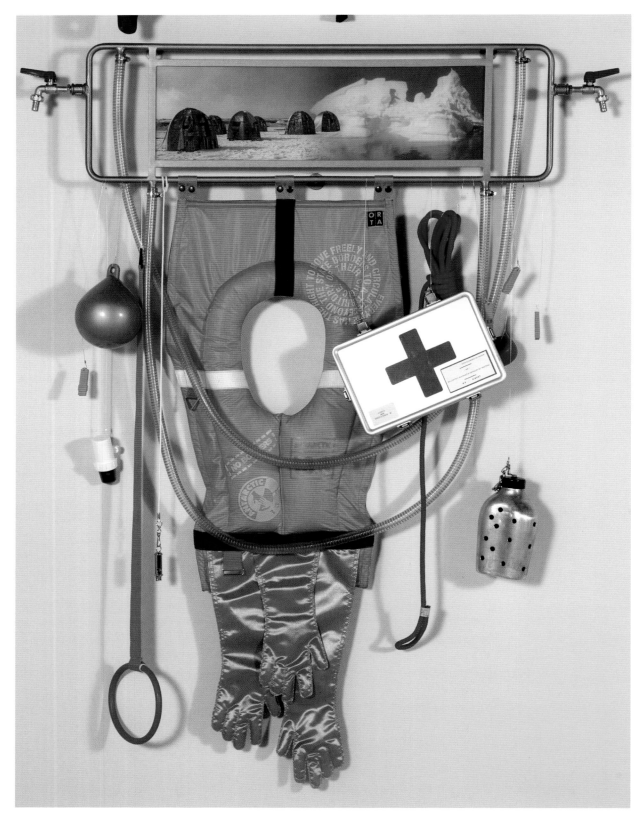

Life Line—Survival Kit, 2008

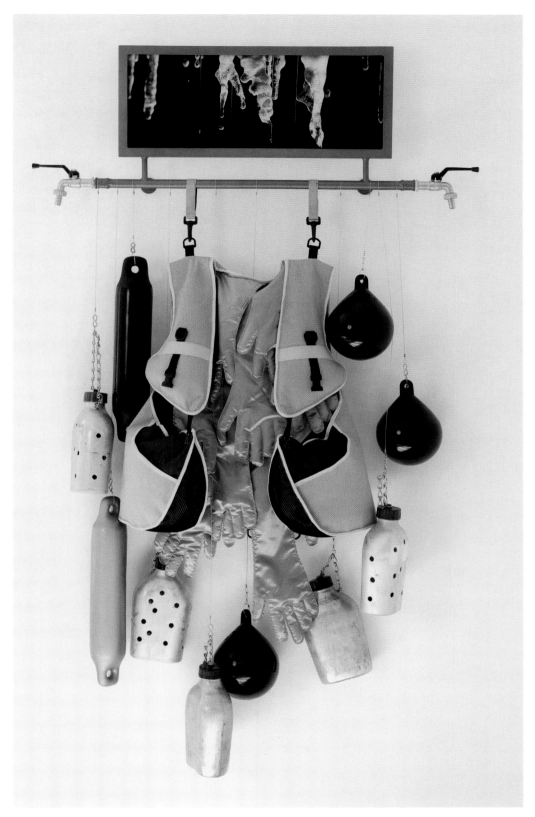

Life Line—Survival Kit, 2008–9

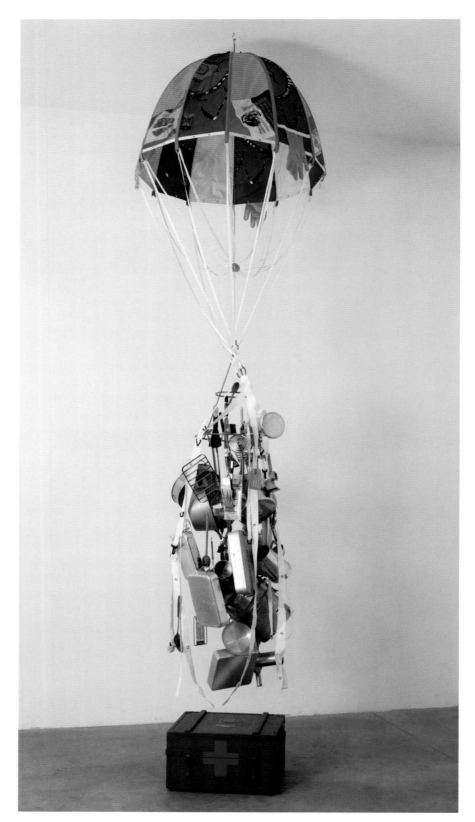

Antarctic Village—No Borders, Drop Parachute, 2007–8

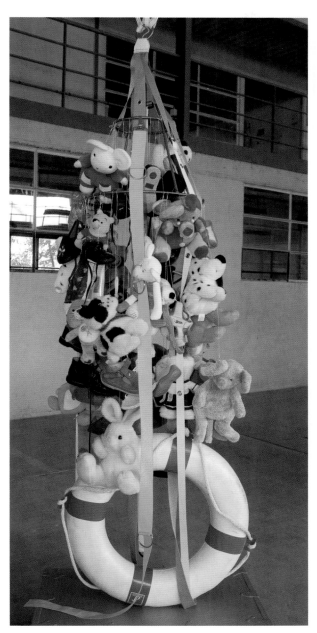

Antarctic Village—No Borders, Drop Parachute, 2007–8

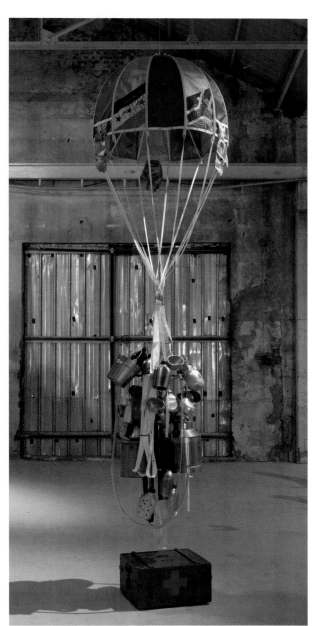

Antarctic Village—No Borders, Drop Parachute, 2007

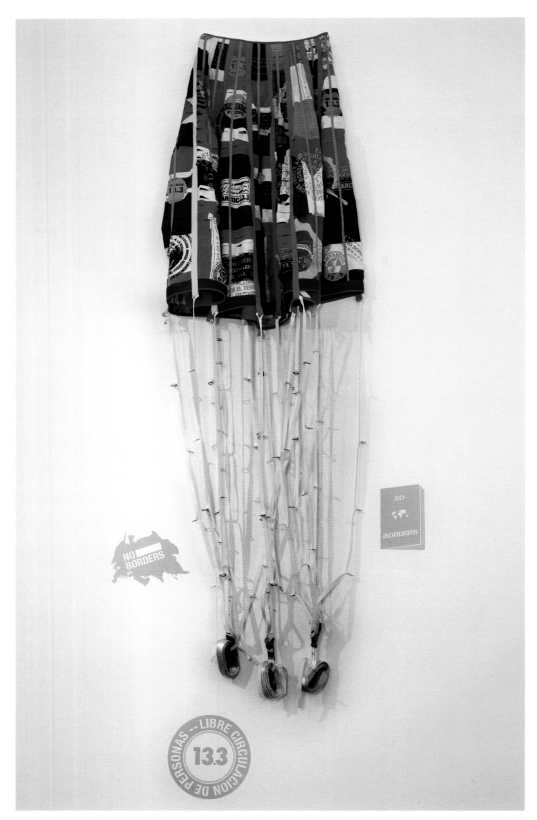

Antarctic Village—No Borders, Drop Parachute, 2007

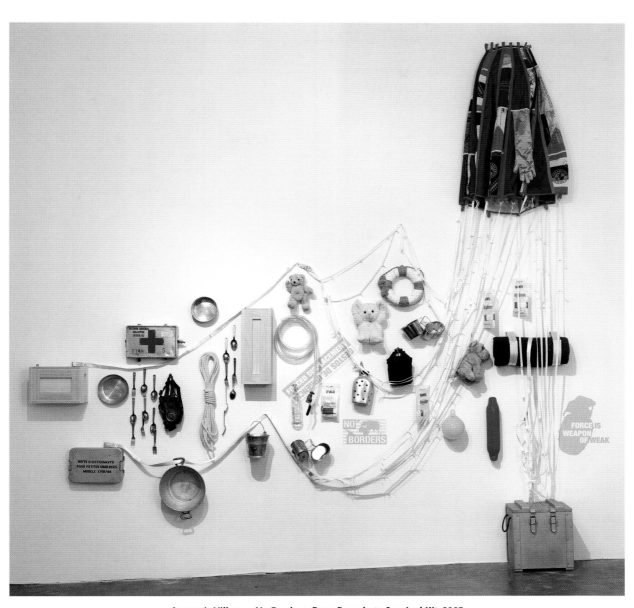

Antarctic Village—No Borders, Drop Parachute Survival Kit, 2007

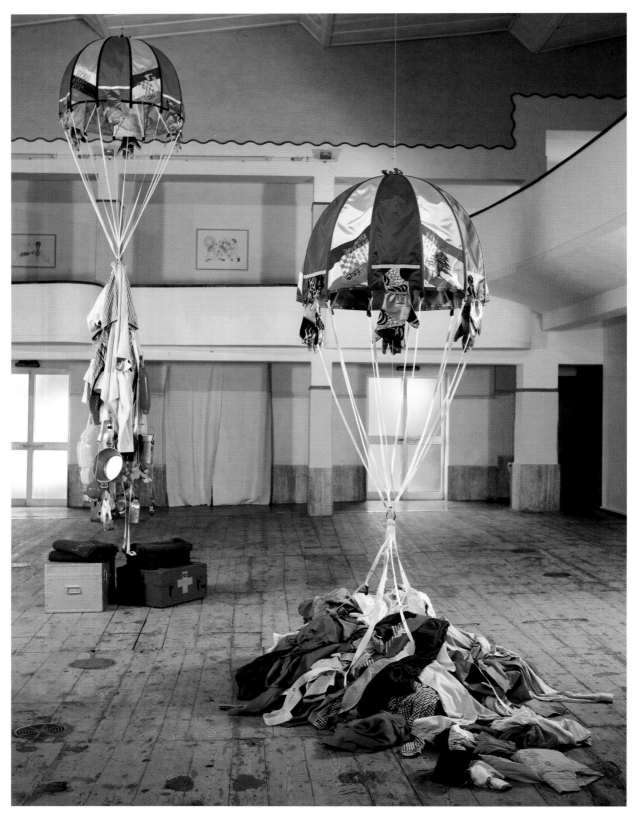

Antarctic Village—No Borders, Drop Parachute (Galleria Continua, San Gimignano, Italy), 2007

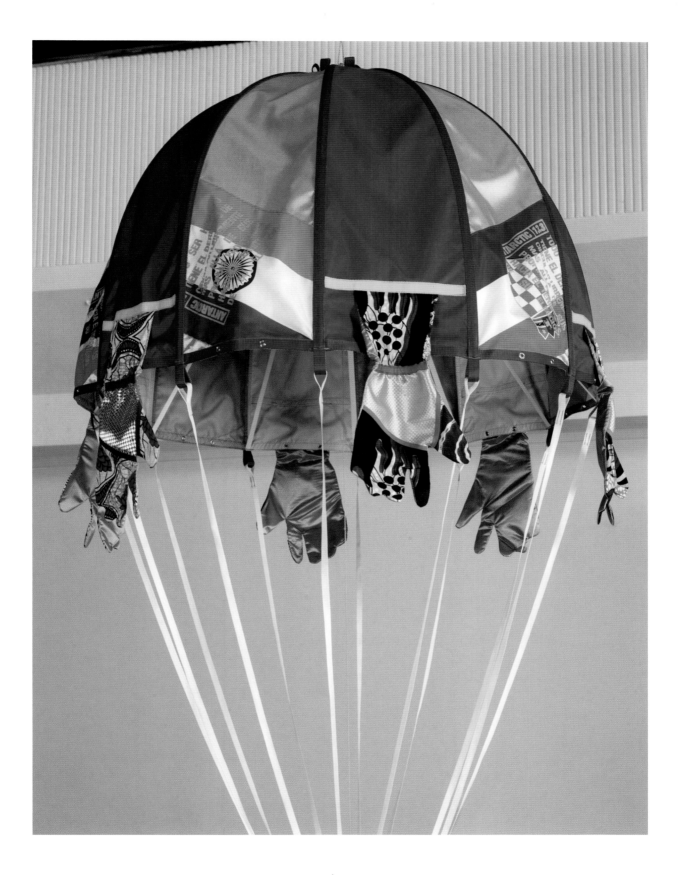

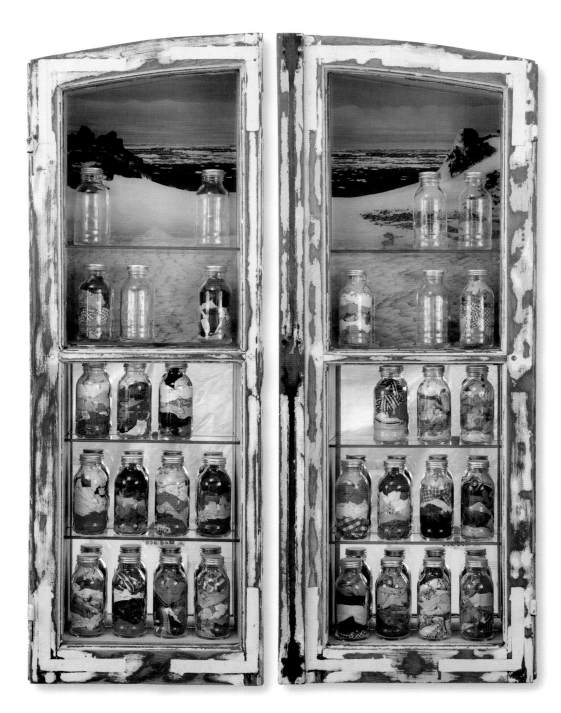

Window on the World—Antarctica, 2008

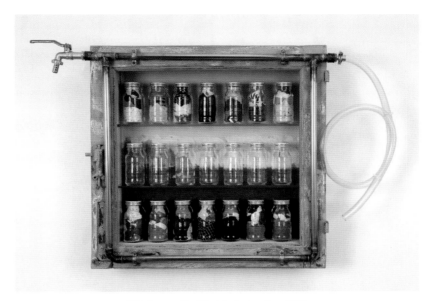

Window on the World—Antarctica, 2007

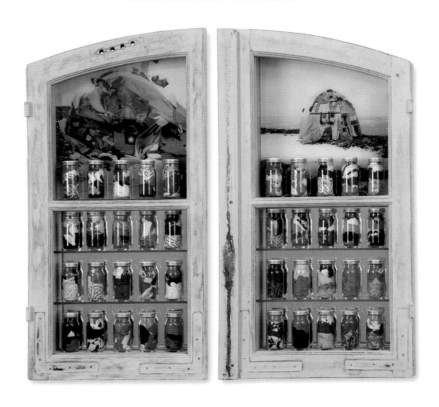

Window on the World—Antarctic Village, No Borders, 2007

**Antarctica World Passport—
International Delivery Bureau**,
2009
Installation along the Paleo Faliro Coast,
for the 2nd Athens Biennale, Greece.

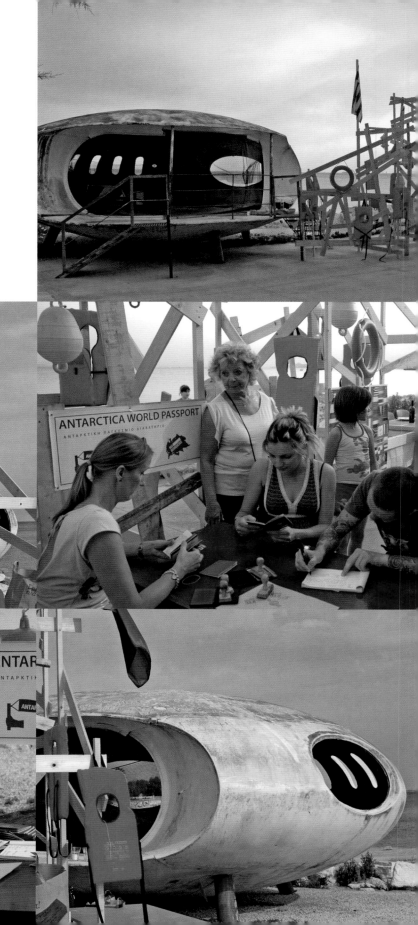

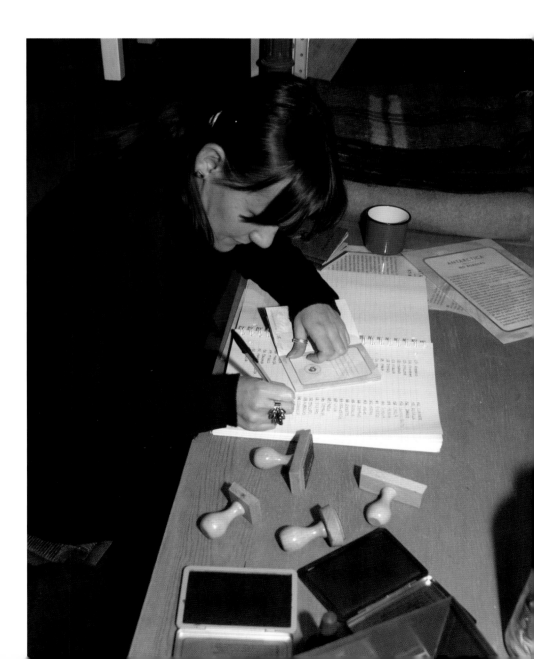

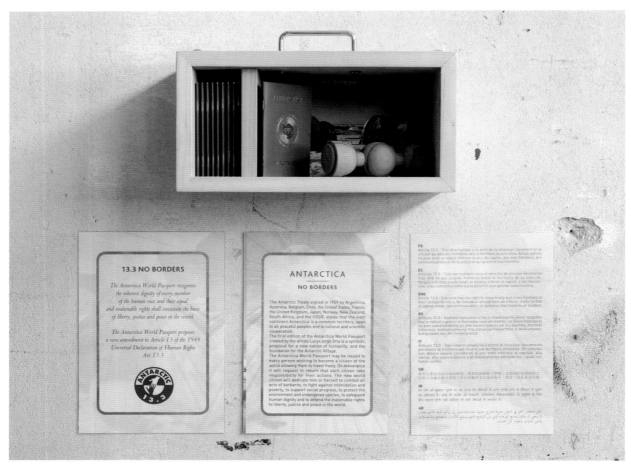

Antarctica World Passport—Delivery Kit, 2008

ANTARCTICA

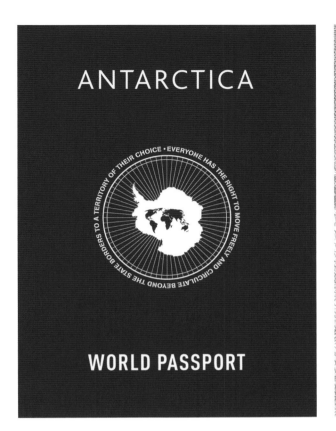

WORLD PASSPORT

ANTARCTICA
NO BORDERS

The Antarctic Treaty signed in 1959 by Argentina, Australia, Belgium, Chile, the United States, France, the United Kingdom, Japan, Norway, New Zealand, South Africa, and the USSR, states that the sixth continent Antarctica is a common territory, open to all peaceful peoples and to cultural and scientific cooperation.

The first edition of the Antarctica World Passport created by the artists Lucy+Jorge Orta is a symbolic proposal for a new nation of humanity, and the foundation for the Antarctic Village.

The Antarctica World Passport may be issued to every person wishing to become a citizen of the world allowing them to travel freely. On deliverance it will request in return that each citizen take responsibility for their actions. The new world citizen will dedicate him or herself to combat all acts of barbarity, to fight against intimidation and poverty, to support social progress, to protect the environment and endangered species, to safeguard human dignity and to defend the inalienable rights to liberty, justice and peace in the world.

13.3 NO BORDERS

The Antarctica World Passport recognises the inherent dignity of every member of the human race and their equal and inalienable rights shall constitute the basis of liberty, justice and peace in the world.

The Antarctica World Passport proposes a new amendment to Article 13 of the 1948 Universal Declaration of Human Rights Art. 13.3

FR
Article 13:3 - Tout être humain a le droit de se déplacer librement et de circuler au-delà des frontières vers le territoire de son choix. Aucun individu ne peut avoir un statut inférieur à celui du capital, des marchandises, des communications et de la pollution qu'ignorent tout frontière.

ES
Artículo 13:3 - Todo ser humano tiene el derecho de circular libremente mas allá de sus propias fronteras hacia el territorio de su elección. Ningún individuo puede tener un estatus inferior al capital, a las mercancías, a las comunicaciones o a la polución que ignoran toda frontera.

ENG
Article 13:3 - Everyone has the right to move freely and cross frontiers to their chosen territory. No individual should have an inferior status to that of capital, trade, telecommunication, or pollution that traverse all borders.

RO
Artikolo 13:3 - Svakone manushes si les o chachimos te phirel slobodno thaj te nakhel e granici le themeske save von kamen. Le dzene trebulas te na aven sokotime/dikhle pe jekh telutno statuso sar si o kapitalo, kinimos/bikinimos, telekomunikacija thaj poluacija/melearimos le mediumosko, bukija saven na-j len limite/granice.

IT
Articolo 13:3 - Ogni essere umano ha il diritto di circolare liberamente attraverso le frontiere per recarsi nel territorio prescelto. Gli individui non devono essere considerati di uno stato inferiore al capitale, alla merce, alla comunicazione e all'inquinamento atmosferico, i quali non hanno confini.

CH
每个人都有自由行动的权利，都有权超越国土界限，去到他们选择的国土，任何人的地位都不得低于可以穿越所有边境的资本、商品、信息甚至污染。

IN
हर एक को मुक्त घूमने का एवं राज्य की सीमाओं से आगे उनके पसंद के विस्तार में घूमने का अधिकार है। कोई भी व्यक्ति को राजधानी, सरोसमान, संदेशव्यवहार, या प्रदूषण के लिये हीन भावना होनी नहीं चाहिये जो सभी सीमाओं से आपार है।

AR
لكل شخص الحق في التنقل بحرية خارج حدود بلده والدخول إلى تراب البلد الذي يختار. لا ينبغي أن يكون وضع أي فرد أدنى من الوضع الذي يسمح للأموال والبضائع والاتصالات وحتى التلوث باجتياز كل الحدود.

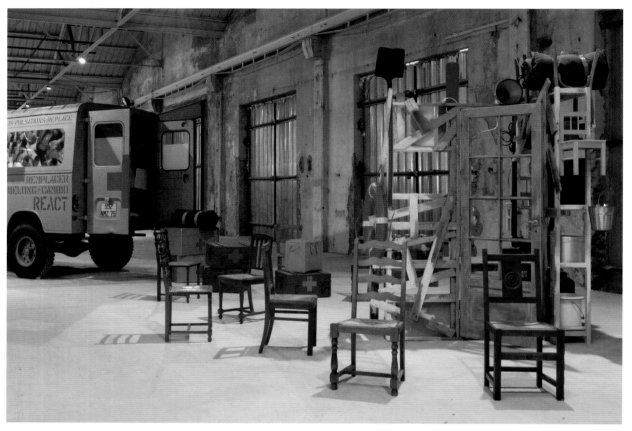

Antarctica World Passport—International Delivery Bureau (Hangar Bicocca, Milan, Italy), 2008

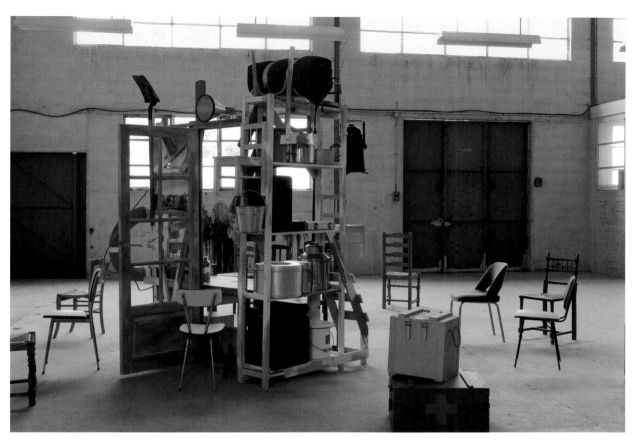

Antarctica World Passport—International Delivery Bureau (Galleria Continua, Le Moulin, France), 2008

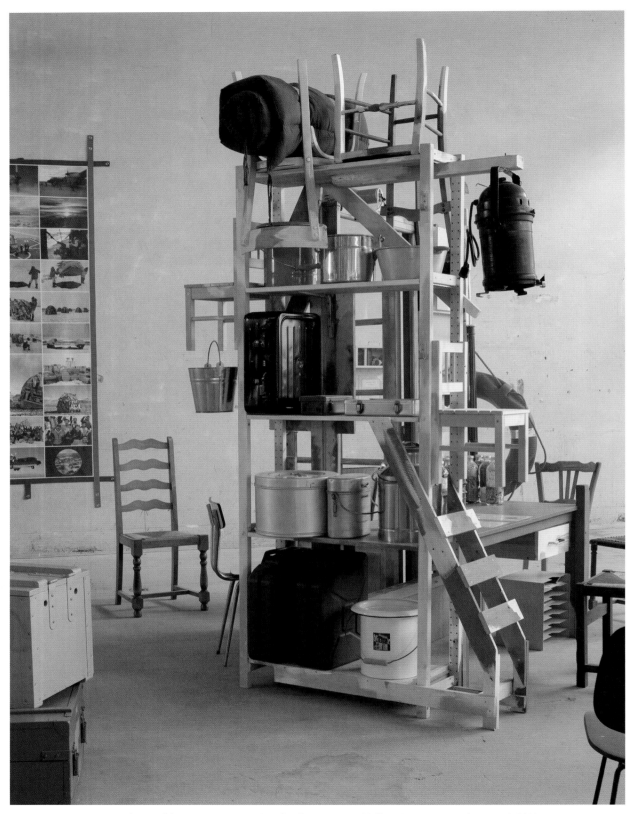

Antarctica World Passport—International Delivery Bureau (Galleria Continua, Le Moulin, France), 2008

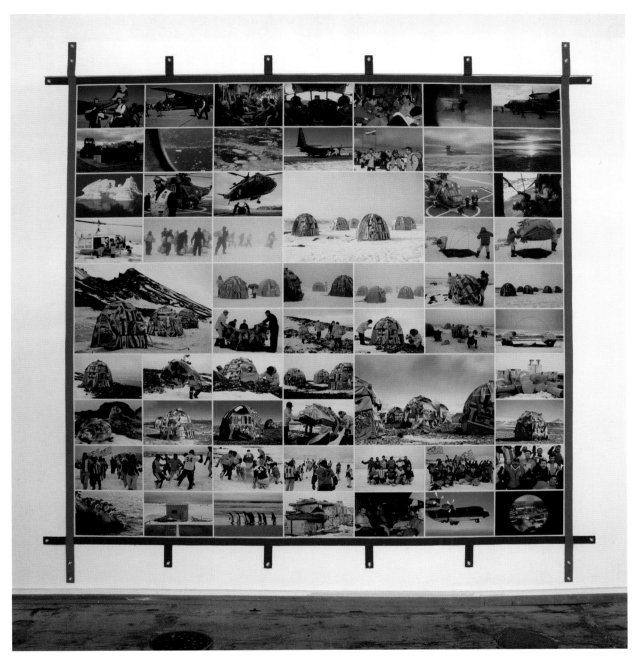

Antarctic Village—No Borders, Expedition Tarpaulin, 2007

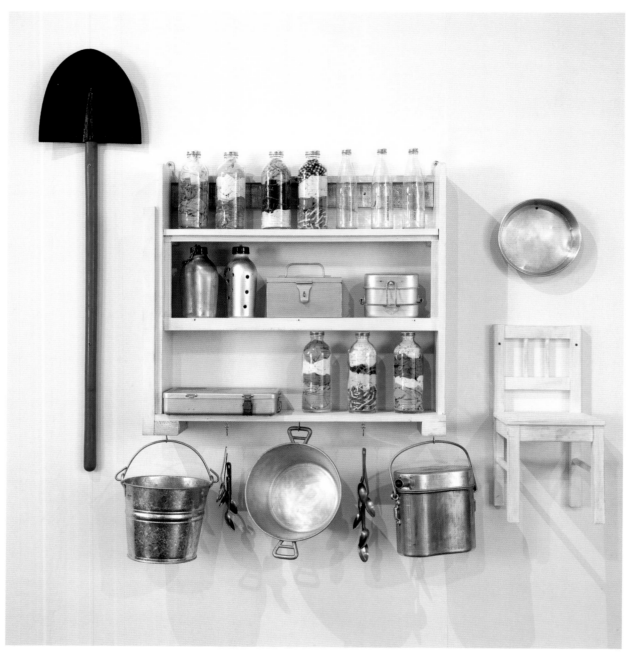

Antarctica World Passport—Mobile Delivery Bureau, 2008

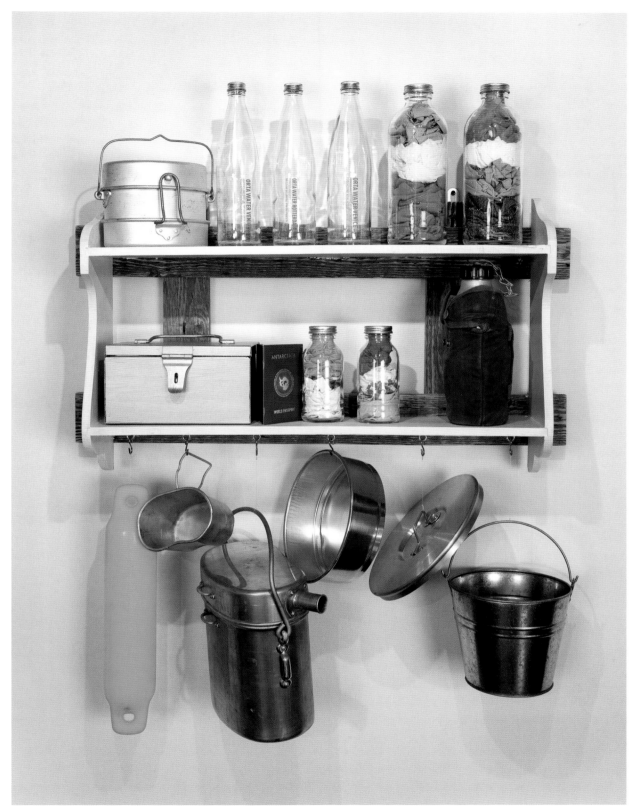

Antarctica World Passport—Mobile Delivery Bureau, 2008

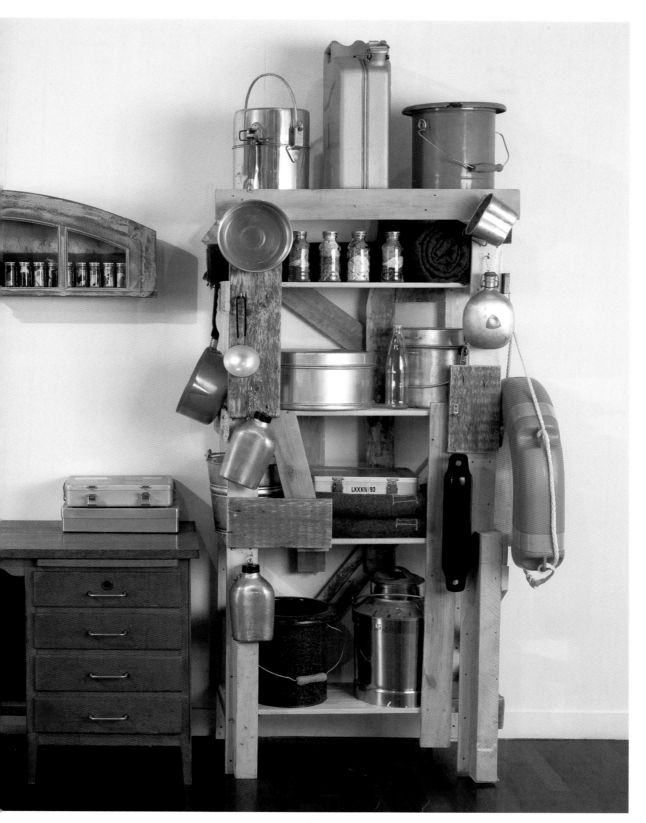

Antarctica World Passport—Mobile Delivery Bureau, 2008

INTERVIEW

In Conversation
with Lucy + Jorge Orta

Hou Hanru

HHR: *Lucy, I remember seeing your work for the first time in Paris. It was in Galerie Anne de Villepoix in 1993, in a group show with other artists, including Peter Fend. I was impressed by your shelter clothes. Since then, your work has made two progressions. First, you shifted from your background in fashion design to working with architectural forms and the merging of human clothing and habitat environments. Second, you opened up your personal designs/creations to allow community participation. Can you describe how this decision has been implemented and how this change manifests itself? Also what are the experiences and conclusions you can draw from such a shift, especially from the process of communicating within the community context?*

LO: I studied fashion-textile design in an excellent design school in Nottingham in the north of England, and worked as a successful designer for various brands in Paris for a number of years, but throughout my practice as an artist, I have not designed fashion per se, even though I make reference to clothing in different bodies of work. The first objects I made were *Refuge Wear* in 1992, conceived as temporary mobile shelters that took the form of tents, bivouacs, and sleeping bags. These were both conceptual and semi-functional, mobile habitats and protective overcoats for nomadic situations. My knowledge as a designer led me to explore new characteristics of fabric membranes and the revolutionary developments that have taken place in synthetic fibers and textile manufacturing since the 1990s, and this opened up an infinite field of material research, far more advanced in applications than what is used in the commercial fashion industry. I was interested in the intelligent textiles revolution—which allowed for a more conceptual approach to design—and in discussions about the new socio-communicative role of clothing. *Body Architecture, Refuge Wear, Modular Architecture*, and *Nexus Architecture* were created as responses to growing problems within our society (loneliness, unemployment, homelessness, and survival in general). By presenting these works in the public sphere, my goals were to raise awareness of the state of these crises and to trigger debate, both within the cultural domain and beyond. I organized workshops, actions, interventions, and public presentations to foster exchange, confronting diverse publics. By bringing together interdisciplinary collaborations between young people, university students, teachers, social workers, architects, and philosophers, our aim was to stimulate discussion and different points of view. Two significant examples are *Nexus Architecture*, created for the second Johannesburg Biennial in 1997, and *Dwelling*, which was staged in numerous cities—from Gorbals, an underprivileged community in Glasgow, Scotland, to Musashino Art University in Tokyo—from 1997 to 2004. These collaborations confirmed that it was possible to team with migrant workers, foster children, design students, unemployed adults, educators, architects, and curators on creative projects that can trigger transformations in people's lives.

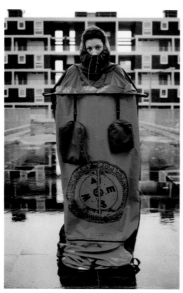

Refuge Wear Intervention London East End, 1998

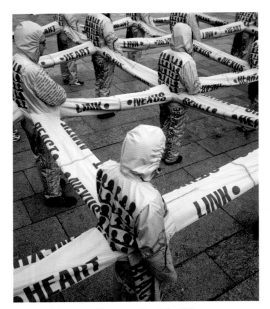

Nexus Architecture × 50 Intervention Köln, 2001

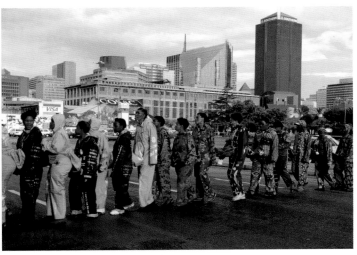

Nexus Architecture Johannesburg Biennale, 1997

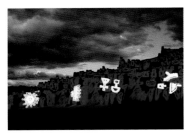

Light Works—Imprints on the Andes, 1992

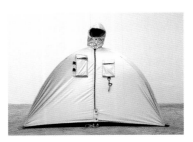

Refuge Wear—Habitent, 1992–93

HHR: *Your works have been presented in many different contexts. However, I often see them in museums and galleries, or "conventional" art contexts.*

LO: Right from the beginning, our work focused on social situations and issues that we thought needed attention in situ. When I met Jorge in 1991, he was in the process of rebuilding an archive of his work—created during the Argentine dictatorship—that had been damaged in a recent studio fire. I assisted him, and we went on to create a series of political artworks and performances in reaction to the Gulf War, followed by the *Light Works* series—large-scale, ephemeral light projections. The first *Light Works* was a 1992 expedition along the Inca trail in Peru, *Imprints on the Andes,* that marked the five-hundredth anniversary of the discovery of the Americas. Around this time I began developing *Refuge Wear* as a response to the Kurd refugee crisis, and organized interventions in public spaces to be in contact with social reality and with communities dealing with the other issues I was investigating through this work. One of the *Refuge Wear* pieces, *Habitent,* was selected for the exhibition at Galerie Anne de Villepoix. I was aware that the work was dissociated from its original context, but it was extremely important, right from the beginning, to communicate to different audiences and create an interface between the two. In addition, by presenting the work within an art context, it received critical attention and media coverage, which in turn furthered the dialogue and broadened the reception of the work to an even wider public.

HHR: *You both are now closely collaborating. But, Jorge, can you talk about your experimental collective work during the dictatorial regime in Argentina? I have learned there was a very active*

avant-garde art scene in the country in the 1960s and 1970s. What was your relationship with it?

JO: I was too young in the 1960s, and this was happening in Buenos Aires, far from my hometown of Rosario. The years of my practice were from 1973 to 1983, a decade of deathly silence and general inactivity. It was this inertia that motivated me to take risks and combat the dominant passivity. My artistic passions and engagement were a prolongation of youth movement ideologies, in particular the obsession with building a more equitable world. Convinced that contemporary art had an important role to play in this process, we felt we should look for new audiences beyond the closed and very conservative traditional art circuits. We explored and experimented with all kinds of new approaches to making and diffusing art to the public at large, inserting the poetic aspects of art into people's daily lives and removing art and the artist from their pedestals. Youth movements were dying out in Europe, but gaining in strength in Latin America as a result of Che Guevara's socialist utopia and liberation theology. It was a period of revolutionary ideas, involving the universities and elitist intellectuals. As a consequence, dictators General Augusto Pinochet in Chile and General Jorge Rafael Videla in Argentina took power between 1976 and 1983. This state of siege banned the organization or holding of private or public meetings. To counteract this, we went underground and employed codified communication strategies to develop new audiences—alternative circuits for long-distance communication. For example, we randomly chose five hundred names in the phone book and contacted them one-by-one, through foot messenger service or coded postal mailings, to make and diffuse artworks—a mini home exhibition. Sometimes we telephoned people and conducted a *Crónica Gráfica, concierto por teléfono*— a telephone concert. You could say that the relationships we wove together in this process prefigured the work that is conducted on the internet today. Our work was done collectively, with the complicity of young artists, musicians, friends, and our students. We invented our own ways of existing, as artists faced with silence and repression. Of course, the museums were not interested in these art forms; we were too far removed from the traditional aesthetic preoccupations of that period. There were no commercial galleries, and we had nothing to sell, so most of our work was given away for free. Despite this, some of the work I made was codified and adapted for museum exhibitions, so that it could be seen both "inside" and "outside."

HHR: *What made you come to Paris? How did your work develop when you arrived in 1984?*

JO: There was nothing more I could do in Argentina. It was becoming increasingly difficult to share my ideas with the new university governors of the arts faculty where I was teaching, so I decided to resign, never to return. I arrived in France thanks to a scholarship artist residency from the Ministry of Foreign and European Affairs. It was

Concierto por teléfono, 1982

a complete shock, and took me several years to overcome. In Argentina there was no economic goal for our artwork—we worked exclusively to participate in the transformation of society. I had two jobs to finance my work, often deprived myself of a family life, and worked nights and weekends to create art.

In Paris, I encountered a commercial art world with no social goal or interest. The FIAC art fair was the pinnacle of professional achievement. I couldn't believe that art could be motivated by commerce. This revolted me, and I decided to revert to fringe activities. Enrolled for a PhD at the Sorbonne, I attempted to reproduce some of the actions and performances from Argentina, to no avail, as my colleagues were not interested in collective activities. The Gulf War broke out in 1990, the stock market crashed, the art system disintegrated and imploded, and finally there was a reason to platform the issues I had left in Argentina. Not only did the recession affect me, but I also lost all of my work in a devastating studio fire, giving me further challenges to overcome. My solo exhibition *Poussière* at the Galerie Bastille in Paris, and Lucy's *Refuge Wear*, were immediate responses to this dire situation.

HHR: *Both your practices have arisen from social situations, and in the case of Jorge, from a traumatic life experience. What are the challenges of working within the context of the art institution in Europe today?*

LO+JO: In the beginning there was a division between our extramural actions and intramural exhibitions. We were working in the public sphere, and the gallery exhibited the results. We were aware of the separation between the living experience and its frozen institutionalization, but felt that the museum public would be able to reconstruct the original context. Wherever possible we would attempt to include the institution in the larger research process right from the beginning, and as a result our projects became more intra-collaborative as curatorial practices changed in the mid-1990s. Artists and curators began working more closely together, conducting community outreach work prior to public presentation, spending time with local groups, understanding the context, elaborating on the artifacts together, and reflecting on how to exhibit the stages of this collaborative process.

One pertinent example of this would be *Commune Communicate*, commissioned in 1996 by the FRAC Lorraine in the city of Metz, France, a collaboration that enabled us to work with inmates of the local detention center, CP Metz. The curators organized a series of workshops inside the prison, and we invited the inmates to talk about their experiences of incarceration. You can imagine how difficult this was to put into place! During the discussions we decided that the artworks would take the form of audio recordings from a selection of our conversations, so that the inmates' voices could resonate beyond the prison walls. We fabricated a communication tool in the form of *Peripheral Communication Units*, small wooden suitcases containing

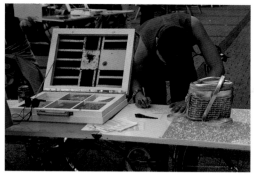

Commune Communicate, 1996

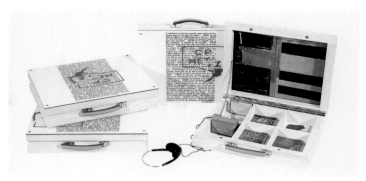

Commune Communicate—19 Doors Dialogue Unit, 1996

Commune Communicate, 1996

Walkmans, personal photographs, and a selection of purpose-made postcards. These were presented to the public of Metz in a busy shopping street on our handmade tables. Passersby could listen to the inmates' personal statements about their past lives and future aspirations, then respond on the postcards, which were in turn posted back to the detention center. This presentation was shown at Casino, a contemporary art gallery in Luxembourg, and then we staged a final exhibition inside the CP Metz for the entire prison community. This type of flux and diversity of public engagement/commissioning agency/non-art institution/street/museum/community can be established at a project's outset when artists and institutions work closely together.

HHR: *This process of public engagement is similar to the approach of HortiRecycling Enterprise, which you presented at the Wiener Secession in Vienna, Austria, in 1999. You connected, in a continuous flow, the interior museum space with the general public of the Naschmarkt open-air market. Can you talk about the food projects as examples of your methodology and approach?*

LO+JO: We don't see museums as static white cubes, but as spaces of intervention, and we work with curators as part of a team enterprise. We tease out a process together to facilitate the participation of a wider audience within and beyond the museum. The physical gallery space allows us to reconstruct projects that have happened elsewhere, and is often a quiet place to reflect on the results of a project, which might still be happening elsewhere simultaneously. At the Secession we experienced an incredible progression in curatorial practice, as initiatives were being instigated in Vienna far beyond the traditional parameters of the job. For example, the curators visited the Naschmarkt vendors daily, invented jam recipes, and discussed health issues with the Viennese chef Han Staud. From our studio in Paris, we mediated between the initiatives so that the enterprise could be carried through from idea to realization.

Instead of discarding their overripe fruit and vegetables, market vendors were given *Collect Units*—brightly colored, silkscreen-printed bags—to fill with rejected produce throughout the day. Another team manning the *Processing Units*—mobile kitchens with integrated

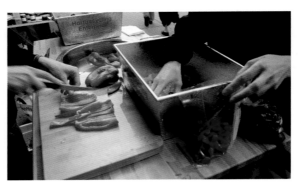

HortiRecycling Enterprise, act II, 1999

HortiRecycling Enterprise, act II, 1999

HortiRecycling Enterprise, act II, 1999

shopping carts, sinks, hotplates, and freezers—collected the produce-filled bags. The ripe produce was cleaned, chopped, and cooked by chef Staud on location in the market. We distributed the fresh delicacies to encourage the public to take up these kinds of sustainable initiatives. In the Wiener Secession's first-floor gallery, we set up a second working kitchen complete with a *Collect Unit Pulley*, a wooden winch reminiscent of the medieval pulley systems used to haul groceries in baskets to the upper floors of tall buildings. Using this device, market produce was delivered to the gallery, cleaned, cooked, and then bottled or frozen in dainty portions ready for distribution. This pilot action took place in both the market and the gallery, illustrating the multiple possibilities of a recycling enterprise and at the same time bringing together an art institution, the street, and the different communities involved.

HHR: *In these works, your role is both artist and project manager: you mobilize the institution (taking it beyond its established limit and out of the art context), involve the community, communicate the project, and encourage wide participation. To what extent do you consider your work to be an artistic project versus a sociological one?*

LO+JO: For us they are one of the same, both creative and sociological, linked and inseparable. For the last decade we have been looking for formats for our work that enable interaction and foster responses to the real challenges and needs of local communities. After *All in One Basket* (1997) and *HortiRecycling Enterprise* (1999), *70 × 7 The Meal* (2000) was the natural next step in our research—from food collecting and recycling, to the fabrication of culinary objects and artifacts, to the actual ritual of dining.

For the *70 × 7 The Meal* series, we invite a small number of guests to become part of an endless banquet, and in turn ask them to invite other people, so the act of creating the event happens through the chain of human interaction. We are merely triggers in that process, or enablers. The artwork becomes almost invisible, taking the form of our most cherished rituals; it mimics the essential human need to eat and to unite. For each meal we try and create a set of bespoke artifacts, such as a hand-printed tablecloth or Royal Limoges porcelain plates, designed in our studio. These become the binding elements

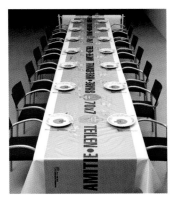

70 × 7 The Meal, act III Innsbruck, 2000

of each meal, leaving a trace that something unusual has brought these guests together. However, we ensure that these clues remain discreet, so as not to incite a "fear of art"; instead, they act as catalysts, stimulating encounters to blossom naturally. By setting the meals in an urban space, we return to the need for spontaneous general assemblies around specific subjects, bringing people together to converse, reconcile, and reflect, with the potentiality of an artwork that is active in the heart of a community. By blurring the boundaries between an art project and a real-life situation, our goal is to incorporate people as active participants, giving them a sense of belonging and empowering communities with a sense of civic responsibility. Each meal changes the world, if only in a small way.

HHR: *This type of project reminds us of past experimental art, in particular Joseph Beuys's concept of "social sculpture." His work is based on a personal belief that creativity is essential and part of human nature. Beuys argued that everyone was an artist. However, his way of communicating this message resembled a priest preaching the truth to people. Your practice is perhaps more open and participatory. How do you initiate this process artistically, and to what extent can you still call this artistic or creative?*

LO+JO: We pursue the idea of art as a catalyst for social change, building on Beuys's legacy. We believe that the individual creative potential of people no longer needs to be proved—it needs to be fully recognized and channeled into initiatives that will mobilize an even wider range of members of the community, be they street vendors, passersby, museum curators, or visitors. These individual initiatives—in the form of art actions, performances, or whatever— are the ingredients to catalyze social change. Throughout our practice we have been moved by various problems our society is facing— solitude, hunger, homelessness, water shortages, climate change, migration—and we create poetic schemas to attempt to tackle these problems. By developing long-term research strategies over a minimum ten-year life span that unfold in a series of "acts," we can actually begin to understand and find solutions for ecological, political, and humanitarian issues. By activating debate and discussion, we aim to change people's attitudes or habits, and thus get closer to the seeds of real change, which can even lead to the modification of legislation. It's not the work of art, but a process— through a chain reaction of events with the participation of people— that can actually make this happen.

Once again, we're exploring the extreme limits of art, the periphery, even if it means leaving the artistic sphere altogether, without worrying about whether our activities fit into actual artistic categories or criteria or not. Our aim is to explore and open up new ways of moving forward.

HHR: *Can you give a few examples of these acts?*

LO+JO: Each act is part of an evolving process that becomes more

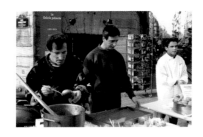

All in One Basket, act I, 1997

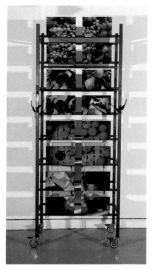

All in One Basket—Les Halles, Conservation Unit, 1997

Wiener Secession, Austria

complex, participative, and embedded with the possibilities that each locale allows. For the first act of the food project *All in One Basket*, we hosted an open-air buffet in one of the busiest central shopping districts of Les Halles, Paris, made with discarded fruit salvaged from Parisian fruit and vegetable markets. A former farmers' market, Les Halles was delocalized in the 1970s, and its site was handed over to real-estate developers, who built a horrific underground shopping mall. *All in One Basket* points a finger at local consumer waste and the inequalities of global food distribution. Using the fruit and vegetable market as an example of a growing urban phenomenon, we were able to generate debate around the broader subject. With more than three hundred kilograms of ripe produce that we had gleaned from the local markets, our professional partner, the famous Parisian pâtissier Stohrer, arduously cooked a variety of sweet dishes. Samples of jams, jellies, and puddings were available to taste for free, and visitors could buy souvenir editions of our bottled and labeled preserves. During the course of the day, thousands of people stopped by, including members of the art community, shoppers, children, tramps, students, and immigrants. In the adjacent gallery of Saint Eustache, we set up an installation of artifacts constructed from wooden fruit crates, and displayed our homemade preserves with photographs of mounds of discarded market produce. The installation also included *Storage Units*, a series of trolleys with baskets symbolizing the collecting of the produce, which were outfitted with a sound system playing the audio recordings of interviews with the community of gleaners at the weekly markets.

Two years later, we were able to stage the second act, *HortiRecycling Enterprise*, thanks to the historical context of the construction of the Wiener Secession, founded in 1897 by artists Gustav Klimt, Koloman Moser, Josef Hoffmann, Joseph Maria Olbrich, Max Kurzweil, Otto Wagner, and others. These artists objected to the conservatism of the Vienna Künstlerhaus, with its orientation toward historicism, and were concerned with exploring the possibilities of art outside the confines of academic tradition. The Secession building could be considered the icon of the movement, and above its entrance is the phrase "To every age its art and to art its freedom." We took advantage of this history, the proximity of the Naschmarkt opposite the gallery, and the energetic curators who carry on the legacy of the Viennese manifesto.

HHR: *How do you shift your practice to specific contexts?*

LO: Sometimes the meal settings are small, so we can focus on specific issues in intimate settings. The larger events for thousands of people allow for greater public participation. The venues range from galleries to restaurants, historic buildings, streets, and open-air parks. For example, *Act XXIII* took place in the Barbican in London, on the occasion of my survey exhibition in The Curve gallery in 2005. The Curve was the ideal setting for piloting *Lunch with Lucy*, a live panel discussion and gastronomic encounter for seven food specialists,

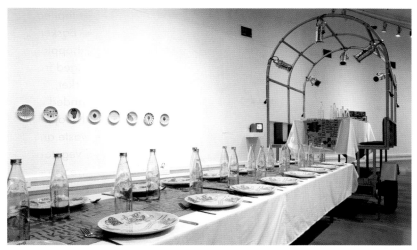

70 × 7 The Meal, act XXIII Barbican, 2005

developed with the education team at the Barbican and broadcast via media channels such as YouTube. The panelists were Harriet Lamb, director of the Fairtrade Foundation, which develops products, licenses brands, and raises awareness of issues surrounding fair trade; Tim Lang, a professor of food policy at City University London who advises food and public health sectors both nationally and internationally; Lucy Stockton-Smith, an artist who designs and builds geodesic ecology domes in schools to promote an educational approach to biodiversity; Wendy Fogarty, the international councilor for Slow Food UK, an association that promotes food and wine culture and also defends food and agricultural biodiversity worldwide; Dr. Peter Barham, a reader in physics at Bristol University, the author of *The Science of Cooking*, and a collaborator with chef Heston Blumenthal in the development of molecular gastronomy; and Allegra McEvedy, the chef and founder of Leon, the United Kingdom's first fast-food chain to feature fresh, organic, and seasonal produce. The seventh guest and chair of the session was John Slyce, a London-based art critic and historian. *Lunch with Lucy* was designed to function as a platform to raise awareness, provoke insight, question practices in the food industry, and bridge the gap between the arts and society.

The twenty-ninth dining experience was held in the historical Savoy palace of Venaria Reale, outside the city of Turin in Italy. It was our first collaboration with the Fondazione Slow Food per la Biodiversità Onlus, with the aim to support the project Cooperativa Cauqueva in Argentina and to protect the production of the Andean potato, a fundamental foodstuff and financial resource for the rural Argentine population. We invited 147 guests to dine on the most basic of dishes: soup. Together with chef Alfredo Russo from the restaurant Dolce Stil Novo, we chose soup as a symbol and common denominator, and it was served throughout the meal, from the main course to the dessert. This sustainable dish brings together populations and cultures of

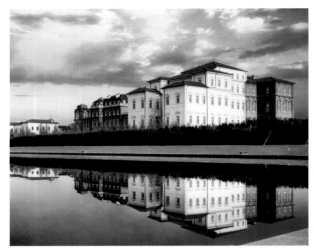

La Venaria Reale, Turin, Italy

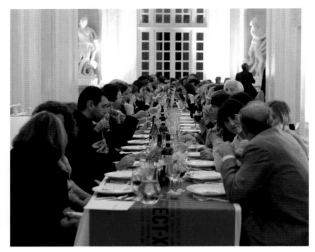

70 × 7 The Meal, act XXIX La Venaria Reale, 2008

70 × 7 The Meal, act XXIX La Venaria Reale, 2008

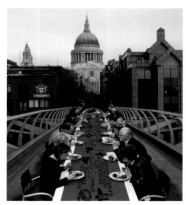

70 × 7 The Meal, act L City of London, 2006–ongoing

every continent, and can have spectacular colors: green vegetables, black beans, red tomatoes, orange pumpkins, white garlic and onions. In contrast with the ornate setting of the palace, we created a huge vegetable kitchen for a live performance at the head of the dining table, where we cleaned and chopped mountains of organic vegetables for each of the guests to take home in a hand-printed calico bag. A Royal Limoges porcelain plate edition designed especially for the occasion celebrated the theme by depicting delicately drawn vegetables and a recipe for potato soup, to be cooked using the vegetables we prepared.

Our fiftieth act—which covers several miles of streets starting from the Tate Modern and running across the Millennium Bridge to Guildhall, the historical center of London—hasn't yet been realized, but from past experience, and with our 70 × 7 multiplication strategy, we know that it is possible to unite several thousand people. All we need now is a good pretext to gather the crowds, but the right occasion hasn't quite arisen yet!

HHR: *It seems that the key to the success of these events is their partnerships and collaborations, so how do you go about determining the occasion for an event?*

LO+JO: There are events that need quick, urgent attention, and then there are issues that may need to be repeated and drawn out over several meals, to sustain the subject in depth.

As a reaction to the invasion of Iraq in 2003, we decided to stage *Act XX* at the UNESCO headquarters in Paris. We invited 490 people— diplomats, representatives from the cultural sector, artists, and media representatives—to dine on bowls of rice (*Un Bol de Riz pour la Paix*) at an immense table. Our choice of the UNESCO headquarters as a setting for the meal was not anodyne. Human rights and funda- mental freedoms were being violated, and we needed a venue to carry the weight of our discussions, as well as a place we knew would be

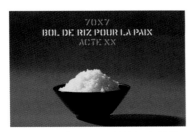

70 × 7 The Meal, act XX UNESCO Paris, 2002

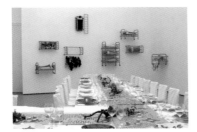

70 × 7 The Meal, act XXVII Albion, London, 2007

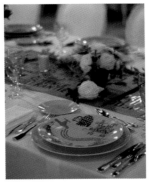

70 × 7 The Meal, act XXVIII Monaco, 2007

frequented by decision-makers in the process of promoting peace and security.

In 2007, the Albion gallery in London hosted our first charity dinner—*70 × 7 The Meal act XXVII*, also on the subject of the Iraq conflict—to close the exhibition *The Politics of Fear*. Here we addressed the themes of forced migration and torture, and the proceeds of the event were donated to the Medical Foundation for the Care of Victims of Torture. We also highlighted the work of charities, including Forward Thinking, Asylum Aid, Information Centre about Asylum and Refugees, and Bail for Immigration Detainees. In keeping with the concept of *70 × 7 The Meal*, the guest list was composed of seven groups of seven people: artists, media representatives, charities, collectors, curators, philanthropists, and political and legal figures. We invited an additional fifty people, for a total of ninety-nine—the Chinese symbol for infinity. This act was also the first time the limited-edition Royal Limoges porcelain plates were designed by collaborating artists: Reza Aramesh, Xu Bing, Shilpa Gupta, Kendell Geers, Rashid Rana, and Avishek Sen.

70 × 7 The Meal act XXVIII at the Ephrussi de Rothschild Villa in Monaco was a small private dinner in the presence of His Serene Highness The Sovereign Prince of Monaco. For this occasion, forty-nine guests—avid supporters of the arts, education, and the environment, with a specific interest in climate change—were invited to inaugurate the Art for the Environment initiative, a partnership formed between the Natural World Museum and the United Nations Environment Programme in 2008. Our common goals were to utilize the universal language of art as a catalyst to unite people in action and thought and to empower individuals, communities, and leaders to focus on environmental values across social, economic, and political realms.

The next dining event will be *Act XXXIII*; this means at least one hundred thousand people will have had a meal at the same ever-extending table.

HHR: *You mentioned something very interesting earlier: legislation. How can art influence legislative change and be a more effective channel for inciting social responsibility?*

LO: It's the research process, followed by hundreds of collective actions and manifestations in the public sphere—through what has been called the "butterfly effect"—that will raise awareness and eventually lead to changes in legislation. *70 × 7 The Meal* is just one of the methods we utilize. Perhaps this is how Beuys's idea of social sculpture can take form and become an integrated part of daily life.

HHR: *How do you think the legislative system, which is often too rigid and bureaucratic, will respond to this proposal?*

JO: It is solely through the collective dimension of these projects and with a transdisciplinary team that a coherent discourse could possibly be noticed by, or even convince, the system. The project *The Gift—Life Nexus*, created from 1996 to 2006, has been one of the most effective

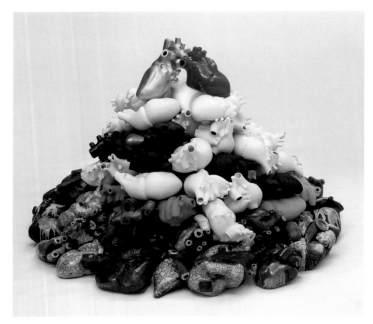

The Gift—Life Nexus, 1996–2006

The Gift—Life Nexus Ráquira and Zipaquirá, 1997–98

The Gift—Life Nexus Cheniers, 2004

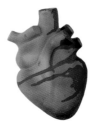

The Gift—Life Nexus Oaxaca, 1999–2002

The Gift—Life Nexus Ráquira and Zipaquirá, 1997–98

artworks in terms of raising awareness. I began working with the symbol of the heart after a dear friend died while on a waiting list for a heart transplant. During our research on the subject of organ donation, we discovered that in France alone there are thousands of deaths per year due to a lack of organ donations, and there are more than 180 organ donor centers trying desperately to find donors. We decided to tackle the issue, in part because of the lack of knowledge around the subject, and perhaps also because of the hesitancy of potential donors. My questions were: Would we discard a vital organ if our neighbor really needed one? Could we really refuse the gift of life if we knew the person? We are so caught up in a frenetic urban rhythm that it affects our relationships with others, contributing to a sense of isolation and indifference—literally, every man for himself! We have simply forgotten that our social connections nourish our personal development and help us grow for the benefit of the whole community.

We believed that the role of art in this sensitive subject area could be to awaken consciousness. We embarked on ten years of collective research, with the collaboration of more than forty cities around the world—staging interventions, actions, and workshops—leading to the production of artifacts, installations, and performances under the name OPERA.tion Life Nexus. The focus of these collaborations became the heart, a symbol of the gifts of generosity, life, and empathy, allowing an open-ended discussion of the meaning of heart in our lives.

I worked with remote potters in Zipaquirá and brick-making communities in Ráquira, both in Colombia, as well as thirty-five thousand high school students in the Meurthe-et-Moselle region in France. We fabricated several hundred heart-shaped artifacts and

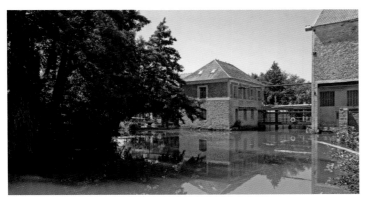

Studio Orta Les Moulins

staged a series of large-scale public works in the *Light Works* series. The project coincided with the inauguration of the fourteenth World Transplant Games in the French city of Nancy, in 2003. Leading up to the event, we conducted workshops across the region and generated a charter for organ donation, entitled *The Gift*. This charter was subsequently adopted by organ donor organizations nationally, and an external audit recorded a 30-percent increase in the wish to donate an organ after death.

Today, it is obvious that the political system is failing and requires these types of initiatives to incite action and positive change.

HHR: *So, do you expect one day to get more directly involved in the political system?*

LO+JO: No, definitely not, and we have both been asked!

LO: I was invited to become a member of the new European Cultural Parliament—even there, there is too much discussion and not enough action.

JO: We are developing a new project, Les Moulins, that is situated along the river from our country studio in a rural region of exceptional beauty, Brie, in the Seine-et-Marne area of France. Here, a complex of historical industrial buildings—the Laiterie (Dairy); and two paper mills, the Moulin de Boissy and the Moulin Sainte-Marie—are being transformed into research laboratories dedicated to artistic research and production. Inspired by the historical and environmental context of the surrounding Grand Morin valley, and more specifically by the industrial heritage of the paper mills, this laboratory will host residencies for international artists and researchers from the domains of contemporary visual arts and ecological science to discuss, develop, create, and present artistic projects through a program of collaborative artistic and scientific activities.

LO+JO: Our artistic practice is our life's work. There is still too much ground to be covered and too many silent voices that need to be heard. The strength of art is its independence.

Biographies

LUCY ORTA was born in 1966 in Sutton Coldfield, United Kingdom. After graduating with an honors degree in fashion-knitwear design from Nottingham Trent University in 1989, Lucy began practicing as a visual artist in Paris in 1991. Her sculptural work investigates the boundaries between the body and architecture, exploring their common social factors, such as communication and identity. Lucy uses the media of sculpture, public intervention, video, and photography to realize her work. Her most emblematic artworks include *Refuge Wear* and *Body Architecture* (1992–98), portable, lightweight, and autonomous structures representing issues of survival. *Nexus Architecture* (1994–2002) is a series of participative interventions in which a variable number of people wear suits connected to each other, shaping modular and collective structures. When recorded in photography and video, these interventions visualize the concept of social links. *Urban Life Guards* (2004–) are wearable objects that reflect on the body as a metaphorical supportive structure.

Lucy's work has been the focus of major survey exhibitions at the Wiener Secession, Austria (1999); the Contemporary Art Museum of the University of South Florida, for which she received the Andy Warhol Foundation for the Visual Arts award (2001); and the Barbican Centre, London (2005). She is a professor of Art, Fashion and the Environment at London College of Fashion, University of the Arts London and was the inaugural Rootstein Hopkins Chair at London College of Fashion from 2002–7. From 2002–5 she was the head of Man and Humanity, a pioneering master's program that stimulates socially driven and sustainable design, which she cofounded with Li Edelkoort at the Design Academy in Eindhoven in 2002. Lucy is currently a Research Fellow at the MIT Program in Art, Culture and Technology.

JORGE ORTA was born in 1953 in Rosario, Argentina. He studied simultaneously at the faculty of fine arts (1972–79) and the faculty of architecture (1973–80) of the Universidad Nacional de Rosario. Dedicated to transforming the methods and expressions of the dominant art academy, his artistic research explores alternative modes of expression and representation resulting from the specific social and political contexts of Argentina and South America. Jorge became convinced of the social role of art during a period of social injustice and revolutionary violence in Argentina, and his work explores the periphery in terms of expression and audience. Jorge was a pioneer of video art, mail art, and large-scale public performances in his hometown of Rosario, representing Argentina with *Crónica Gráfica* at the Biennale de Paris in 1982. Interested in interdisciplinary and collective art practices, he founded the research groups Huapi and Ceac to create a bridge between contemporary art and mass audiences, creating public works including *Transcurso Vital* (1978), *Testigos Blancos* (1982), *Madera y Trapo* (1983), *Arte Portable* (1983), and *Fusion de Sangre Latinoamericana* (1984). He has published several Manifestos, including: *Arte Constructor, Arte Catalizador, and Utopias Fundadoras.*

Jorge was a lecturer in the faculty of fine arts of the Universidad Nacional de Rosario and a member of CONICET, the Argentine national council for scientific research, until 1984, when he received a scholarship from the Ministry of Foreign and European affairs to pursue a D.E.A. (Diplôme d'études approfondies) at the Sorbonne in Paris. In 1991, a fire tragically destroyed his entire archive of work conducted in Argentina. Parallel to a studio-based practice in Paris, Jorge Orta continued his 1978 light technology artworks and created the first ceramic glass plates for the PAE (Projector Art Effect) 2500, which would allow him to pursue large-scale image projections, called *Light Works*. From 1991, he created *Light Works* in mythical sites of architecture of cultural significance across the world, including the Mount Aso volcano, Japan; Cappadocia, Turkey; the Zocòlo, Mexico City; the Gorges du Verdon, France; and the Venetian palaces along the Grand Canal, representing Argentina for the Venice Biennale in 1995.

Lucy + Jorge created **STUDIO ORTA**, an interdisciplinary structure for the development of their work, in Paris in 1992. More recently, they restored three historical sites along the Grand Morin river in Marne-la-Vallée, France: the Laiterie (the Dairy) in 2000, and the Moulin de Boissy and the Moulin Sainte-Marie, two former paper mills, in 2007 and 2009, respectively. They relocated their large-scale studios to these former industrial buildings for experimentation and production, as well as workshops, presentation spaces, artist residencies, and a laboratory for artistic and environmental research.

The Ortas' collaborative artwork, which often deals with issues of sustainability, has been the focus of major solo exhibitions, including *OrtaWater*, held at the Fondazione Bevilacqua La Masa in Venice (2005), the Museum Boijmans Van Beuningen in Rotterdam (2006), and the Galleria Continua in Beijing, San Gimignano, and Le Moulin (2007–8); *Antarctica*, held at the Biennial of the End of the World, Ushuaia, and the Antarctic Peninsula (2007), and the Hangar Bicocca spazio d'arte in Milan (2008); and *Amazonia*, held at the Natural History Museum, London (2010). In 2007, the artists received the Green Leaf Award for artistic excellence with an environmental message, presented by the United Nations Environment Programme in partnership with the Natural World Museum at the Nobel Peace Center in Oslo, Norway.

Contributors

SIMONETTA CARBONARO is Professor of Design Management and Humanistic Marketing at the University of Borås in Sweden. She is a member and cofounder of the European Cultural Parliament.

ZOË RYAN is a British writer and curator. She holds the position of Neville Bryan Curator of Design at the Art Institute of Chicago, and in addition is currently the Acting John H. Bryan Curatorial Chair of Architecture and Design. Her role includes building the museum's first collection of contemporary design. Her recent exhibitions include *Konstantin Grcic: Decisive Design* (2009) and *Graphic Thought Facility: Resourceful Design* (2008). Prior to working at the Art Institute, Zoë was senior curator at the Van Alen Institute in New York, where she organized exhibitions including *The Good Life: New Public Spaces for Recreation* (2006). Zoë is regularly called upon as a lecturer, critic, and juror, and her writing on architecture and design has been published internationally. She is the author of numerous publications, including *Building with Water: Concepts, Typology, Design* (2010). Zoë is an adjunct assistant professor at the school of art and design at the University of Illinois at Chicago, where she teaches an interdisciplinary design seminar.

ELLEN LUPTON is a curator of contemporary design at the Cooper-Hewitt, National Design Museum in New York City and director of the graphic design MFA program at Maryland Institute College of Art (MICA) in Baltimore. She has produced numerous books and exhibitions, including *The Bathroom, the Kitchen, and the Aesthetics of Waste* (1992), *Mechanical Brides: Women and Machines from Home to Office* (1993), and *Skin: Surface, Substance, and Design* (2002). She has produced a series of books with MICA graduate students, including *D.I.Y.: Design It Yourself* (2006), *Indie Publishing: How to Design and Produce Your Own Book* (2008), and *Graphic Design: The New Basics* (2008). Ellen has contributed to various design magazines, including *Print, Eye, I.D.,* and *Metropolis.* She is a 2007 recipient of the AIGA Gold Medal. Ellen lectures frequently in the United States and internationally.

GINGER GREGG DUGGAN and **JUDITH HOOS FOX**, independent curators based in the United States, work under the moniker c^2 (curatorsquared) to develop exhibitions of international, cross-media contemporary art that explore current issues in culture and design. Recent projects include the exhibitions *Over + Over: Passion for Process* (2005), *Branded and On Display* (2007), *Facades* (2008), *Blown Away* (2008), *Under Control* (2009), *Art on Speed* (2010), and *Designing Machines: Fashioning a New Order* (2010). Gregg Duggan has been a curator at the Museum of Art Fort Lauderdale, Florida, and the Bellevue Arts Museum, Washington. Hoos Fox has been a curator at the Davis Museum and Cultural Center at Wellesley College, Massachusetts, the Museum of Art at the Rhode Island School of Design, and the Institute of Contemporary Art in Boston, and has been a visiting curator at the Harvard Art Museums and the Krannert Art Museum at the University of Illinois.

HOU HANRU is a critic and curator who divides his time between Paris and San Francisco. He is the director of exhibitions and public programs at the San Francisco Art Institute. Hanru is a consultant for several cultural institutions internationally, including the Solomon R. Guggenheim Museum in New York and the Deutsche Bank Collection in Frankfurt. He has lectured at numerous institutions, including the Rijksakademie van Beeldende Kunsten in Amsterdam and the Hoger Instituut voor Schone Kunsten in Ghent. Hanru's recent exhibitions include the tenth Biennale de Lyon in France (2009) and the tenth Istanbul Biennial in Turkey (2007).

Exhibition History

Solo Exhibitions

2010
Amazonia. Natural History Museum, London, United Kingdom

The Gift. Adelaide International 2010: Apart, we are together; Jam Factory, Adelaide, Australia

Lucy Orta. CCANW: Centre for Contemporary Art and the Natural World, Exeter, United Kingdom

Antarctica. Eté des Arts en Auxois-Morvan, Montbard, France

2009
OrtaWater. Motive Gallery / Vienna Art Fair, Austria

OrtaWater. DSM, Heerlen and Sittard, The Netherlands

70 × 7 The Meal, act XXXI. Sherwell Church Hall, Plymouth, United Kingdom

Lucy Orta. Plymouth Arts Centre / Plymouth College of Art & Design, United Kingdom

Light Works—Brasilia em Luz (project). Brasilia, Brazil

2008
Antarctica. Galleria Continua: Le Moulin, Boissy-le-Châtel, France

Antarctica. Hangar Bicocca spazio d'arte, Milan, Italy

Antarctic Village—13:3. Fries Museum, Leeuwarden, The Netherlands

Antarctic Village—Works in Progress. Motive Gallery, Amsterdam, The Netherlands

70 × 7 The Meal, act XXIX. La Venaria Reale, Turin, Italy

70 × 7 The Meal, act XXVIII. Villa Ephrussi de Rothschild, Cap Ferrat, Monaco

OrtaWater. Expo Zaragoza 2008, Austrian Pavilion, Spain

Body Architecture. The Swedish Museum of Architecture, Stockholm, Sweden

Survival. Fashion Space Gallery, London College of Fashion, United Kingdom

2007
Antarctic Village—No Borders. Galleria Continua: San Gimignano, Italy

Antarctic Village—No Borders. Antarctic Peninsula, Antarctica

Heads or Tails, Tails or Heads. Antarctic Marambio Base, Antarctica

Fallujah—works in progress. Galerie Peter Kilchmann, Zurich, Switzerland

Fallujah. Institute of Contemporary Art / Old Truman Brewery, London, United Kingdom

Fallujah—Casey's Pawns. 11th Prague Quadrennial International Exhibition of Scenography and Theatre Architecture, Czech Republic

Fallujah. Art Forum Berlin / Motive Gallery, Germany

Fallujah—Auszug 01. Context Festival, Hebbel am Ufer, Berlin, Germany

70 × 7 The Meal, act XXVII. Albion Gallery, London, United Kingdom

Nexus Architecture. Tramway, Glasgow, Scotland

2006
OrtaWater. Galleria Continua: Beijing, China

70 × 7 The Meal, act XXV, Open House. Casa Argentina, London, United Kingdom

Light Works—Lights on Tampa. Tampa Bay Hotel / University of Tampa, Florida, United States

Light Works—Open House / Casa Abierta. Casa Argentina, London, United Kingdom

Selected Works: Lucy + Jorge Orta. Motive Gallery, Amsterdam, The Netherlands

2005
Lucy Orta. The Curve, Barbican Centre, London, United Kingdom

Drink Water! 51st Venice Biennale, Fondazione Bevilacqua La Masa, Italy

Water & Works. Museum Boijmans Van Beuningen, Rotterdam, The Netherlands

70 × 7 The Meal, act XXIII—Lunch with Lucy. The Curve, Barbican Centre, London, United Kingdom

70 × 7 The Meal, act XXII. Z33, Hasselt, Belgium

70 × 7 The Meal, act XXI. Pleinmuseum / Centraal Museum, Utrecht, The Netherlands

Totipotent Architecture. Centre for Contemporary Visual Arts, University of Brighton, United Kingdom

2004
Casey's Pawns—Nexus Architecture. Victoria & Albert Museum, London, United Kingdom

Dwelling X. RIBA, London, United Kingdom

Nexus Architecture × 110. Attwood Green, Birmingham, United Kingdom

Light Works—Lille European Cultural Capital 2004. Opera House, France

2003
70 × 7 The Meal, act XX. UNESCO, Paris, France

Connector Mobile Village. Southeastern Center for Contemporary Art, Winston-Salem, North Carolina, United States

Body Architecture. Lothringer13, Munich, Germany

Dwelling X. Old Market Square, Nottingham, United Kingdom

Collective Dwelling, act IX. Institute for Contemporary Art, Brisbane, Australia

Collective Dwelling, act VIII. Cicignon High School, Fredrikstad, Norway

Light Works—OPÉRA.tion Life Nexus, act IX. 14th World Transplant Games, Place Stanislas, Nancy, France

2002
70 × 7 The Meal, act XIX. Design Academy Eindhoven, The Netherlands

70 × 7 The Meal, act XVII (Enactments of the Self). Sterischer Herbst, Graz, Austria

70 × 7 The Meal, act XVII. Rio Garonne, Toulouse, France

70 × 7 The Meal, act XVI. ar/ge Kunst Galerie Museum, Bolzano, Italy

Connector Body Architecture sector IX. Musée d'Art et d'Histoire de Cholet, France

Connector Mobile Village. Florida Atlantic University Galleries, Boca Raton, Florida, United States

Nexus Architecture × 110. Miami Design District / Art Basel Miami Beach, Florida, United States

Fluid Architecture II workshops. The Dairy, Saint-Siméon, France / Stroom Den Haag, The Hague, The Netherlands

Fluid Architecture I workshops. Drill Hall, Melbourne, Australia

Light Works—OPÉRA.tion Life Nexus, act VIII. Saint-Eustache, Paris, France

The Gift—Life Nexus. TwoTen Gallery, The Wellcome Trust, London, United Kingdom

Borderline. Berlin Ballet: Komische Oper Berlin, Germany / Compagnie Blanca Li: Créteil Maison des Arts, France

2001
70 × 7 The Meal, act XIII. Firstsite gallery, Colchester, United Kingdom

70 × 7 The Meal, act XII. Parc Beauvillé, Amiens, France

70 × 7 The Meal, act XI (They say this is the Place). Antwerp, Belgium

70 × 7 The Meal, act X (Active Ingredients). COPIA: The American Center for Wine, Food and the Arts, Napa, California, United States

70 × 7 The Meal, act IX (OPÉRA.tion Life Nexus, act VII). Museum für Angewandte Kunst, Cologne, Germany

70 × 7 The Meal, act V–VII. Casa de Francia / Museo Diego Rivera/ Couvent de la Mercedes, Mexico City, Mexico

Connector Guardian Angel sector VIII. Casa de Francia, Mexico City, Mexico

Connector Mobile Village sector IV. University of South Florida Contemporary Art Museum, Tampa, Florida, United States

Light Works—OPÉRA.tion Life Nexus, act VI—Battement des Grands Jours. Palais de Tau / Reims Cathedral, France

Light Works—OPÉRA.tion Nexo Corazòn, act V. Festival del Centro Histórico, El Zocalo, Mexico City, Mexico

The Gift. Firstsite gallery, Colchester, United Kingdom

Arbor Vitae (Making History). Freeport Talke, Staffordshire, United Kingdom

2000
70 × 7 The Meal, act IV. Dieuze, France

70 × 7 The Meal, act III (The Invisible Touch). Kunstraum Innsbruck, Austria

Connector Mobile Village sector VII. Talbot Rice Gallery, Edinburgh, United Kingdom

Connector MacroWear sector VI. Kapelica Gallery, Ljubljana, Slovenia

Connector Mobile Village III. Australian Centre for Contemporary Art, Melbourne, Australia

Connector Mobile Village II. La Cambre E.N.S.A.V., Brussels, Belgium

Connector Mobile Village I. Pitti Immagine, Florence, Italy

The Gift—Life Nexus. Cité des Sciences et de l'Industrie, Parc de la Villette, Paris, France

Light Works—OPÉRA.tion Life Nexus, act IV Millennium. Le Grenier du Siècle / Lieu Unique, Nantes, France

OPERA.tion Life Nexus, act III. Chapiteau Larue Foraine, Paris, France

Light Works—OPERA.tion Life Nexus, act II. Hôpital Robert Giffard, Québec, Canada

Light Works—OPÉRA.tion Life Nexus, act I. Festival Internacional de Arte, Medellin, Colombia
The Gift—Life Nexus. Athens Sculpture Biennale, Greece
The Gift—Life Nexus. Mediterranean seabed, France
Jorge Orta recent works. Galeria El Museo, Bogota, Colombia

1999
HortiRecycling Enterprise, act II. Wiener Secession, Vienna, Austria
Nexus Architecture. Haus der Kulturen der Welt, Berlin, Germany
Nexus Architecture. Passages centre d'art contemporain, Troyes, France
Collective Dwelling, act VII. Fabrica gallery, Brighton, United Kingdom
Urban Life Guards—works in progress. Expofil, Paris, France

1998
Lucy Orta—Urban Armour. Art Gallery of Western Australia, Perth, Australia
Nexus Architecture. Appel d'Air, Paris, France
Nexus Architecture. March Against Child Labour, Lyon, France
Questions from the heart 0023. Espace d'Art Yvonamor Palix, Paris, France

1997
Collective Dwelling, act II. Le Creux de l'Enfer, Thiers, France
All in One Basket, act I. Galerie du Forum Saint-Eustache, Paris, France
Refuge Wear. East End London, United Kingdom
Commune Communicate (Actions Urbaines). C.P. Metz detention centre, France
Ici et Ailleurs. Le Parvis, Tarbes, France

1996
Modular Architecture. Soirées Nomades, Fondation Cartier pour l'art contemporain, Paris, France
Refuge Wear—Nexus Architecture. Soho Festival, New York, United States
Refuge Wear. Espace d'Art Yvonamor Palix, Paris, France
Light Messenger. Galerie du Dourven, Trédrez-Locquémeau, France
Light Works—Cardinal Cross. Évry Cathedral, France
Light Works—Light Messenger. Coastline of Brittany, France
Light Works—Heart of the Moon. Causseaux Kiln, Limoges, France

1995
Identity + Refuge Act I. Salvation Army Cité de Refuge, Paris, France
Nexus Architecture—Collective Wear × 16. 46th Venice Biennale, Italy
Light Works—Light Messenger. 46th Venice Biennale, Italy
Light Works—Paths of Light. Gorges du Verdon, France
Light Works—Woven Light. Troglodyte villages, Cappadocia, Turkey

1994
Refuge Wear. Montparnasse Station, Paris, France
Nexus Architecture × 8. Cité La Noue, Montreuil, France
Refuge Wear. Louvre / Le Pont des Arts, Paris, France
Refuge Wear. Salvation Army Cité de Refuge, Paris, France
Light Works—Plea from the Earth. Mount Aso, Kyushu, Japan
Light Works—Sacred Light. Chartres Cathedral, France

1993
Light Works—Light of Stone. Castilla-La Mancha, Cuenca, Spain
Light Works—Fire Signs (project). Vesuvius / Institut Français, Naples, Italy
Jorge Orta. Recoleta Cultural Centre, Buenos Aires, Argentina

1992
Light Works—Imprints on the Andes. Machu Picchu Andes Mountain Range, Peru
Light Works—Rive des Amériques. Palais de Tokyo, Paris, France
Jorge Orta. Center for Art and Communication, Buenos Aires, Argentina
Terre. Galerie Procréart, Paris, France

1991
Light Works—Graphic Light Poem. Centre Pompidou, Paris, France
Light Works—Lecons Ténèbres. Basilique de Neuvy-Saint-Sépulchre, France
Light Works—unititled. Chapelle de la Salpetrière, Paris, France
Jorge Orta. Galería La Kabla, Madrid, Spain
Poussière / Dust. Galerie Paris-Bastille, France

1984–90
Jorge Orta. Keller-Kinder Gallery, Paris, France
Jorge Orta. Frankfurter Buchemesse, Frankfurt, Germany
Jorge Orta. Galérie Seul, Brussels, Belgium
Rito y sacrificios. Cloitre des Billettes, Paris, France
Irracional Alatorio. Bernanos Gallery, Paris, France
Sustancia e immaterialidad de signos. Le Pont d'Arcole, Paris, France
Jorge Orta. Galería Krass, Rosario, Argentina

1984
Fusion de sangre Latinoamericana. Bernardino Rivadavia centro cultural, Rosario, Argentina

1983
Madera y Trapo. Bernardino Rivadavia centro cultural, Rosario, Argentina
Testigos Blancos. Plaza Santa Cruz, Rosario, Argentina

1982
Cronica Grafica. XII Biennale de Paris, France / Bernardino Rivadavia centro cultural, Rosario, Argentina
Jorge Orta. Buonarroti Gallery, Rosario, Argentina

1981
Transcurso Vital. Museu de Arte Contemporanea da Universidade Sao Paulo, Brazil

1978
Transcurso Vital. Plaza Vicene Lopez y Planes, Fisherton, Rosario, Argentina
Jorge Orta. Galería Krass, Rosario, Argentina

1977
Jorge Orta. Galería del Bajo, Rosario, Argentina

1976
Jorge Orta. Galería Dalila Bonomi, Rosario, Argentina

1975
Jorge Orta. Galería Sala de la Pequena Muestra, Rosario, Argentina

1974
Jorge Orta. Galería de Arte Il Duomo, Rosario, Argentina
Jorge Orta. Galería Lirolay, Buenos Aires, Argentina

1973
Jorge Orta. Galería Raquel Real, Rosario, Argentina
Jorge Orta. Galería Krass, Rosario, Argentina
Jorge Orta. Galería Lirolay, Buenos Aires, Argentina
Jorge Orta. Colegio de Graduados de Ciencias Económicas de Rosario, Argentina

Group Exhibitions

2010
Urban Life Guard (Eclaircies). Le Quai d'Angers, France
Antarctic Village—No Borders. MAXXI, Rome, Italy
A New Stance For Tomorrow: Part 3. Sketch, London, United Kingdom
Climate Capsules: Means of Surviving Disaster. Museum für Kunst und Gewerbe, Hamburg, Germany

2009
GSK Contemporary, Earth: Art of a changing world. Royal Academy of Arts, London, United Kingdom
Green Platform: Art Ecology Sustainability. Palazzo Strozzi, Florence, Italy
Dress Code. ISELP, Brussels, Belgium
Pot Luck: Food and Art. The New Art Gallery, Walsall, United Kingdom
Intemperie: Fenomenos Esteticos da Mudanca Climatica e da Antartida. Centro Cultural Oi Futuro, Rio de Janeiro, Brazil
Sur Polar: Arte en Antartida. MUTEC, Mexico City, Mexico
Return to Function. Madison Museum of Contemporary Art, Wisconsin, United States
Frozen Time: Art from the Antarctic. Stadtgalerie Kiel, Germany
Antarctica World Passport distribution bureau. HEAVEN, 2nd Athens Biennale, Greece
Retreat. KunstFort Asperen, Acquoy, The Netherlands
Off the Beaten Path: Violence, Women and Art. The Stenersen Museum, Oslo, Norway

(Un)Inhabitable? Art of Extreme Environments. Festival @rt Outsiders 2009, Maison Européenne de la Photographie, Paris, France

A Way Beyond Fashion. Apexart, New York, United States

Antarctic Village—Nuit Blanche. FRAC Lorraine, Metz, France

Esthétique des pôles: Le testament des glaces. FRAC Lorraine, Metz, France

Sphères. Galleria Continua: Le Moulin, Boissy-le-Châtel, France

AntArctica. Haugar Vestfold Kunstmuseum, Tønsberg, Norway

The Spectacle of the Everyday—TAMA project. 10th Biennale de Lyon, Museum of Contemporary Art, France

2008

Life-Size Utopia. Motive Gallery, Amsterdam, The Netherlands

Poëziezomer Watou 2008. Belgium

1% Water and our future. Z33, Hasselt, Belgium

Shelter × Survival: Alternative Homes for Fantastic Lives. Hiroshima City Museum of Contemporary Art, Japan

Totipotent Architecture—Skin Deep. KunstFort Asperen, Acquoy, The Netherlands

Sur Polar: Arte en Antártida. MUNTREF Museo de la Universidad Nacional de Tres de Febrero, Buenos Aires, Argentina

Carried Away—Procession in Art. MMKA, Arnhem, The Netherlands

2007

The Politics of Fear. Albion Gallery, London, United Kingdom

OrtaWater—Envisioning Change. Nobel Peace Center, Oslo, Norway

OrtaWater—Environmental Renaissance. City Hall, San Francisco, California, United States

OrtaWater—Dans ces eaux là... Chateau d'Avignon, Saintes Maries de la Mer, France

Urban Life Guard. Galleria Continua: Le Moulin, Boissy-le-Châtel, France

Antarctic Village—No Borders. 1st Biennial of the End of the World, Ushuaia, Tierra del Fuego, Argentina

2006

Nexus Architecture. 9th Havana Biennale, La Habana Vieja, Cuba

LESS—Alternative Strategies for Living. PAC contemporary art museum, Milan, Italy

This is America! Centraal Museum, Utrecht, The Netherlands

Monument Minimal. Château d'Avignon, Saintes-Maries-de-la-Mer, France

Metro Pictures, part two. Museum of Contemporary Art, North Miami, Florida, United States

Taille Humaine. Orangerie du Sénat, Le Jardin du Luxembourg, Paris, France

Other than Art. G Fine Art Gallery, Washington, DC, United States

Channel. Cupola Gallery, Sheffield, United Kingdom

The Fashion of Architecture. Center for Architecture, New York, United States

Dark Places. The Santa Monica Museum of Art, California, United States

2005

Contemporaneo Liquido. Franco Soffiantino Gallery, Turin, Italy

Five Rings: Ornaments of Suffering. Fort of Exilles, Piedmont, Italy

Sweet Taboos. Tirana Biennale 3, Albania

Fear Gear. Roebling Hall, New York, United States

Pattern Language: Clothing as Communicator. Tufts University Art Gallery, Aidekman Arts Center, Medford, Massachusetts, United States

Fée Maison. La Briqueterie en Bourgogne, Le Creusot, France

Est-Ouest/Nord-Sud: faire habiter l'homme, là encore, autrement. arc-en-reve centre d'architecture, Bordeaux, France

Art-Robe: Women Artists in a Nexus of Art and Fashion. UNESCO, Paris, France

On Conceptual Clothing. Kirishima Open-Air Museum, Kagoshima, Japan

Biennale de l'urgence en Tchétchénie. Palais de Tokyo, Paris, France

2004

On Conceptual Clothing. Musashino Art University, Tokyo, Japan

A Grain of Dust A Drop of Water. Gwangju Biennale 2004, South Korea

Totipotent Architectecture (Arte all'Arte: Arte Architettura Paesaggio). Associazione Arte Continua, Buonconvento, Italy

The Interventionists: Art in the Social Sphere. MASS MoCA, North Adams, Massachusetts, United States

Flexible 4: Identities. Kunsthallen Brandts Klædefabrik, Odense, Denmark

The Space Between. John Curtin Gallery, Curtin University of Technology, Perth, Australia

Lies and Lust: Art & Fashion. Podewil, Berlin, Germany

Dwelling X. Northern Gallery for Contemporary Art, Sunderland, United Kingdom

2003

Design et Habitats. Centre Pompidou, Paris, France

Flexible. Whitworth Art Gallery, The University of Manchester, United Kingdom

Creuats/Cruzados/Crossed. CCCB, Barcelona, Spain

Armour: The Fortification of Man. KunstFort Asperen, Acquoy, The Netherlands

Nexus Architecture × 50 (Micro Utopias). Art and Architecture Biennale, Valencia, Spain

M.I.U. Mobile Intervention Units (Kaape Helder). Den Helder, The Netherlands

Fashion: The Greatest Show on Earth. Bellevue Art Museum, Bellevue, Washington, United States

Doublures. Musée national des beaux-arts du Québec, Canada

2002

Connector Body Architecture. Laing Art Gallery, Newcastle, United Kingdom

Strike. Wolverhampton Art Gallery, United Kingdom

Somewhere: Places in Refuge. Angel Row Gallery, Nottingham, United Kingdom

Shine. The Lowry, Salford Quays, United Kingdom

Portable Living Spaces. The Fabric Workshop and Museum, Philadelphia, Pennsylvania, United States

Fragilités. Le Printemps de Septembre, Toulouse, France

2001

Mobile Village: Plug In. Westfälisches Landesmuseum für Kunst und Kulturgeschichte, Munster, Germany

Untragbar. Museum für Angewandte Kunst Köln, Cologne, Germany

To the Trade. Diverse Works Art Space, Houston, Texas, United States

Wegziehen. Frauen Museum, Bonn, Germany

Global Tools. Künstlerhaus Wien, Vienna, Austria

M.I.U. (Transforms). G8 Environment Summit, Trieste, Italy

2000

Dynamic City. La Fondation pour l'Architecture, Brussels, Belgium

Air en Forme. Musée des Arts Décoratifs / Vitra Design Museum, Lausanne, Switzerland

Ici On Peut Toucher. Galerie TBN, Rennes, France

Life Nexus Village Fête (Home). Art Gallery of Western Australia, Perth, Australia

Mutations/Modes 1960–2000. Musée Galliera, Paris, France

1999

Body Architecture. Institut Français d'Architecture, Paris, France

Visions of the Body. Museum of Modern Art, Kyoto / Museum of Contemporary Art, Tokyo, Japan

Life Nexus Village Fête (In the Midst of Things). Bournville Village Green, Birmingham, United Kingdom

Collective Dwelling (Design Machine). Kelvingrove Museum, Glasgow, Scotland

Model Homes: Explorations in Alternate Living. The Edmonton Art Gallery, Alberta, Canada

Untitled. Ronald Feldman Gallery, New York, United States

1998

Personal Effects: The Collective Unconscious. Museum of Contemporary Art, Sydney, Australia

Addressing the Century: 100 Years of Art and Fashion. The Hayward Gallery, London, United Kingdom

The Campaign Against Living Miserably. The Royal College of Art Galleries, London, United Kingdom

Nexus Architecture. Passage de Retz, Paris, France

1997

Nexus Architecture (Trade Routes: History and Geography). 2nd Johannesburg Biennale, Electric Workshop, South Africa

Produire Créer Collectionner. Musée du Luxembourg, Paris, France

P.S.I. Open. MoMA P.S.I., New York, United States

Bournes Citoyenne (Ici et Maintenant). Parc de la Villette, Paris, France

Touche pour Voir. Le Creux de l'Enfer, Thiers, France

List of Works Illustrated

p. 32
70 × 7 The Meal, act XII Amiens, 2001
Open-air picnic in the Parc de Beauvillé to celebrate the Year of Mexico festival in Amiens, France. Inkjet picnic cloth measuring 1,500 meters, designed to be cut into sections for passers-by.

p. 33
70 × 7 The Meal, act XVI Bolzano, 2002
Installation dinner in Waltherplatz piazza, in the Province of Bozen, Austria. Table set for 170 guests with silkscreen-printed table runner and edition of 490 Royal Limoges porcelain plates.

p. 34
70 × 7 The Meal, act XVII Toulouse, 2002
Open-air picnic along the banks of the Garonne River to celebrate the annual Rio Garonne festival in Toulouse, France. Silkscreen-printed picnic cloth for 400 people.

p. 35
70 × 7 The Meal, act XXII Hasselt, 2005
Installation and open-air buffet in the gardens of Z33 Centre for Contemporary Art and Design, to inaugurate the Hasselt Triennial in Belgium. Buffet table set with silkscreen-printed table runner and edition of 210 Royal Limoges porcelain plates.

pp. 36–37
70 × 7 The Meal, act XXVII Albion, 2007
Installation and fundraising dinner to support the Medical Foundation for the Care of the Victims of Torture, and to coincide with the group exhibition *The Politics of Fear* at the Albion Gallery in London. Table set for 99 guests with silkscreen-printed table runner and edition of 100 Royal Limoges porcelain plates with 7 different designs created in collaboration with Reza Aramesh, Shilpa Gupta, Kendell Geers, Rachid Rana, Aveshek Sen, and Xu Bing.
Photography: Thierry Bal

pp. 38–39
70 × 7 The Meal, act XXVIII Monaco, 2008
Installation and dinner in the presence of His Serene Highness The Sovereign Prince of Monaco at the Villa Ephrussi de Rothschild, to launch the collaboration between the United Nations Art for the Environment Programme and the Natural World Museum. Table set for 50 guests with silkscreen-printed table runner and edition of 100 Royal Limoges porcelain plates.
Photography: Thierry Bal

pp. 40–43
70 × 7 The Meal, act XXIX La Venaria Reale, 2008
Performance and dinner staged inside the historic Savoy palace of Venaria Reale to launch the collaboration with Fondazione Slow Food per la Biodiversità Onlus in support of the Andean potato research project founded by the Cooperativa Cauqueva in Argentina; performance of preparation of basic ingredients for vegetable soup, to be distributed to each guest at the end of the meal. Soup menu created by chef Alfredo Russo, from Dolce Stil Novo. Table set for 150 guests with silkscreen-printed table runner and edition of 150 Royal Limoges porcelain plates.
Photography: Thierry Bal

p. 44
70 × 7 The Meal, act XXXI Plymouth, 2009
Foraged foodstuffs gathered by ecologist Caroline Davey from Fat Hen, a rural enterprise specializing in professional foraging.
Photography: Simon Keitch

p. 45
70 × 7 The Meal, act XXXI Plymouth, 2009
Installation and dinner in collaboration with local artists Jo Salter and Anne-Marie Culhane, to celebrate sustainable methods of collecting, preparing, and sharing food. Cooking by Caroline Davey and chef Justin Ashton. Table set for 70 guests with silkscreen-printed table runner and Royal Limoges porcelain plates from previous meals.
Photography: Simon Keitch

pp. 46–47
70 × 7 The Meal, act L City of London, 2006–ongoing
Proposal for open-air dinner across the City of London, from the Tate Modern across the Millennium Bridge to Saint Paul's Cathedral, along King and Queen Street to the Guildhall. Table to be set for an estimated 8,000 guests with silkscreen-printed table runner and edition of Royal Limoges porcelain plates.
Renderings: Anna Kubelik

pp. 48–49
70 × 7 The Meal
Royal Limoges porcelain plates
Each 10½ in. (27 cm) diameter
Courtesy of Studio Orta Limited Editions

p. 48, from left to right, top to bottom:
Act III Innsbruck, 2000
Edition of 490 plates dated and signed by the artist
3-color enamel
Act IV Dieuze, 2000
Edition of 700 plates dated and signed by the artist
3-color enamel
Act V–VII Mexico City, 2001
Edition of 490 plates dated and signed by the artist
Gold and platinum, enamel
Act X Napa Valley, 2001
Edition of 210 plates dated and signed by the artist
4-color enamel
Act XI Antwerp, 2001
Edition of 210 plates dated and signed by the artist
3-color enamel
Act XIII Colchester, 2001
Edition of 210 plates dated and signed by the artist
4-color enamel

Act XVI Bolzano, 2002
Edition of 490 plates dated and signed by the artist
Platinum, enamel
Act XVII Toulouse, 2002
Edition of 350 plates dated and signed by the artist
3-color enamel
Act XIX Einhoven, 2002
Edition of 35 sets of 7 plates with different designs on the face and reverse side, dated and signed by the artist
Enamel, offset

p. 49, from left to right, top to bottom:
Act XX UNESCO, Paris, 2003
Edition of 210 plates dated and signed by the artist
Platinum, enamel
Act XXI Neude Square, Utrecht, 2005
Edition of 210 plates dated and signed by the artist
Platinum, enamel
Act XXII Hasselt, 2005
Edition of 210 plates dated and signed by the artist
3-color enamel
Act XXIII Barbican Art Gallery, London, 2005
Edition of 210 plates dated and signed by the artist
Platinum, enamel
Act XXIV ArtAids, Amsterdam, 2006
Edition of 150 sets of 7 plates each with different face designs, dated and signed by the artist
13-color enamel
Act XXV Open House, 2006
Edition of 150 plates dated and signed by the artist
12-color enamel
Act XXV Open House, 2006
Edition of 150 plates dated and signed by the artist
12-color enamel
Act XXVIII Monaco, 2008
Edition of 100 plates dated and signed by the artists
3-color enamel
Act XXIX La Venaria Reale, 2008
Edition of 150 plates dated and signed by the artists
4-color enamel

p. 50, top
70 × 7 The Meal—Crystal Table, 2005
Design for tabletop: glycerol paint, laser-engraved glass
78¾ × 39½ × ½ in. (200 × 100 × 1.2 cm)
Edition of 7

p. 50, bottom
70 × 7 The Meal, act XXI—Table Runner, 2005
Silver-coated polyamide, blue silkscreen print
78¾ × 19¾ in. (200 × 50 cm)
Edition of 20

p. 51, top and bottom
70 × 7 The Meal, act X—M.I.U. V, 2002
Installation for the inaugural exhibition *Active Ingredients* at COPIA: The American Center for Wine, Food and the Arts, Napa, California. Trailer, steel structure, wood, cushions, telescopic table, 70 × 7 silkscreen-printed table runner, Royal Limoges porcelain plates
472½ × 78¾ × 114¼ in. (1,200 × 200 × 290 cm)

p. 52, top, all
All in One Basket—Buffet Table, 1997
Folding decorator's table, laminated C-print, stitched leather handle
23½ × 94½ × 1½ in. (60 × 240 × 4 cm)
Photography: JJ Crance

p. 52, bottom, all
All in One Basket—Reliquary, 1997
Recycled fruit crate, laminated C-print, labeled and signed jam jars
14½ × 8 × 3¼ in. (37 × 20 × 8 cm)
Photography: JJ Crance

p. 53, top and bottom left
HortiRecycling Enterprise, act II—Reliquary Jars, 1997–99
Wooden shelf, 23 labeled and numbered jam and pickle jars
98½ × 6 × 4¾ in. (250 × 15 × 12 cm)
Photography: Pez Hejduk

p. 53, bottom right
All in One Basket—Stirrers, 1997
Wooden spoon, silkscreen print
31½ × 4 × 8 in. (80 × 10 × 20 cm)
Edition of 10
Photography: Pez Hejduk

pp. 54–55
HortiRecycling Enterprise, act II—Conservation Unit, 1997–2005
Steel structure, recycled fruit crates, laminated C-print, wicker baskets, amplifiers, hi-fi, CD player, headphones, 2 CD audio recordings, labeled and signed jam jars
31½ × 19 × 61 in. (80 × 48 × 155 cm)
Photography: Thierry Bal

p. 56
HortiRecycling Enterprise, act II, 1999
Installation at Wiener Secession, Vienna, Austria. Steel structure, shopping caddie, sink, cooking utensils, jam jars, buckets, laminated C-print, vinyl adhesives, wooden pulley, and silkscreen-printed food recycling bags
Variable dimensions
Photography: Pez Hejduk

p. 57, top
HortiRecycling Enterprise, act II—Processing Unit, 1999
Steel structure, shopping caddie, freezer, hot plate, utensils, jam jars, buckets, laminated C-print, vinyl adhesives
78¾ × 37½ × 25½ in. (200 × 95 × 65 cm)
Photography: Thierry Bal

p. 57, bottom
HortiRecycling Enterprise, act II—Processing Unit, 1999
Steel structure, shopping caddie, sink, water pipes, cooking utensils, jam jars, buckets, laminated C-print, vinyl adhesives
78¾ × 37½ × 25½ in. (200 × 95 × 65 cm)
Photography: Thierry Bal

p. 58
HortiRecycling, 1997–2005
Steel structure, 8 recycled fruit crates, 8 laminated Lambda photographs, 22 labeled and signed jam jars, various utensils, 2 wheels
47¼ × 35½ × 8½ in. (120 × 90 × 22 cm)
Photography: Thierry Bal

p. 59
HortiRecycling, 1997–2005
Steel structure, 4 recycled fruit crates, 4 laminated Lambda photographs, 14 labeled and signed jam jars, various utensils, 2 wheels
26½ × 35½ × 8¾ in. (67 × 90 × 22 cm)
Photography: Thierry Bal

p. 60, top
HortiRecycling Enterprise, act II—Vitrine, 1997–2008
Steel structure, 8 recycled fruit crates, 8 laminated Lambda photographs, 12 labeled and signed jam jars, 6 small recycled crates, 2 wheels
47¼ × 31½ × 8¾ in. (120 × 80 × 22 cm)
Photography: Thierry Bal

p. 60, bottom left
HortiRecycling Enterprise, act II—Vitrine, 1997–2008
Steel structure, 4 recycled fruit crates, 4 laminated Lambda photographs, 9 labeled and signed jam jars, small recycled crate, 2 wheels
26½ × 31½ × 8¾ in. (67 × 80 × 22 cm)
Photography: Bertrand Huet

p. 60, bottom right
HortiRecycling Enterprise, act II—Vitrine, 1997–2008
Steel structure, 4 recycled fruit crates, 4 laminated Lambda photographs, 14 labeled and signed jam jars, 2 wheels
26½ × 31½ × 8¾ in. (67 × 80 × 22 cm)
Photography: Bertrand Huet

p. 61
HortiRecycling—Mexican Kitchen, 1997–2008
Recycled Mexican gas cooker, steel structure, mirrors, 8 recycled fruit crates, 8 laminated Lambda photographs, various utensils, taps, 4 wheels
78¾ × 71 × 23½ in. (200 × 180 × 60 cm)
Photography: Bertrand Huet

WATER
p. 66
OrtaWater—Urban Life Guard, 2005
Various OrtaWater objects, aluminum-coated polyamide, inflatable life ring, PU-coated polyamide, clips, webbing, silkscreen print
71 × 106¼ × 114¼ in. (180 × 270 × 290 cm)
Courtesy of the artists and Galleria Continua, San Gimignano / Beijing / Le Moulin
E. Righi Collection, Italy
Photography: Gino Gabrieli

p. 67
OrtaWater—Barcode, 2005
Steel structure, laminated Lambda photograph, copper tubes, taps, assorted objects, barcode scanning device, computer
94½ × 78¾ × 39½ in. (240 × 200 × 100 cm)
Courtesy of the artists and Galleria Continua, San Gimignano / Beijing / Le Moulin
Photography: Gino Gabrieli

pp. 68–69
OrtaWater—Sleeping Suspension, 2005–7
Steel structure, bed tarp, assorted textiles, 7 OrtaWater bottles, tap, 2 wheels
43¼ × 31½ × 9¾ in. (110 × 80 × 25 cm)
Photography: Bertrand Huet

p. 70, top left
OrtaWater—Vitrine, 2006
Steel structure, mirror, glass, 3 OrtaWater bottles, Royal Limoges porcelain heart, aluminum flask, tap, 2 wheels
17¾ × 20½ × 9½ in. (45 × 52 × 24 cm)
Collection of the artists
Photography: Gino Gabrieli

p. 70, top center
OrtaWater—Vitrine, 2005
Steel structure, glass, tap, 4 OrtaWater bottles, laminated Lambda photograph
17¾ × 20½ × 9½ in. (45 × 52 × 24 cm)
Private collection, Italy
Photography: Gino Gabrieli

p. 70, top right
OrtaWater—Vitrine, 2005
Steel structure, laminated Lambda photograph, glass, 4 OrtaWater bottles, aluminum flask, tap
17¾ × 20½ × 9½ in. (45 × 52 × 24 cm)
Collection of the artists
Photography: Bertrand Huet

p. 70, bottom
Amazonia—Vitrine, 2010
Steel structure, copper tube, tap, laminated Lambda photograph, 4 OrtaWater bottles, 2 floats, 2 aluminum flasks, aluminum cup
17¾ × 35 × 9½ in. (45 × 89 × 24 cm)
Photography: Bertrand Huet

p. 71
OrtaWater—Glacier Wall Unit, 2005
Steel structure, laminated Lambda photograph, glass, Royal Limoges porcelain heart, 20 OrtaWater bottles, 2 taps
49¼ × 27½ × 15¾ in. (125 × 70 × 40 cm)
Private collection, Italy
Photography: Gino Gabrieli

p. 72, left
OrtaWater—Life Line, 2005
OrtaWater life jacket, laminated Lambda
photograph, silkscreen print, clips, rope
92½ × 23½ × 4 in. (235 × 60 × 10 cm)
Collection of the artists
Photography: Bertrand Huet

p. 72, right
OrtaWater—Life Line, 2005
OrtaWater life jacket, laminated Lambda
photograph, silkscreen print, clips, rope
92½ × 23½ × 4 in. (235 × 60 × 10 cm)
Private collection
Photography: Bertrand Huet

p. 73
OrtaWater—Storage Unit, 2005–8
Steel structure, glass, copper, plastic tubes,
projector, felt blankets, jerry can, water drum,
first aid kits, glass carafe, taps, rope, aluminum
flasks, bucket, 35 OrtaWater bottles
82¾ × 59 × 31½ in. (210 × 150 × 80 cm)
Courtesy of the artists and Motive Gallery,
Amsterdam, The Netherlands
Photography: Bertrand Huet

pp. 74–75
**OrtaWater—Light Messenger
Wall Unit**, 2005
Iron structure, laminated Lambda photograph,
2 projectors, aluminum flasks, plastic tube,
8 OrtaWater bottles, bucket, copper tube, taps
49¼ × 98½ × 15¾ in. (125 × 250 × 40 cm)
Courtesy of the artists and Galleria Continua,
San Gimignano / Beijing / Le Moulin
Photography: Gino Gabrieli

p. 76
OrtaWater—Exodus, 2007
Row boat, assorted textiles, steel structure,
laminated Lambda photograph, 3 Royal Limoges
porcelain hearts, 2 life rings, 2 oars, 3 water
flasks, 8 OrtaWater bottles
59 × 59 × 23½ in. (150 × 150 × 60 cm)
Courtesy of the artists and Galleria Continua,
San Gimignano / Beijing / Le Moulin
Photography: Ela Bialkowska

p. 77
OrtaWater—Bottle Rack, 2005
Bottle rack, 100 OrtaWater bottles,
Mexican water carafe
74¾ × 35½ × 39½ in. (190 × 90 × 100 cm)
Photography: Gino Gabrieli

pp. 78–79, all
Amazonia—Window on the World, 2010
Wooden window frame with shutters, Dibond
laminated Lambda photographs, 20 plasma
bottles
35½ × 39½ × 9¾ in. (90 × 100 × 25 cm)
Courtesy of the artists and Galleria Continua,
San Gimignano / Beijing / Le Moulin
Photography: Ela Bialkowska

p. 80
OrtaWater—Window on the World, 2005
Diptych window frames, laminated photographs,
copper tubing, sample bottles, children's clothes
47¼ × 23½ × 6 in. (120 × 60 × 15 cm)
Giuliani Collection, Rome
Photography: Gino Gabrieli

p. 81, top
OrtaWater—Vitrine, 2005–6
Steel structure, laminated Lambda photograph,
felt blanket, 2 glass carafes, aluminum flask,
Red Cross box, 28 OrtaWater bottles, 2 taps,
2 wheels
51¼ × 67 × 13¾ in. (130 × 170 × 35 cm)
Courtesy of the artists and Motive Gallery,
Amsterdam, The Netherlands

p. 81, bottom
OrtaWater—Iguazu Wall Unit, 2005
Steel structure, laminated Lambda photograph,
2 felt blankets, 2 glass carafes, 2 aluminum flasks,
34 OrtaWater bottles, 2 taps, 2 wheels
51¼ × 67 × 13¾ in. (130 × 170 × 35 cm)
Hans Oberrauch. Finstral Collection, Renon
Photography: Gino Gabrieli

p. 82, top and bottom
**OrtaWater—Portable Water
Fountain**, 2005
Steel structure, water drum, rubber wheels,
OrtaWater life jacket, copper tube, bucket, taps,
33 OrtaWater bottles, 4 wheels
71 × 74¾ × 19¾ in. (180 × 190 × 50 cm)
Courtesy of the artists and Motive Gallery,
Amsterdam, The Netherlands
Photography: Gino Gabrieli

p. 83
**OrtaWater—Mobile Intervention
Unit**, 2005
Mexican transport tricycle, steel structure,
4 bivouacs, 2 Mexican water carafes, 6 OrtaWater
bottles, 2 jerry cans, plastic tubes, 2 taps
86½ × 90½ × 43¼ in. (220 × 230 × 110 cm)
Private collection, Asiago
Photography: Gino Gabrieli

p. 84
OrtaWater—Mobile Intervention Unit,
2005
Mexican transport tricycle, steel structure,
5 sinks, glass shelf, light projector, plastic tube,
OrtaWater life jacket, 2 glass carafes, 2 jerry cans,
2 OrtaWater bottles
86½ × 78¾ × 39½ in. (220 × 200 × 100 cm)
Courtesy of Galleria Continua, San Gimignano /
Beijing / Le Moulin
Photography: Gino Gabrieli

p. 85
OrtaWater—Trolley Unit, 2005
Steel structure, glass, 3 buckets, jerry cans,
wooden crate, 8 OrtaWater bottles, water canister,
rope, 2 taps, copper tubes, 4 wheels
74¾ × 74¾ × 39½ in. (190 × 190 × 100 cm)
Photography: Gino Gabrieli

pp. 86–87, all
OrtaWater—M.I.U. Reservoir, 2007
APE 50 Piaggio, steel structure, water drum,
aluminum flasks, copper and plastic pipes,
taps, 28 OrtaWater bottles, 24 textile hands,
felt blankets
Variable dimensions: 103.5 × 102½ × 63½ in.
(263 × 260 × 161 cm)
Courtesy of the artists and Galleria Continua,
San Gimignano / Beijing / Le Moulin
Photography: Ela Bialkowska

pp. 88–89, all
**OrtaWater—Mobile Storage Tank
Unit**, 2005
APE 50 Piaggio, light projector, steel structure,
6 water drums, plastic tubes, copper taps
and tubes, 3 buckets
Variable dimensions: 99½ × 126 × 49½ in.
(253 × 320 × 126 cm)
Photography: Thierry Bal and Bob Goedewaagen

p. 90
OrtaWater—M.I.U. Life Line, 2005
APE 50 Piaggio, steel structure, 15 OrtaWater life
jackets, silkscreen print, 9 buckets, 8 copper taps
Variable dimensions: 99½ × 90½ × 49½ in.
(253 × 230 × 126 cm)
Photography: Gino Gabrieli

p. 91
OrtaWater—Refuge Wear 0816, 2005
Sleeping bag, Clerprem Solden Lycra,
silkscreen print, webbing, clips
78¾ × 19¾ × 11¾ in. (200 × 50 × 30 cm)
Photography: Bertrand Huet

pp. 92–93, all
**OrtaWater—Antarctica Fluvial
Intervention Unit**, 2005–8
Row boat, steel structure, neon, light box,
15 bivouacs, assorted textiles, 5 projectors,
warning light, copper and plastic tubes, taps,
plasma bottles, clothing fragments, national flags
118 × 98½ × 47¼ in. (300 × 250 × 120 cm)
Courtesy of the artists and Galleria Continua,
San Gimignano / Beijing / Le Moulin
Photography: Bertrand Huet

pp. 94–97, all
**OrtaWater—Fluvial Intervention
Unit**, 2005
Canadian maple wood canoe, steel structure,
glass shelves, copper and plastic tubes, gloves,
4 buckets, 4 crates, 4 water drums, 2 water tanks,
2 light projectors, 4 flasks, copper tubes and taps,
audio MP3, speakers, 24 OrtaWater bottles
102½ × 200¾ × 47¼ in. (260 × 510 × 120 cm)
Courtesy of the artists and Galleria Continua,
San Gimignano / Beijing / Le Moulin
Photography: Gino Gabrieli

pp. 98–99
OrtaWater—Purification Station, 2005
Installation in the Museum Boijmans Van
Beuningen, Rotterdam, The Netherlands.
Row boat, drinking water purification system,
steel structure, water tanks, jerry cans, canteens,
assorted objects, tubes, MP3 audio player,
4 speakers, OrtaWater bottles
316½ × 116–135¾ [variable] × 212½ in.
(804 × 295–345 [variable] × 540 cm)
Private Collection, Bologna, Italy
Photography: Bob Goedewaagen

LIFE
p. 107
Photography: Dirección Nacional del Antártico

pp. 109–19, all
Antarctic Village—No Borders, 2007
From February through March 2007, the artists
and their team traveled to the Antarctic Peninsula
to install the Antarctic Village. The incredible
journey, which originated from Buenos Aires, took
place during the austral summer. The ephemeral
installation coincided with the last of the scientific
expeditions before the winter months, when the
ice mass becomes too thick to traverse. Aided
by the logistical crew and scientists stationed at
the Marambio Antarctic Base, the artists scouted
the Antarctic Peninsula by helicopter searching for
different locations for the north, south, east, and
west encampments of the 50 Dome Dwellings.
Photography: Thierry Bal and Dirección Nacional
del Antártico

p. 120
**Antarctic Village—No Borders,
Métisse Flag**, 2007
Installation on the Antarctic Peninsula.
Inkjet on polyamide, eyelets
39½ × 59 in. (100 × 150 cm)
Edition of 7
Photography: Thierry Bal

p. 121
**Antarctic Village—No Borders,
Métisse Flag**, 2007
Installation at FRAC Lorraine, Metz, France.
Inkjet on polyamide, eyelets
39½ × 59 in. (100 × 150 cm)
Edition of 7
Photography: Rémi Villaggi

p. 122
Antarctic Village—No Borders, 2007
Installation in the Galleria Continua,
Le Moulin, France.
Photography: Bertrand Huet

pp. 123–27, all
**Antarctic Village—No Borders,
Dome Dwelling**, 2007
Coated polyamide, assorted textiles,
national flags, silkscreen print, second-hand
clothing, webbing, clips
71 × 71 × 59 in. (180 × 180 × 150 cm)
Photography: Bertrand Huet and JJ Crance

pp. 128–29
Antarctic Village—No Borders, 2007
Installation in the Hangar Bicocca, Milan, Italy.
Photography: Thierry Bal

pp. 130–31
Life Line—Survival Kit, 2008
Installation at Galleria Continua,
Le Moulin, France.
Steel structures, taps, piping, assorted textiles,
silkscreen print, webbing, assorted objects,
prototypes, drawings
Variable dimensions
Photography: Bertrand Huet

p. 132
Life Line—Survival Kit, 2008
Steel structure, 2 taps, piping, assorted textiles,
silkscreen print, webbing, rope, 2 floats, rescue
ring, horn, various water flasks and containers
59 × 31½ × 6 in. (150 × 80 × 15 cm)
Courtesy of the artists and Galleria Continua,
San Gimignano / Beijing / Le Moulin
Photography: Bertrand Huet

p. 133
Life Line—Survival Kit, 2008
Steel structure, 2 taps, piping, assorted textiles,
silkscreen print, webbing, national flags,
2 children's shoes, floats, rescue ring, rope,
whistles
59 × 31½ × 6 in. (150 × 80 × 15 cm)
Photography: Bertrand Huet

p. 134
Life Line—Survival Kit, 2008
Steel structure, 5 taps, piping, assorted textiles,
silkscreen print, webbing, flask, float, shoes, rope
59 × 31½ × 6 in. (150 × 80 × 15 cm)
Photography: Bertrand Huet

p. 135
Life Line—Survival Kit, 2008
Cotton toile, various clips
39½ × 27½ × 1¼ in. (100 × 70 × 3 cm)
Photography: Bertrand Huet

p. 136
Life Line—Survival Kit, 2008
Steel structure, laminated Lambda photograph,
piping, 2 taps, assorted fabrics, webbing, 2 water
flasks, whistle
61 × 47¼ × 6 in. (155 × 120 × 15 cm)
Photography: Bertrand Huet

p. 137
Life Line—Survival Kit, 2008
Steel structure, assorted textiles, webbing, acrylic
paint, 2 flasks, 2 buoys, floats, rope
47¼ × 41¼ × 6 in. (120 × 105 × 15 cm)
Courtesy of the artists and Motive Gallery,
Amsterdam, The Netherlands
Photography: Bertrand Huet

p. 138
Life Line—Survival Kit, 2008
Steel structure, laminated Lambda photograph,
piping, 2 taps, assorted fabrics, silkscreen print,
webbing, float, first aid box, flask, whistles,
assorted found objects
59 × 47¼ × 6 in. (150 × 120 × 15 cm)
Gemma De Angelis Testa Collection, Milan
Photography: Thierry Bal

p. 139
Life Line—Survival Kit, 2008-9
Steel structure, laminated Lambda photograph,
assorted fabrics, webbing, 5 floats, 5 flasks, 2 taps
59 × 35½ × 6 in. (150 × 90 × 15 cm)
Photography: Bertrand Huet

p. 140
**Antarctic Village—No Borders,
Drop Parachute**, 2007–8
Coated polyamide, fiberglass rods, assorted
textiles, national flags, cooking utensils, assorted
objects, silkscreen print, webbing, Red Cross crate
47¼ in. (120 cm) diameter, variable length
from ground
Collection of MAXXI, Museo nazionale delle
arti del XXI secolo, Rome, Italy
Photography: Ela Bialkowska

p. 141, left
**Antarctic Village—No Borders,
Drop Parachute**, 2007–8
Coated polyamide, fiberglass rods, assorted
textiles, national flags, children's toys and shoes,
assorted objects, silkscreen print, webbing, Red
Cross crate
47¼ in. (120 cm) diameter, variable length
from ground
Photography: Bertrand Huet

p. 141, right
**Antarctic Village—No Borders,
Drop Parachute**, 2007
Coated polyamide, fiberglass rods, assorted
textiles, national flags, water flasks buckets,
utensils, assorted objects, silkscreen print,
webbing, Red Cross crate
47¼ in. (120 cm) diameter, variable length
from ground
Photography: Thierry Bal

p. 142
**Antarctic Village—No Borders,
Drop Parachute**, 2007
Coated polyamide, fiberglass rods, assorted
textiles, national flags, silkscreen print,
webbing, wall stencils
59 × 19¾ in. (150 × 50 cm)
Courtesy of the artists and Galleria Continua,
San Gimignano / Beijing / Le Moulin
Photography: Ela Bialkowska

p. 143
**Antarctic Village—No Borders,
Drop Parachute Survival Kit**, 2007
Coated polyamide, fiberglass rods, assorted
textiles, national flags, silkscreen print,
webbing, clips, assorted objects, wooden crates,
laminated Lambda photographs, wall stencils
Variable dimensions
Courtesy of the artists and Galleria Continua,
San Gimignano / Beijing / Le Moulin
Photography: Ela Bialkowska

pp. 144–45
**Antarctic Village—No Borders,
Drop Parachutes**, 2007
Installation in the Galleria Continua, San
Gimignano, Italy.
Coated polyamide, fiberglass rods, assorted
textiles, national flags, silkscreen print, webbing,
clips, second-hand clothing, various objects, plinths
47¼ in. (120 cm) diameter, variable length
from ground
Parachute in rear: Hans Oberrauch. Finstral
Collection, Renon
Photography: Ela Bialkowska

p. 146
Window on the World—Antarctica, 2008
Diptych window frames, laminated Lambda
photograph, mirror, glass, 32 plasma bottles,
clothing fragments
48¾ × 39½ × 5 in. (124 × 100 × 13 cm)
Ghidoni Collection, Trento
Photography: Bertrand Huet

p. 147, top
Window on the World—Antarctica, 2007
Window frame, laminated Lambda photograph,
21 plasma bottles, clothing fragments, flags,
copper tube, tap
23½ × 33½ × 6 in. (60 × 85 × 15 cm)
Courtesy of the artists and Motive Gallery,
Amsterdam, The Netherlands
Photography: Bertrand Huet

p. 147, bottom
**Window on the World—Antarctic Village,
No Borders**, 2007
2 diptych window frames, laminated Lambda
photograph, 40 plasma bottles, clothing
fragments, flags
36½ × 41¾ × 5 in. (93 × 106 × 13 cm)
Courtesy of the artists and Motive Gallery,
Amsterdam, The Netherlands
Photography: Bertrand Huet

p. 148
**Antarctica World Passport—International
Delivery Bureau**, 2009
Installation along the Paleo Faliro Coast, for
the 2nd Athens Biennale, Greece.
Bureau construction attached to existing
architectural structure, chairs, assorted objects,
4 passport stamps, inkpads, Antarctica World
Passports

p. 149
**Antarctica World Passport—
International Delivery Bureau**, 2008
Installation at Hangar Bicocca, Milan, Italy.
Bureau construction, 10 chairs, Red Cross crates,
assorted objects, 4 passport stamps, inkpads,
Antarctica World Passports
Variable dimensions

p. 150
**Antarctica World Passport—
Delivery Kit**, 2008
Wooden valise, laminated Lambda photograph,
glass, 10 Antarctica World Passports, hand-turned
wooden passport stamp with rubber embossed
motif, inkpad
8 × 13¾ × 4 in. (20 × 35 × 10 cm)
Edition of 25
Courtesy of the artists and Galerie Multiple,
Paris, France
Photography: Bertrand Huet

p. 151
Antarctica World Passport, 2008
Edition of 10,000 passports and an online
database for Antarctica World Citizens
http://antarcticaworldpassport.mit.edu/
5 × 3½ in. (12.5 × 8.5 cm)

p. 152
**Antarctica World Passport—International
Delivery Bureau**, 2008
Installation at Hangar Bicocca, Milan, Italy.
Bureau construction, 10 chairs, Red Cross crates,
assorted objects, 4 passport stamps, inkpads,
Antarctica World Passports
Variable dimensions
Photography: Thierry Bal

pp. 153–54
**Antarctica World Passport—
International Delivery Bureau**, 2008
Installation at Galleria Continua, Le Moulin,
France.
Bureau construction, 10 chairs, Red Cross crates,
assorted objects, 4 passport stamps, inkpads,
Antarctica World Passports
Variable dimensions
Photography: Bertrand Huet

p. 155
**Antarctic Village—No Borders,
Expedition Tarpaulin**, 2007
Jet Tex, inkjet print, webbing, eyelets
98½ × 98½ in. (250 × 250 cm)
Courtesy of the artists and Galleria Continua,
San Gimignano / Beijing / Le Moulin
Photography: Ela Bialkowska

p. 156
**Antarctica World Passport—
Mobile Delivery Bureau**, 2008
Wooden shelf, shovel, chair, 10 plasma bottles,
clothing fragments, 2 flasks, first aid box, passport
valise, assorted aluminum utensils
59 × 51¼ × 15¾ in. (150 × 130 × 40 cm)
Courtesy of the artists and Motive Gallery,
Amsterdam, The Netherlands
Photography: Bertrand Huet

p. 157
**Antarctica World Passport—
Mobile Delivery Bureau**, 2008
Wooden shelf, 3 OrtaWater bottles, 2 plasma
bottles, 2 sample bottles, clothing fragments, flask,
float, passport valise, assorted aluminum utensils
43¼ × 35½ × 11¾ in. (110 × 90 × 30 cm)
Photography: Bertrand Huet

pp. 158–59
**Antarctica World Passport—
Mobile Delivery Bureau**, 2008
Window on the World diptych, laminated
Lambda photograph, sample bottles, bureau and
chair, wooden shelves, plasma bottles, clothing
fragments, flasks, first aid box, woolen blankets,
passport valise, floats, assorted aluminum
utensils and pots, wall stencil
71 × 71 × 31½ in. (180 × 180 × 80 cm)
Photography: Bertrand Huet

INTERVIEW
p. 161
**Refuge Wear Intervention
London East End**, 1998
Lambda color photograph, laminated
on Dibond
59 × 47¼ in. (150 × 120 cm)
Edition of 7
Photography: John Akehurst

p. 162, top left
**Nexus Architecture × 50 Intervention
Köln**, 2001
Lambda color photograph, laminated on Dibond
59 × 47¼ in. (150 × 120 cm)
Edition of 7
Photography: Peter Guenzel

p. 162, top right
**Nexus Architecture Johannesburg
Biennale**, 1997
Intervention with women from Usindiso Shelter
Trade Routes: History and Geography, 2nd
Johannesburg Biennale

p. 162, center
**Light Works—Imprints on the
Andes**, 1992
Ephemeral work to mark the 500th anniversary of
the discovery of the Americas. Mobile light images
projected onto Inca sites along the Peruvian
cordillera from Cusco to Machu Picchu during a
5-week expedition.

p. 162, bottom
Refuge Wear—Habitent, 1992–93
Aluminum-coated polyamide, polar fleece,
telescopic aluminum poles, whistle, lantern,
transport bag, silkscreen print
49¼ × 49¼ × 49¼ in. (125 × 125 × 125 cm)
Private collection

Bibliography

Monographs

Orta, Lucy, ed. *Lucy + Jorge Orta: Light Works*. London: Black Dog Publishing, 2010.

Pietromarchi, Bartolomeo, ed. *Antarctica*. Milan: Mondadori Electa, 2008.

Orrell, Paula, ed. *Lucy + Jorge Orta Pattern Book: An Introduction to Collaborative Practices*. London: Black Dog Publishing, 2007.

Prince, Nigel, ed. *Lucy + Jorge Orta: Collective Space*. Birmingham, UK: Article Press, 2006.

Smith, Courtney, ed. *Body Architecture*. Munich: Silke Schreiber Verlag, 2003.

Williams, Gilda, ed. *Lucy Orta*. Contemporary Artist. London: Phaidon, 2003.

Budney, Jen, ed. *Process of Transformation*. Paris: Editions Jean-Michel Place, 1999.

Glusberg, Jorge, ed. *Transparence*. Paris: Editions Jean-Michel Place, 1996.

Orta, Jorge, ed. *Light Messenger*. Paris: Editions Jean-Michel Place, 1996.

Orta, Lucy, ed. *Refuge Wear*. Paris: Editions Jean-Michel Place, 1996.

Solo Exhibition Catalogues

Perisino, Maria, and Bartolomeo Pietromarchi, eds. *Lucy + Jorge Orta: 70 × 7 The Meal*. Turin: Pocko Editions, 2008.

Guérin, Paul, ed. *OrtaWater, Lucy + Jorge Orta*. Strasbourg: Centre Européen d'Actions Artistiques Contemporaines, 2007.

Holmes, Jonathan, and Chris Townsend. *Fallujah*. London: ICA London, 2007.

Cairns, Stephen, and Joanne Entwistle. *Refuge Wear and Nexus Architecture*. Havana: 9th Havana Biennale, 2006.

Vettese, Angela, ed. *DrinkWater!* Pistoia, Italy: Gli Ori, 2005.

Hanru, Hou. *HortiRecycling*. Vienna: Wiener Secession, June 1999.

Pettigas, Catherine, ed. *Incandescence*. Paris: Editions Jean-Michel Place, 1998.

Group Exhibition Catalogues

Bureaud, Annick, and Jean-Luc Soret, eds. "Antarctica." In *(IN)Habitable? L'art des environnements extrêmes*. Paris: Festival @rt Outsiders / Maison Europeenne de La Photographie, 2009.

Gensini, Valentina, ed. *Green Platform: Through the Platform, Art Ecology Sustainability*. Florence: Centro di Cultura Contemporanea Strozzina Firenze, 2009.

Kainrath, Peter Paul. "Lucy + Jorge Orta." In *The Delight of Collecting, Works from the Finstral Collection*. Merano, Italy: Kunst Merano Arte, 2009.

Lyngstad Nyaas, Tone, ed. *Antarctica*. Tønsberg: Hauger Vestfold Kunstmuseum, 2009.

Scardi, Gabi. "TAMA Project Side Effects." In *× Biennale de Lyon*. Dijon, France: les presses du reel, 2009.

Comisso, Francesca, ed. "Lucy Orta, Totipotent Architecture Atoll." In *New Patrons, Contemporary Art, Society and Public Space*. Milan: Silvana Editoriale, 2008.

Joly, Eric. "Lucy et Jorge Orta. Le bureau de délivrance du passeport universel." In *Art Grandeur Nature*. Le Blanc-Mesnil, France: Forum de Blanc Mesnil, 2008.

Matsuoka, Takeshi, ed. *Shelter × Survival: Alternative Homes for Fantastic Lives*. Hiroshima: Hiroshima City Art Museum, 2008.

Barruol, Agnes, ed. *Dans ces eaux-là*. Paris: Actes Sud, 2007.

Knol, Meta, ed. *This Is America*. Amsterdam: J.M. Meulenhoff, 2006.

Scardi, Gabi, ed. "Urban Armor." In *Alternative Living Strategies*. Milan: 5 Continents Editions, 2006.

Koike, Kazuko, ed. "Connector." In *On Conceptual Clothing*. Tokyo: Musashino Art University Museum, 2005.

Hoos Fox, Judy, ed. *Pattern Language: Clothing as Communicator*. Medford, MA: Tufts University Art Gallery, 2005.

Zucca Alessandrelli, Irina. "Lucy Orta." In *Exilles: The Five Rings*. Turin: Umberto Allemandi, 2005.

Pinto, Roberto. *A Grain of Dust, a Drop of Water*. Gwangju, South Korea: Gwangju Biennale, 2004.

Putman, James. "Totipotent Architecture." In *Arte All'Arte: Arte Architettura Paesaggio*. Pistoia, Italy: Gli Ori, 2004.

Thompson, Nato, ed. *The Interventionists, Trespassing Toward Relevance*. North Adams, MA: Mass MoCA, 2004.

De Roden, Peter, ed. "Lucy + Jorge Orta." In *Art from a Natural Source, Kaap Helder*. Den Helder, The Netherlands: Kunst en Cultuur Nord-Holland, 2003.

Lamoureux, Johanne, ed. *Doublures: Vêtements de l'art contemporain*. Quebec: Musée National des Beaux-Arts Québec, 2003.

Damianovic, Maia, and Sabina Gamper, eds. *To Actuality*. Bolzano, Italy: Ar/ge Kunst Galerie Museum, 2002.

Beyerle, Tulga, ed. "Collective Wear × 3." In *Global Tools*. Zurich: Kunsthaus Zurich, 2001.

Cappellazo, Amy, and Margaret Miller, eds. "70 × 7 The Meal." In *Active Ingredients*. Napa, CA: COPIA: The American Center for Wine, Food and the Arts, 2001.

Heinzelmann, Markus, ed. *Plug In*. Münster, Germany: Westfälisches Landesmuseum für Kunst und Kulturgeschichte, 2001.

Heinzelmann, Markus, ed. *Untragbar*. Ostfildern, Germany: Hatje Cantz / Museum für Angewandte Kunst Köln, 2001.

Pinto, Roberto, and Emanuela De Cecco, eds. *Transforms*. Trieste, Italy: CCNI, 2001.

Koop, Stuart, and Vikki McInnes, eds. *Red*. Melbourne: Australian Centre for Contemporary Art, 2000.

Prince, Nigel, and Gavin Wade, eds. "Life Nexus Village." In *In the Midst of Things*. Birmingham, UK: August Media, 2000.

Smith, Trevor, ed. *Home: An Archaeology of the Social Link*. Perth: Art Gallery of Western Australia, 2000.

Kohmoto, Shinji, ed. *Visions of the Body: Fashion or Invisible Corset*. Kyoto: National Museum of Modern Art; Tokyo: Museum of Contemporary Art, 1999.

McDonald, Ewen, ed. *Personal Effects*. Sydney: Museum of Contemporary Art, 1998.

Wollen, Peter, ed. *Addressing the Century*. London: Hayward Gallery, 1998.

Lacloche, Francis, ed. "Lucy Orta, Dans Le Meme Panier." In *Carnet d'un mécène*. Paris: Caisse des Depots et Consignation, 1997.

Jammet, Yves, ed. "Lucy Orta, bornes citoyennes." In *Ici et maintenant*. Paris: APSV, Parc de la Vilette, 1996.

Sans, Jérôme, ed. *On Board Log Book*. Venice, 1995.

Pagé, Suzanne, and Béatrice Parent, eds. *Ateliers 94*. Paris: Musée d'Art Moderne de la Ville de Paris, 1994.

Piguet, Philippe, ed. "Vetements Refuges." Seine-Saint-Denis, France: Fond Departemental d'Art Contemporain, Departement de Seine-Saint-Denis, 1994.

Ardenne, Paul, and Denis Lebaillif, eds. *Art Fonction Sociale!* Paris: Cité de Refuge Paris, 1993.

Books, Magazines, and Journals

2010

Fluck, Apolline. "Vetements vehicules, Lucy + Jorge Orta." *Azimuts revue de design* 34 (Spring 2010): 8–23.

Girault, Marie. "Lucy et Jorge Orta, poetes engagés." *Artension* 99 (January/February 2010): 30–34.

Gowronski, Alex. "Between Art and Action." *Contemporary Visual Art + Culture Broadsheet* 39 (March 2010): 49–52.

2009

Barbero, Luca Massimo, and Elena Ciresola, eds. "Lucy + Jorge Orta." In *Index 2*. Venice: Marsilio, 2009.

Berk, Anne. "Hoopvolle Kunst van Studio Orta." *Financieel Dagblad*. January 10, 2009.

Carbonaro, Simonetta. "If Only We Wanted To." *The Hub: Focus on Research* 6 (February 2009): 19–20.

Chavez, Juan David, ed. *Habitarte: La mirada crítica desde el espacio escultórico contemporáneo hacia la arquitectura doméstica actual*. Medellín, Colombia: Consejo Profesional Nacional de Arquitectura y sus Profesiones Auxiliares: Universidad de Antioquia, Facultad de Artes, 2009.

Hambly, Vivienne. "Into the Amazon's Earth." *Sublime* 17 (October 2009): 13–20.

Jocks, Heinz-Norbert. "Kelider Machen Identitaten." In *Dressed! Art en Vogue*. Ruppichteroth, Germany: Kunstforum International, 2009.

Klanten, Robert, and Lukas Feireiss, eds. *Spacecraft 2: More Fleeting Architecture and Hideouts*. Berlin: Gestalten, 2009.

Lamunière, Simon, ed. "Antarctic Village—No Borders (Lucy + Jorge Orta)." In *Utopics: Systems and Landmarks*. Zurich: JRP Rigier, 2009.

Orta, Lucy, ed. *Mapping the Invisible, EU-Roma Gypsies*. London: Black Dog Publishing, 2009.

Papastergiadis, Nikos. "Lucy Orta: The Artist as Enabler." *Art & Australia* 47, no. 2 (Summer 2009): 240–41.

2008

"Antarctica." *Urban* 21 (April 2008): 21–26.

"Antarctica al confini del mondo." *Gd'A*, May 2008, 98–99.

"Antarctica: Viaggio al confini del mondo." *Elle Decor* 19 (May 2008): 626.

Capelli, Pia. "All'Hangar Bicocca, Da Oggi a Milano la grande mostra di Jorge + Lucy." *Libero*. April 2, 2008.

———. "All'Hangar Bicocca gli Orta." *Arte*. April 3–9, 2008.

Casati, Marta. "Lucy + Jorge Orta." *EspoArte*, April–May 2008, 79–85.

Chiodi, Stefano. "Visionari del pronto soccorso." *Specchio: La Stampa*, May 2008, 104–6.

Di Genova, Arianna. "Antartide, il continente dell'utopia no borders." *Visioni*. April 3, 2008.

Echavarria, Pilar. "Life Nexus Village et Refuge Wear." In *Architecture Portative: Environnements Imprévisibles*. Barcelona: Links Books, 2008.

Grassi, Manuela. "Antartide formato Bicocca." *Panorama*. March 28, 2008.

Irace, Fulvio, ed. *Casa per Tutti: Abitare la citta globale*. Milan: Mondadori Electa, 2008.

Legrenzi, Susanna. "Un nuovo mondo venuto dal Freddo." *Corriere Della Serra*. March 15, 2008.

Mammi, Alessandra. "Red Carpet. Colloquio con Lucy e Jorge Orta." *L'Espresso*. March 13, 2008.

Meneguzzo, Marco. "Gli Orta in Antartide, l'ultima terra senza confini nazionalistici." *Avvenire*. April 8, 2008.

Mirenzi, Franco. "Lucy + Jorge Orta, Antarctica." *OFArch*, June 2008, 16.

Monem, Nadine, ed. *Contemporary Textiles: The Fabric of Fine Art*. London: Black Dog Publishing, 2008.

Moralto, Rossella. "Lucy + Jorge Orta." *Arte e Critica* 55 (June–August 2008): 94.

Moretti, Silvia. "La globalizzazione fra i Ghiacci." *Insideart*, April 2008, 30–31.

Mostafavi, Mohsen. "Architecture's Inside." In "What about the Inside." Special issue, *Harvard Design Magazine* 29 (Fall 2008): 107.

Naidoo, Ravi. "A Better Future by Design Art Fashion and Social Consciousness." *Design Indaba* (2008): 7–15.

Orta, Jorge. "The Antarctica Project." In *Urban Climate Change Crossroads*. New York: Urban Design Lab, 2008.

Perra, Daniele. "Design on Ice." *BOX*, Summer 2008, 36–51.

———. "Beyond Borders." *BOX*, Summer 2008, 36.

———. "Installazioni Nomadi, Antartico alla Bicocca." *Luna*, April 2008, 78.

Pirovano, Stefano. "Vernissage in Antartide." *Casamica*, February 2008, 62.

Pratesi, Ludovico. "Dal Polo Sud la mostra glaciale che affronta temi scottanti." *Il Venderedi di Republica*. March 28, 2008.

Rovesti, Fabrizio. "Lucy e Jorge: La fine del mondo dall'Antartide alla Bicocca." *Prealpina*. April 13, 2008.

Rowena, Liu. "Lucy + Jorge Orta, Antarctica Hangar Bicocca Milan." *IW Magazine*, July–August 2008, 88–91.

Tamburi, Laura. "Lucy + Jorge Orta, La missione libertaria dell'arte." *New Age*, May 2008, 72–75.

Zambianchi, Ivana. "Installazioni/ai confini del mondo." *Brava Casa*, May 2008, 61.

2007

Bannet, Alma. "Lucy Orta il cibo avanzato." *Velvet*, August 2007, 157.

Bigi, Daniela. "Antarctica: An Emblematic Village." *Arte e Critica* 53 (December 2007): 60–65.

Bubmann, Klaus. "Lucy Orta." In *Plug-in*. Amsterdam: Einst und Mobilitat, 2007.

Harris, Gareth. "Antarctic Village." *Art Newspaper* 172, no. 180 (2007): 6.

Lagroue, Bruno. "Nouvelle vie pour le Moulin de Boissy." *Le Briard Coulommiers*. October 19, 2007.

Mandrini, Riccarda. "Antarctica." *Vogue Italia*, December 2007, 58.

Moreno, Shonquis. "Antarctic Village." *Surface Magazine* 66, no. 180 (2007): 70.

Peña, Ann Marie. "Antarctic Village—No Borders, A Project by Lucy and Jorge Orta." *Diversifying Fashion*, June 2007, 14–18.

Perlez, Jane. "Fallujah: An Assault in Iraq." *New York Times*. May 29, 2007.

Virilio, Paul. "Interview with Lucy Orta." In *Design and Art: Documents of Contemporary Art*. London: Whitechapel Press; Cambridge, MA: MIT Press, 2007.

2006

Doswald, Christoph, ed. *Double-Face: The Story about Fashion and Art from Mohammed to Warhol*. Zurich: JRP Ringer, 2006.

Drummond, Diana. "Lucy Orta." In *Textile Art for Our Time*. Oxford: Berg Publishers, 2006.

Hanisch, Ruth. *Absolutely Fabulous! Architecture for Fashion*. Munich: Prestel, 2006.

Hemmings, Jessica, and Marilyn Murphy. "Adorned in Ideas." *Fiber Arts* 32, no. 4 (2006): 40–41.

Kaufman, David, and Christian Schwalbach. "Body of Work." *Departures*, Autumn 2006, 114.

MJM. "Retablir le lien social." In *Inspirations*. Paris: Maison & Objet, 2006.

Pinto, Roberto. "Lucy Orta." In *The Power of Fashion: About Design and Meaning*. Brooklyn, NY: Terra Press; Arnhem, The Netherlands: ArtEZ Press, 2006.

Teunisson, José, ed. *The Power of Fashion: About Design and Meaning*. Brooklyn, NY: Terra Press; Arnhem, The Netherlands: ArtEZ Press, 2006.

Thackara, Davina. "Lucy Orta." *Contemporary* 21, no. 87 (2006): 58–61.

2005

Antonelli, Paola, ed. *Safe: Design Takes on Risk*. New York: Museum of Modern Art, 2005.

Beckers, Macribe. "Positief Design." *Elle Wonen* 98 (March 2005): 36–37.

Braddock, Sarah, and Marie O'Mahony. *Techno Textiles: Revolutionary Fabrics for Fashion and Design*. London: Thames and Hudson, 2005.

Cooke, Rachel. "Be Prepared." *Observer*. September 11, 2005.

Croci, Valentina. "Lucy Orta." *Ottagono*, June 2005, 21–22.

Di Marzio, Mimmo. "La Biennale nel sogno dell'acqua." *Il Giornale*. June 20, 2005.

Hains, Bruce. "Gwangju Biennale." *Frieze* 89 (2005): 127–29.

Melhuish, Clare. "Lucy Orta." In *Home Cultures 2*. Oxford: Berg Publishers, 2005.

Morozzi, Cristina. "Vestito da abitare." *Amica* 39 (2005): 104–7.

Putnam, James. "No Labels." *Art Review* LVI (September 2005): 60–65.

Roots, Frank. *Cabins: Dens and Bolt Houses*. Paris: Fitway Publishing, 2005.

Schofield, John. *Combat Archaeology: Material Culture and Modern Conflict*. London: Duckworth Publishers, 2005.

Smith, Courtenay, and Sean Topham, eds. *Xtreme Fashion*. Munich: Prestel, 2005.

Townsend, Chris. "Lucy Orta: Art, Fashion, Mobility." *Art & Architecture Journal* 62 (Summer 2005): 37–39.

"Transgressing Fashion." *Crudelia* 23 (2005): 10–11.

Von Fichern, Sigrid. "Ein Kleid, Ein Haus." *Vogue Deutsch*, April 2005, 162–64.

Von Naso, Rudiger. "Gesellschaftsspiele." *Madame*, May 2005, 68.

2004

Apfelbaum, Sue. "Social Fabric: Lucy Orta." *RES* 7, no. 4 (2004): 22.

Baqué, Dominique, ed. *Pour un Nouvel Art Politique*. Paris: Flammarion, 2004.

Barano, Claudia. "La visibilita degli invisibili." *Activa Fashion Design Management* 39 (2004): 108–15.

Becker, Jack. "Recent Projects." *Public Art Review*, Fall–Winter 2004, 48.

Caretta, Enrica. "Meglio condividere." *Marie Claire Italia* 5 (2004): 161–66.

Conekin, Becky. "Orta's Current Collaboration." *Research Publication*, November 2004, 55–57.

Coomer, Martin. "Showgirls." *Elle UK*, September 2004, 105.

Cuenca la luz en el paisaje. La Fondacion Cultural Banesto, 2004.

Gabrielli, Paolo. "Art as Fashion." *Art Review* 54 (September 2003): 50–55.

Gockel, Cornelia. "Lucy Orta: Body Architecture." In *Garbage Art*. Ruppichteroth, Germany: Kunstforum International, 2004.

Laurence, Dreyfus. "70 × 7: la comida." In *Deguste*. Paris: CulturesFrance, 2004.

Long, Kieran. "Nexus Architecture." *Icon*, October 2004, 186–87.

Pawson, John, and Lucy Orta. "To Be Minimalist... or Maximalist." *Guardian*. April 19, 2004.

Phillips, Ian. "Worlds Apart." *Independent*. April 3, 2004.

Quinn, Bradley. "Body Architecture." *Selvedge* 1 (July/August 2004): 52–55.

Saltzman, Andrea. *El cuerpo disenado sobre la forma en el proyecto de la vestimenta*. Buenos Aires: Editorial Paidos SAICF, 2004.

Tevi, Alice. "Lucy Che Salva il Mondo." *La repubblica delle donne*. September 11, 2004.

Thompson, Henrietta. "Chalayan versus Orta." *Blueprint* 219 (May 2004): 128–29.

———. "Home Is Where The Art Is." *Blueprint* 217 (March 2004): 86.

Topham, Sean, ed. *Move House*. Munich: Prestel, 2004.

Vettese, Angela. "Lucy e ombre." *Vernissage* 52 (September 2004): 3.

Von Naso, Rudiger. "Charakter zeigen!" *Madame*, February 2004, 72–75.

Willemin, Veronique, ed. "Les Vetements Refuges et Nexus Architecture." In *Maisons Mobile*. Paris: Collection Anarchitecture, 2004.

2003

Bick, Emily. "Techno Fashion." *Contemporary* 51 (2003): 66–68.

Evans, Caroline, ed. *Fashion at the Edge: Spectacle, Modernity and Deathliness*. New Haven, CT: Yale University Press, 2003.

Fossati, Maddalena. "Insieme si può." *Marie Claire Italia* 5 (May 2003): 166.

Goetz, Joachim. "Das Bedurfnis nach Schutz, Geborgenheit und Gemeinsamkei." *TDK*. September 24, 2003.

Hermann, Alice. "Il faut avoir une esthetique et un statement, l'un ne fonctionne pas sans l'autre." Paris: Stiletto Edition, 2003.

Hoffmann, Justin. "Lucy Orta." *Kunst-Bulletin* 11 (November 2003).

Mulholland, Neil. "All You Need to Know." *Frieze* 73 (March 2003): 91–92.

Paolo, Gabrielle. "Art as Fashion." *Art Review* LIV (September 2003): 54–59.

Quinn, Bradley, ed. *The Fashion of Architecture*. Oxford: Berg Publishers, 2003.

Van den Hoven, Geerit. "En zorgouldig Vormgegem Utopia." *Uit & Kunst*. October 30, 2003.

White, Lisa. "Lucy Orta: Mobile Intervention Unit IV." *View on Colour* 24 (June 2003): 34–35.

2002

Altena, Arie. "Over de gastvrijheid van kunst." *Metropolis* 5 (October 2002): 51–53.

Bokern, Anneke. "Lucy Orta, Fluid Architecture." *Bauwelt* 35 (September 2002).

Bolton, Andrew, ed. "Interview with Lucy Orta." In *The Super Modern Wardrobe*. London: V&A Publications, 2002.

Boucault, Vincent. "Lucy Orta habille le monde de ses Vêtements Refuges." *Le Monde*. June 17, 2002.

Braddock, Sarah, and Marie O'Mahony, eds. *Sport Tech Sportswear: Revolutionary Fabrics*. London: Thames and Hudson, 2002.

Budney, Jen, and Adrian Blackwell, eds. *Unboxed: Engagements in Social Space*. Ottawa, ON: G-101 Publications, 2005.

De Martrin, Maia. "Sans rêves il n'y a pas de projets." *Art Actuel* 19 (March 2002): 56–59.

Haagsma, Lotte. "Beschermende kleding als symbol." *Tubelight* 2 (September 2002): 19–20.

Hamaid, Chantal. "Le village mobile de Lucy Orta." *Intramuros*, June/July 2002.

Price, Matt. "Somewhere, Places of Refuge in Art and Life." *a-n*, November 2002.

Quinn, Bradley, ed. *Techno Fashion*. Oxford: Berg Publishers, 2002.

Smith, Courtenay, and Sean Topham, eds. *Xtreme Houses*. Munich: Prestel, 2002.

Sozanski, Edward J. "Art in the Bag." *Philadelphia Inquirer*. January 3, 2002.

Such, Robert. "Out of the Woods." *Blueprint* 194 (April 2002): 72–74.

Van Driel, Anne. "Solidair regenjack." *De Volkskrant Amsterdam*. July 25, 2002.

2001

Berwick, Carly. "Clothes Encounters." *ARTnews* 100 (November 2001).

Bralic, John. "Corporeal Limits." *Monument*, June/July 2001, 74–77.

Comte, Beatrice. "Le Zocalo de Mexico—L'Oeuvre d'un soir." *Le Figaro Magazine*, April 2001, 96–98.

Ishiguro, Tomoko. "Creating a Future from Voluntary Social Action." *Axis Japan* 90 (January 2001): 89–93.

Jeffett, William. "Lucy Orta." *New York Arts* 12 (December 2001): 9.

Jiménez Flores, Maricruz. "Connector Gardien." *Cronica Mexico City*. March 31, 2001.

Marger, Ann-Mary. "Lucy Orta: Fashioning Change Through Art." *St. Petersburg Times*. November 18, 2001.

Muchnic, Suzanne. "Eat, Drink and Be Cultural." *Los Angeles Times*. November 25, 2001.

Neradil, Barbara. "The Art of Connection." *Oracle Tampa*. November 21, 2001.

Noé, Paola. "Transforms." *Tema Celeste*, March 2001.

Poncet, Emmanuel. "L'art à l'école." *Beaux Arts Magazine*, October 2001, 156.

Posca, Claudia. "Plug-in: Einheit und Mobiliat." *Kunstforum International* 156 (2001): 391–93.

Schulze, Karin. "Zwischen Qual und Lust." *Financial Times Deutschland*. July 17, 2001.

Socha, Miles. "The Great Unworn." *Women's Wear Daily*. August 7, 2001.

White, Lisa. "Hortirecycling." *View on Colour* 18 (2001): 26–27.

Wright, Bruce. "Fabric Interventions." *Public Arts Review* 12 (2001): 11–14.

2000

Aberle, Marion. "Wohnkleider und Hosenzelte für die Nomaden des 21 Jahrhunderts." *Frankfurter Allgemeine*. January 15, 2000.

Bartolotti, Paola. "Le umane tribu rivestite da Lucy." *Corriere di Firenze*. January 12, 2000.

Gallagher, Bryan. "Portable Habitat." *b-guided*, 2000, 40–43.

Hill, Peter. "Deconstructing Deconstruction." *Art Monthly Australia* 130 (June 2000): 13–14.

Hufschlag, Inge. "Im Overall das Wohnen Wagen." *Handelsblatt Düsseldorf*. January 18, 2000.

Leprun, Sylviane. "Le temps du risque: La création comme enterprise." In *Le Risque en Art*. Paris: Editions Klincksieck, 2000.

Piccinini, Laura. "Trovare Casa in un Vestito." *Amica* 8 (February 2000): 226–27.

Reid, Chris. "It's in Your Head, Outside Inside." *Space Time*, 2000, 52–55.

Rota, Nelda. "A Firenze in Mostra l'Uomo Oggetto." *Il Secolo XIX*. January 16, 2000.

Taroni, Francesca. "La nuova estetica delle relazioni tra open-air buffets e banchetti senza fine." *Casa Vogue Italy*, October 2000, 70.

Tommasini, Cristina Maria. "Body Architectures, Survival Clothes." *Domus*, March 2000, 74.

Virilio, Paul. "Un habitat exorbitant." *Architecture d'Aujourd'hui* 328 (June 2000): 112–19.

Warr, Tracey, and Amelia Jones, eds. *The Artist's Body*. London: Phaidon, 2000.

1999

Borchhardt-Birbaumer, Brigitte. "Soziale und strukturale Strategien." *Wiener Zeitung*. July 16, 1999.

Chelotti, Chiara. "Lucy Transformation for Multiples Architecture Modulari." *L'Uomo Vogue* (1999): 136–43.

Fitoussi, Brigitte. "Robe 'n' Nobel." *Numéro* 8 (November 1999): 50.

Goldberg, Roselee, ed. *Performance, l'art en action*. London: Thames and Hudson, 1999.

Harmel, Francoise. "Process of Transformation." *Architecture d'Aujourd'hui* 225 (March 1999): 6.

Hirvensalo, Virve. "Wrap around Shelter." *Frame* 2 (1999): 21.

Hofleitner, Johanna. "Landwirtschaft & das Kleinstadtische." *Schaufenster Die Presse*. June 25, 1999.

Milani, Joanne. "Artist Weaves Activism into Unorthodox Garments." *Tampa Tribune*. February 21, 1999.

Miller, Margaret. "Body Architecture." *Tampa Tribune*. February 28, 1999.

Morozzi, Cristina. "L'Art à porter." *Intramuros* 73 (October/November 1999): 24–25.

Müller, Florence, ed. "Collective Survival Sack." In *Art & Mode*. Paris: Editions Assouline / Thames and Hudson, 1999.

Pignalosa, Maria-Cristina. "Jorge Orta abre el circulo del arte." *El Tiempo*. June 15, 1999.

Szabo, Julia. "Wear House." *I-D* 46 (May 1999): 58–63.

1998

Budney, Jen. "Who's It For? 2nd Johannesburg Biennale." *Third Text* 42 (February 1998): 88–94.

Charland, Denis. "La route du coeur1998/1999/2000." In *Le Sabord*. Trois Rivières, QC: Edition Le Sabord, 1998.

Crosling, John. "Body Architecture." *Architectural Review* 65 (Spring 1998): 98.

De Santis, Sophie. "Les formes de Lucy Orta." *Figaroscope*. May 13–19, 1998.

Diawara, Manthia. "Moving Company: 2nd Johannesburg Biennale." *Artforum International*, March 1998, 86–89.

Eshun, Kodwo. "Refuge Wear." *ID Magazine* 179 (September 1998): 106.

Farina, Fernando. "Una mujer colombiana tambien es una especie en extencion." *La Capital*. December 13, 1998.

Goldberg, Roselee, ed. *Performance Live Art since the 60's*. London: Thames and Hudson, 1998.

Gooding, Mel. "Jorge Orta with Lucy Orta Signs-Light." In *Public, Art, Space*. London: Merrell Holberton, 1998.

Heartney, Eleanor. "Mapping the Postcolonial." *Art in America* 6 (June 1998): 51.

Quick, Harriet. "Refuge Wear." *Frank*, October 1998, 74–75.

Sanders, Mark. "Lucy Orta." *Blueprint* 150 (May 1998): 34.

Sumpter, Helen. "Art Couture." *The Big Issue London*. April 27, 1998.

Yann, C. "La Street Life de Lucy Orta." *Jalouse* 8 (March 1998).

Zaya, Octavio, and Paul Virilio. "Nexus Architecture." *Atlantica* 19 (1998): 74–81.

1997

Ardenne, Paul, ed. *L'Age Contemporain*. Paris: Editions du Regard, 1997.

David, Catherine, and Paul Virilio, eds. "The Dark Spot of Art." In *Documenta Documents 1*. Ostfildern, Germany: Hatje Cantz, 1997.

Dikeou, Devon. "Survival Kit." *Zing Magazine*, 1997.

Guillaume, Valérie. "Architectures Corporelles." *Art Press* 18 (1997): 84–85.

Morozzi, Cristina. "Wearing vs. Inhabiting." *Intramuros* 73 (1997): 25.

Quick, Harriet. "Lucy Orta: la mode dans la rue." *Vogues Hommes International* 2 (1997): 154–55.

Orta, Jorge. "Antartique 2000." *Effet de Lieu— 3e imperial*, 1997, 39–46.

Orta, Lucy. "From the Nest to the Web." *View Point*, 1997, 116–24.

Restany, Pierre. "La drammatizzazione del vincolo sociale." *Domus* 793 (May 1997): 102–3.

Virilio, Paul. "Les scaphandres urbains." In *Le Sabord*. Trois Rivières, QC: Edition Le Sabord, 1997.

———. "Urban Armor." *Dazed & Confused* 29 (March 1997): 72–79.

Zugazagoitia, Julian. *Misteri della presenza, magia della luce*. Spoleto, Italy: Spoleto Festival, 1997.

1996

Bamberger, Nicole. *Lucy Orta, kits de survie*. Paris: Jardin des Modes, 1996.

Coleman, David. "In Soho, Art and Fashion Are on the Outs." *New York Times*. September 15, 1996.

Piguet, Philippe. "Architectures Corporelles." *L'Oeil* 478 (January 1996): 10.

Polegato, Lino. "Commune Communicate." *Flux News Liege* 10 (August 1996): 3.

Sans, Jérôme, ed. "Identity + Refuge." *Time Out New York*. September 4, 1996.

1995

Cabasset, Patrick. "Lucy Orta." *Vogue France* 754 (March 1995): 85.

Dellinger, Jade. "Lucy Orta." *Zing Magazine*, Autumn 1995.

De Vandière, Anne. "Éthique dans l'esthétique." *Avenue* 1 (1995): 53–55.

Mohal, Anna. "Der Kunstler als Dandy." *Atelier 1* (1995).

Sans, Jérôme, ed. "Un sac pour la rue." *CAPC Magazine*. September 9, 1995.

Siegle, Jean-Dominique. "Des top models à l'armee du salut." *Beaux Arts Magazine*, 1995, 20.

1994

Boutoulle, Myriam. "Après les falaises de Cuenca, il va tagger la cathédrale de Chartres." *VSD*. September 8, 1994.

"Chartres Celebrates Its 800th Birthday in Light." *European*, September 1994, 4.

Fayolle, Claire. "Vetement Refuge." *Archicrée* 260 (Autumn 1994): 26.

Gauville, Hervé. "Tremplin pour debutants." *Libération*. November 9, 1994.

Piguet, Philippe. "Cité de Refuge." *La Croix*. November 7, 1994.

Pittolo, Veronique. "Les petits endroits pour le corps." *Beaux Arts Magazine*, 1994, 129.

1993

Ergino, Nathalie. "Living Room." *Documents* 2 (February 1993): 24–26.

Hemmings, Jessica. "Political Art." *Fiberarts USA*, January 1993.

Silva-Sebasteban, Roccio. "Huela en los Andes." *Somos Cronicas*, May 1993, 41.

1992

Bruzzone, Andres. "Fuego sobre Machu Picchu." *Descubrir*, November 1992, 17–20.

Dupoint, Juliette. "E improvisamente sul Machu Picchu." *Corriere della Sera*. September 11, 1992.

Mongibeaux, Jean-Francois. "Feux sur Machu Picchu" *Le Figaro Magazine*. July 11, 1992.

1983

"Una nueva forma de arte 'para ponerse.'" *Democracia del litoral*. December 13, 1993.

1981

"Artista purificador de sus propias busquedas." *Rosario*. April 19, 1981.

Acknowledgments

We hold in great esteem the faithful team at Studio Orta for
their commitment to our projects over the last two decades:
Roxanne Andres, Thierry Bal, Sandrine Blanchard, Adeline Cousin,
Jean Jacques Crance, Nicolas Doerler, Ellen Gogler,
Bertrand Huet, Anna Kubleik, Isabelle Lintignat, Elise Magne,
Paula Orrell, Eric Paillet, Camilla Palestra, Ann-Marie Peña,
Francois Proust, Emmanuel Roux, Emma Shercliff,
Isabelle Thibault, and others who have passed through
for shorter periods. We would like to thank Galleria Continua
San Gimignano/Beijing/Le Moulin and Motive Gallery
Amsterdam, as well as the dedicated interns and external
collaborators Michel Aubrey, Roberto Bracali, Daniele Provvedi,
and Patricia Le Roux.

Throughout our artistic journeys, many dear friendships have
been formed. We are deeply grateful for these and for all the
encouragement we have received, in particular for Jorge,
Rubén de la Colina, Padre Libio Gorza, and Ricardo Bruera,
and for Lucy, Helen Thomas and Frances Corner.

We often cite "1+1 = millions," and however absurd it may
seem to our children, Ramiro, Leo, Pablo, and Emily, we can
tell them this is a mathematical fact, as no matter how difficult
the objectives may seem, it's possible to attain the most
surprising results.

—Lucy and Jorge Orta, Paris, 2010